INTRODUCING SCIENCE THROUGH IMAGES

STUDIES IN RHETORIC/COMMUNICATION
Thomas W. Benson, Series Editor

INTRODUCING SCIENCE THROUGH IMAGES

••

Cases of Visual Popularization

Maria E. Gigante

THE UNIVERSITY OF SOUTH CAROLINA PRESS

© 2018 University of South Carolina

Published by the University of South Carolina Press
Columbia, South Carolina 29208

www.sc.edu/uscpress

Manufactured in the United States of America

27 26 25 24 23 22 21 20 19 18
10 9 8 7 6 5 4 3 2 1

Library of Congress Cataloging-in-Publication Data
can be found at http://catalog.loc.gov/.

ISBN 978-1-61117-874-6 (cloth)
ISBN 978-1-61117-875-3 (ebook)

This book was printed on recycled paper with
30 percent postconsumer waste content.

CONTENTS

SERIES EDITOR'S PREFACE

In *Introducing Science through Images*, Maria Gigante offers a critical history and analysis of the way scientific writing that targets popular general audiences has used illustrations to capture and frame readers' attention to the text. Because such writing is directed at a popular audience, it is not expected that the images would perform the function of advancing strictly scientific evidence—and they typically do not. But the images inevitably do exercise a didactic, or teaching, function, shaping the reader's understanding of the writing that follows. Professor Gigante considers such scientific illustrations as "portals," as entry points and introductions to popular scientific writing. She traces the use of such portals across centuries and genres, seeking to find how they may appropriately create public understanding of science.

Professor Gigante argues that popular scientific illustration has the potential to build a deeper understanding of the scientific mission that would in turn encourage reliable public support for science as an institution. Yet she finds that the illustrations in frontispieces, portraits of scientists at work, popular science magazine covers, and online science-art competitions often fall short of their potential to democratize scientific understanding and instead obscure or mystify the scientific enterprise. These failures of popular scientific illustration are conventional, generic, and widespread, but they are not, argues Professor Gigante, necessary. *Introducing Science through Images* has the potential to re-shape artistic representation of popular science. This brisk, pointed, historically rooted, theoretically scrupulous, and critically attentive account is sure to be of interest to all of us who study visual rhetoric and the rhetoric of science, and it has practical advice for scientists and the artists and writers who help to make their work accessible to a wider public.

Thomas W. Benson

PREFACE

When I began this project, several years ago, I was intrigued by the culturally imposed rift between the sciences and the arts. A bit of research proved that others were curious about this rift, too; there are several articles, books, and blogs with titles like "Science and Art," "Art and Science," or "Art Meets Science." What I found, however, was that this literature, for the most part, seemed to privilege science over art, as if art were the handmaiden of the sciences. It struck me that it was also possible for art to complicate science, especially because art is so open to multiple, even conflicting, interpretations. Visuals cannot be controlled like words, and visuals have taken the lead in our culture.

With the inherent visuality of Internet communication and the inordinate quantity of visual stimuli that bombard the average person on a daily basis, we have grown accustomed to receiving information through complex symbolic and iconic codes. A website containing large blocks of text with no images would not survive in this overwhelmingly visual climate. It is not so much disconcerting that the digital/visual has overthrown the textual; more problematic is that the vast majority of consumers have not been trained in visual communication. That is, the educational system has until very recently privileged linguistic modes of discourse over other modes. I suspect that many people reading this book did not learn how to analyze and communicate effectively with images in grade school.

As a result of this lack of training in visual communication, we have a problem: lots of people want to communicate visually, and they go ahead and do so, even if they have not been well trained. Unfortunately, the entities that attempt visual communication (unsuccessfully) are influential. The National Science Foundation (NSF), for example, hosts an annual visualization competition that is meant to garner public support for science. This study is about science images, or, rather, images that are associated with science: popular science images. Given the cultural expectation for image-rich communication, scientific organizations like the NSF must incorporate images into public-outreach efforts. The "gap" between science and society has long been lamented, and

science communicators—the intermediaries between scientific communities and nonexpert publics—have developed models for more effective communication. Visual communication, however, is not generally included in these models. Thus, scientific communities that are interested in communicating research to nonspecialists with striking images are lacking heuristics for doing so effectively.

I wrote this book, initially, because I wanted to assist in this effort by exploring how popular science images have been used in the past. I became invested in finding examples of visual science communication that have largely been overlooked as being merely ornamental or decorative images but that actually served a persuasive function. My line of thinking was that, if only experts and practitioners could see how popular images have been used in different contexts, they might be able to use that template to set up communications with nonspecialist publics today. My foray into such visuals began with the images that appeared in the front of early books in natural or experimental philosophy: frontispieces. Studying frontispieces in early scientific books confirmed my hunch that seemingly ornamental images served a deeper purpose, and this led me to question other ostensibly aesthetic but actually persuasive scientific images that served as a "front" for scientific information. I decided to call this category of scientific visuals "portal images": they occupied an introductory position in relationship to text and thus characterized subsequent discourse for audiences, potentially predisposing them to a particular reading of the text. Portal images, it seemed to me, presented an excellent opportunity for scientists and science communicators.

Scholarship in science communication and related fields informed my study and served as my motivation for discovering a responsible and effective means of visualizing science for nonspecialist publics: a means of both engaging and informing. I strove to align my suggestions about using images with the accepted scholarship on verbal or textual communication of science to nonspecialist publics; this body of work argues for more transparency about scientific processes, about science being fallible like any other human discipline, and about giving audiences tools to make more informed policy decisions. My book was going to propose a way for images to participate in ethical and engaging science communication. Examples of portal images across time would serve as templates, I thought, to be emulated by science communicators and practitioners to assist with responsible and ethical public outreach. The book would make a meaningful contribution to science communication studies as well as to the niche subfield of rhetoric concerned with popular science images.

But then I realized something about the portal images that I had been studying for years that made it impossible for me to continue promoting them as worthy of emulation today. Looking back now, the "realization" is somewhat

obvious, but at the time, because I was so invested in demonstrating how portal images could benefit science communication efforts, it was not only surprising but devastating. All of the cases of portal images that I had been examining were actually subversive to the models of science communication promoted by theorists and practitioners today. Whereas these new models of science communication advocate for situating science in society, making science a part of civic matters rather than above or separate from them, the portal images I had been studying serve to valorize the scientific enterprise, to set it in a realm above society and civic matters.

My project had to change. This book advances a revised argument about portal images. The examples of portal images discussed in each chapter can be used to make several arguments, but, instead of arguing that scientists and practitioners use past models as templates for visual communication today, I am arguing that scientists, communicators, scholars, and consumers of scientific discourse must think more critically about visual communication. The question that readers should ask themselves after reading this book is: How can we learn from past examples and use visuals responsibly to both engage and inform non-specialist audiences?

This book charts a path that leads up to twenty-first-century attempts to secure public support for science through the use of images. The chapters address images of science chronologically, beginning with frontispieces in early natural philosophy books, then portraits of scientists in the early twentieth century, popular science magazine covers, and, finally, science-art competitions. All of the images addressed in this book, despite differences in time period, serve an introductory function—that is, the images appear in a position of primacy relative to the text and have the potential to make audiences attentive and well disposed to the coming subject matter. In the introduction, I elaborate on the "portal image" concept and explain its utility for rhetorical studies of science. A rhetorical approach allows for the possibility of tracing persuasive visual communication across the centuries and illuminates the themes that stand the test of time. Accordingly, because of the historical progression represented, the types of images presented in each chapter of this book invite diverse interpretive lenses, despite the fact that they all share the same portal function.

The main audience for this book consists of scholars in rhetoric who are interested in information design, graphic design, digital humanities, writing studies, communication, and journalism. However, an important secondary audience for this book comprises practitioners, including scientists, science communicators, and scientific organizations. Science communication handbooks and science communication theory books are in surplus, but these handbooks do not address the affordances and impact of images in the context of public outreach.

Popular science images have as much potential to engage and inform as they do to mislead and confuse. The question becomes whether the persuasive power of images will be harnessed for civic engagement or for reinforcing the divide between scientific communities and nonspecialist publics. This book creates a new avenue for exploration in current scholarship in the field of science communication in that it addresses the concern surrounding the lack of connection between scientific communities and nonspecialist publics, and it considers how science can be communicated visually in a more responsible and effective way. I want to emphasize that, although it takes a critical stance toward visual science communication, this book has an ameliorative aim: to inspire change that I hope will lead to improvements.

Last, a word about the images. This book is missing some key images due to various issues obtaining permissions. Although important work is being done regarding the redefinition of "fair use" as it pertains to visual studies, publishing in the field of visual rhetoric is, currently, a difficult endeavor. In cases in which I was unable to reproduce images, I have attempted to describe them in detail and provide information for readers who wish to find them online.

ACKNOWLEDGMENTS

Many people contributed to the production of this book, at different times and in different ways. I am especially grateful to Jeanne Fahnestock, who guided the project through its earliest stages and has continued to be very generous with her time and insights. One of the (many) things that I appreciate about Jeanne is that, even though she is one of the most brilliant scholars in the field, she delivers criticism with humility and charm. Other faculty members at the University of Maryland were instrumental in the completion of earlier versions of this project: Vessela Valiavitcharska, Shirley Logan, Scott Wible, and Shawn Perry-Giles. In addition to the wonderful faculty at UMD, I am grateful to my graduate student cohort for their camaraderie and support: Martin Camper, Lindsay Dunne Jacoby, Andy Black, Cameron Mozafari, Heather Brown, Mark Hoffmann, Kisa Lape, Paul Cote, Rachel Vorona Cote, and, last but not least, Katie Stanutz, who will always be my "Maryland Person."

The English department at Western Michigan University has been welcoming and supportive of my research on popular science images. In particular, Brian Gogan, Jonathan Bush, Staci Perryman-Clark, Charie Thralls, and Nic Witschi have been forthcoming with their time, energy, and resources. At Western's library, Kate Langan was spectacular at tracking down images and answering my questions.

The participants in Alan Gross's 2011 RSA seminar on the rhetoric of science helped to improve my chapter on magazine covers. Likewise, the participants in Leah Ceccerelli and Carolyn Miller's 2015 seminar helped me to work through my ideas as I embarked on the process of revising this book. Parts of chapter 2 and 4 in this book are from previously published articles and are reprinted courtesy of Taylor and Francis and SAGE, respectively.

Thanks to Jim Denton at the University of South Carolina Press for his patience and guidance throughout the submission process, especially regarding the images, and for providing two reviewers who offered valuable suggestions for revision and took great care in formulating their responses to the manuscript.

I am deeply grateful to the artists and scientists who allowed me to reproduce their images in this book: Darren Hopes, Christos Magganas, Andrew Noske, Thomas Deerinck, Horng Ou, Clodagh O'Shea, Luc Bernard, Richard Palais, Andrea Ottesen, Lee Sierad, and Jerry Ross. Without their generosity, this book would be nearly image-less. All of the criticisms in the book are directed not at the image creators, who have produced captivating and beautiful work, but at the larger social problem of visual science communication. I thank Patricia Aufderheide at American University for providing valuable resources on fair use in the visual arts and for being so forthcoming with advice, even though I contacted her on a whim. Projects in any field of study dealing with visuals will benefit from her work with Peter Jaszi on fair use.

It is fair to say that none of this would have been possible without the support of my parents, who encouraged my intellectual curiosity early on. Finally, I am immeasurably grateful to Casey for being my sounding board, editor, motivational speaker, and adventure partner. Thank you for believing in me and showing me how to celebrate the journey as well as the destination.

Introduction

....................................

Popular Science Images and Portals

Popular science images are difficult to classify on the basis of their surface-level features alone. Images as disparate as, for example, a photograph of a scientist working in a laboratory and a rainbow-dyed visualization of a mouse's neural circuitry can both be considered popular science images. Rather than being predicated on its surface features, an image's classification as "popular" depends on a variety of factors, such as the agents producing it, the venues in which it is published, and the purposes (as far as they are discernible) for its circulation outside the scientific community. Addressing these factors from a sociological perspective, Huppauf and Weingart identify, in the introduction to *Science Images and Popular Images of the Sciences,*[1] different categories of popular science images. For example, there are distinctions between images created in the scientific community and purposefully circulated in public venues (think of NASA's Hubble telescope images) and those created by the media to represent science for the public (think of movie representations of scientists). This book is particularly concerned with popular science images created by scientists, or scientist–artist collaborations, and then aimed at audiences outside the scientific community. Popular science images can include visualizations, photographs, drawings, graphic designs, and other genres that leave the scientific community and are purposefully circulated for public consumption, as well as images created specifically for public consumption, such as portraits of scientists, that were probably not used within the scientific community.[2]

There is an important distinction to be made between popular science images and scientific visualizations—the images found in research papers that are aimed at audiences of experts and practitioners.[3] The latter have been the subject of many studies in sociology, history, and rhetoric. Scholars in these fields have attended to scientific visualizations because of their epistemological function.[4] Rhetoricians of science have established that visualizations are indispensable to

scientific argumentation—that they are not supplemental to linguistic compo-nents but equally important for advancing knowledge in the scientific commu-nity.[5] Scientific visualizations in research reports are a part of *internal* rhetorics of science, situated among scientists, within scientific communities. If and when these visualizations leave the scientific community, they become a part of *exter-nal* rhetorics of science, situated outside scientific communities, in some type of public venue.[6] When images circulate in public venues, such as in newspapers or blogs, their primary function is likely to be not epistemological but, rather, didactic—or, as in many of the cases in this book, to inspire awe.

Regarding external visual rhetorics of science, there are still further dis-tinctions to be made. Data-driven visualizations and infographics, which are designed to communicate complex information to uninitiated audiences, have been the subject of many studies in technical communication, and they, too, belong to external rhetorics of science.[7] The effectiveness of informational graphics and data displays aimed at uninitiated audiences is determined by such factors as usability, concision, and clarity.[8] Popular science images typi-cally are not of the same ilk as data displays and informational graphics; rather, popular science images are seemingly innocuous, aesthetically pleasing images of science that circulate in society and fly under the critical radar. Because they cannot necessarily be assessed for their effectiveness at conveying data, they require different treatment. Studying popular science images can be challenging because of their seeming simplicity and consequent resistance to some types of criticism.

Despite these challenges, the use of art to communicate science has been gaining traction in the scientific community because of its promise for captivat-ing nonexpert publics. In a visually striking book titled *Envisioning Science,* the MIT and Harvard professor Felice Frankel instructs scientists in the art of turn-ing their visualizations into breathtaking images that can promote science in the public eye.[9] Science images are seen as a way of making science more accessible to the average citizen. "Pictures speak to all of us," claims Piers Bizony in an ar-ticle in *Engineering & Technology*—even, he says, to "people who aren't so fluent in that [scientific] language."[10] Ostensibly predicated on that belief, the National Science Foundation (NSF) holds an annual competition for aesthetically pleasing scientific images, which, according to the competition's mission statement, are supposed to increase "public understanding of research developments."[11] When funding for basic scientific research is increasingly difficult to secure, public support becomes all the more essential. But, although visual communication is used in an effort to improve the fraught relationship between science and so-ciety, the effective and responsible use of visual communication in this context has not been well studied.

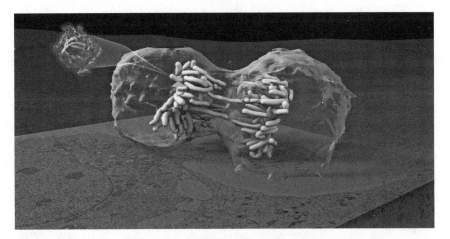

Fig. 1. "Separation of a Cell." National Science Foundation Science & Engineering Visualization Challenge 2011 People's Choice Award in Illustration. Credit: Andrew Noske, Thomas Deerinck, National Center for Microscopy & Imaging Research; Horng Ou, Clodagh O'Shea, Salk Institute. Available from https://www.nsf.gov/news/special _reports/scivis/winners_2011.jsp (accessed February 6, 2012). Reprinted with permission.

Consider the example, above, from the NSF's visualization competition. Figure 1, "Separation of a Cell," is the 2011 winner of the People's Choice award in the category "Illustration." There were 3,200 votes from visitors to the NSF's website, and these were tabulated to determine the People's Choice award winners, according to the Special Feature article in *Science* that reported on the competition. What the article does not say, and perhaps what cannot be determined from the voting mechanism, is who these voters were. According to the competition's mission statement, the intended audience was the "general public."

Given that audience, what can be said about the educational capacity of this image? The title of the image, "Separation of a Cell," tells viewers what they are looking at, but the title certainly cannot be expected to assist viewers in comprehending all of the aspects of the image. The various components, such as the objects inside the two spheres and the small orb emerging from them, are left unlabeled. There is no key or legend included with the image to help viewers identify these different components. There is, however, a caption for the image provided on the NSF's website: "This new and tactile view of a cell undergoing division comes thanks to a specialized protein called MiniSOG. This illustration shows the molecule zipping toward the reader, fluorescent and standing out crisply from an electron microscope image. With some tweaking, MiniSOG binds tightly to a second protein closely associated with DNA, giving scientists the ability to target and view chromosomes in detail as they peel apart during mitosis."[12] Unless viewers are familiar with biology or have recently taken a

class in it, the caption probably does not help them identify the various components in the image. Several terms in the caption would need to be defined for viewers who have not recently been in a biology class. For instance, the terms "MiniSOG" (which stands for "mini singlet oxygen generator") and "protein" the way that it is used in this context, and maybe even "mitosis," might require definitions. Beyond unfamiliar terminology, general audiences lack context for the image. In other words, what is the significance of scientists being able to "target and view chromosomes as they peel apart"? What exciting things can happen now because of that new ability?

Because of its prominent placement relative to text on the website, the image is poised to be a portal into scientific discourse. But it is not, actually, for the reasons mentioned here. I begin with this example because it illustrates some of the issues surrounding current science communication efforts. The NSF's visualization competition draws attention to the *potential* of visual discourse to improve public outreach, and it also exhibits some of the challenges associated with visual communication that must be addressed. One of these challenges pertains to audience conceptualization. When the intended and the actual audiences for an image are different, there are bound to be communicative problems, as the example demonstrates, because different audiences require different amounts and types of contextualization. Figure 1 has the potential to introduce uninitiated audiences to scientific information, but it fails because the image does not lead to substantive, accessible text that explains the relevance of the image to science for the intended nonexpert public audience. The NSF's visualization competition is considered at length in chapter 4. In the meantime, it must be said that reaching out to public audiences with aesthetically pleasing images is not, in itself, an issue. Problems arise when popular images position science as being out of reach for the average citizen and above societal concerns.

MODELS OF SCIENCE COMMUNICATION: ADDING A VISUAL COMPONENT

The rift between science and society is well documented by communication scholars, philosophers, sociologists, rhetoricians, and scholars of science and technology in society (STS).[13] Models for successful communication between scientists and publics have been created and discarded to make way for newer and more effective models. Doing justice to the complexities of this large and interdisciplinary field of study is not possible here,[14] but a brief overview of its basic objectives is important to this study.

The early model of science communication, developed in the 1980s, is now referred to as the Deficit model of communication, and it has been rejected by science communication scholars. Alternately referred to as the Public

Understanding of Science model, the Deficit model presumes that the public is ignorant about science and that, if people were more educated by scientists, they would be supportive (that is, fund research). The grounds for the rejection of this model include that it represents a one-way flow of information (from scientists to publics) that neglects societal beliefs and values and that it presents an infeasible task: educating the public in science. Although newer models of science communication have been created and revised by scholars to replace the deficit model, the scientific community has not yet adopted them.[15] Even if the language of newer models, which focus on public engagement with science issues, is used, the ideals of the deficit model remain intact.[16] Continued adherence to the deficit model is a problem because it perpetuates the idea that science operates above society, thus maintaining the divide between science and nonexpert publics.

The most recent movement can be characterized as an attempt both to dispel the myth that science is separate from (and above) society and to argue that science should be held accountable to the citizenry that it serves. Representing this movement is the newest model of science communication, called Critical Understanding of Science in Public (CUSP) or Critical Science Literacy.[17] The basic tenets of this movement can be summarized as follows: the scientific community and science communicators are responsible for describing research in context, explaining details about the risks, controversies, and uncertainties surrounding the research process; moreover, scientists are to engage with citizens respectfully as stakeholders. Sarah Perrault's *Communicating Popular Science: From Deficit to Democracy* reveals the ideologies at work in popular science communication and provides concrete advice for communicators to shift away from traditional-idealist perspectives (science as having access to "Truth") and toward a "realist-skepticism" perspective that aligns with the CUSP model and works to democratize science. CUSP-model writing is concerned with revealing science as socially situated, accessible, relevant, and realistic. The overarching objective of this model is to foster a citizenry that is equipped to make informed policy decisions—to serve democracy.

All of the models of science communication described here pertain to linguistic communication; they do not encompass visual discourse. The neglect of visual communication, specifically through popular science images, has left a blind spot in our understanding of science communication with nonexpert publics.[18] Moreover, given the problems with, on one side, scientists struggling to secure research funding and, on the other side, citizens struggling to make informed policy decisions, it seems that attempting to use popular science images in alignment with CUSP-model communication is one viable method for improving communicative efforts.

For years, popular images, such as advertisements, billboards, and logos, were dismissed as simple and unworthy of study.[19] In the twentieth century, theoretical perspectives on the functions of images in society emerged,[20] and visual studies has become a flourishing subfield in the rhetorical community as well as in other disciplines. Still, curriculum that engages with visual persuasion is only just making its way into primary and secondary schools. Most of us were trained, in other words, from a young age, to believe that images are not intellectual or worthy of study.[21] Images that are considered "popular" remain an underprivileged means of communication in our culture, and, as a result, they are misunderstood as being "easier" and "simpler" than linguistic discourse. And yet, the persuasive use of images in society is becoming far more prolific than linguistic modes.[22] The lack of education in "how images work" and how to use them opens the door to image mishandling on the part of producers and passive image consumption on the part of audiences.[23]

Popular science images are one of the many rhetorical tools available to communicators of scientific information, and, as such, they merit as much consideration as linguistic tools. Images, like language, can be used to mislead and manipulate, just as they can be used to inspire and inform. Although there are both implicit and explicit codes of ethics regarding linguistic communication, and readers have a means of assessing and speaking out against ethical breaches, there are no such ethical codes when it comes to visual communication. As of now, what is considered to be "effective" visual communication is left to the discretion of agents who produce and circulate images. If a scientific organization wants to say that a beautiful image of a nebula educates the public, for example, there is no structure in place to either validate or negate that claim. Scientific entities attempting to use images to increase support for science are faced with a predicament: they are told by our society that images can make science accessible, when, in reality, images used without rhetorical precision can result in imbuing their subject matter with mysteriousness, rendering it inaccessible.

This book considers how visuals have been used to persuade audiences outside the scientific community to support and appreciate the scientific enterprise. More to the point, each chapter presents a different way in which the scientific enterprise has been mystified in the public eye. The purpose of this particular focus is not to malign or discredit the scientific community but, rather, to provide a more comprehensive understanding of the persuasive capacity of popular science images than studies that have focused mainly on the potential for images to teach and inspire.[24] Ultimately, when a framework for visual communication is adopted, it ought to adhere to the tenets of the CUSP model of communication and critical science literacy mentioned earlier.

All of the examples of images in this book are specifically those that serve an introductory function to scientific discourse. The term I use to refer to this type of image is "portal." Portal images, as the name suggests, serve as entry points into scientific discourse for uninitiated audiences. They occupy a privileged position relative to text and are thus poised to influence readers' perceptions of the text that follows them. The cover of a magazine is an example of a portal image—it prepares readers to encounter the discourse beyond the cover. The examples I have mentioned so far are all fairly current, but the use of images to introduce science is not a twenty-first-century phenomenon, despite all of the hype surrounding aestheticized images in the scientific community. Moreover, to understand the potential of popular science images, it is necessary to look at a variety of cases, not only from the present time but also from the past.[25]

Considering both historical and current examples of popular science images allows for trends to emerge that stand the test of time, even considering changes to the scientific enterprise, the audiences for scientific communication, and the available means of image production and reproduction. The chapters in this book sample popular science images from the seventeenth century to the twenty-first, beginning with the frontispieces to Sir Francis Bacon's work, which is credited with heralding a new, "scientific" way of looking at the natural world. Examining salient examples of popular science images over time and considering how they have contributed to the divide between science and society can provide insight into the choices available to science communicators, as well as the potential consequences, positive and negative, of those choices. It is hoped that, in revealing these consequences, this book will also lead to ways in which images might be used to assist in both the advancement of scientific research and the enfranchisement of citizens.

THE PORTAL IMAGE: A TOOL TO BE PERFECTED

A portal image, broadly speaking, can be conceived of as an introduction. Images can be considered portals in situations in which images are the primary focal point relative to text. I argue that those images have the potential to influence consumers' perspectives of the text that follows the image(s). It has long been thought that text provides the grounds for understanding images. The semiotician Roland Barthes described the function of text as "remote controlling" the reader to a certain meaning or interpretation of the image.[26] But portal images, because they appear in a position of primacy relative to text, can be more predisposed to influencing impressions of the text that comes after them. Portal images are also more likely to yield conflicting interpretations than are images that operate alongside text. An important modification of Barthes's theory was

proposed by Kress and van Leeuwen, who argued that "the visual component of a text is an independently organized and structured message—connected with the verbal text, but in no way dependent on it: and similarly the other way around."[27] In other words, images and text can supply different messages, and it is necessary to attend to both.[28] There are some cases in which the textual "anchorage" is essential if the popular science images is to have scientific import, as explored in chapter 4. However, there are also cases in which the image is in a position to influence perceptions of the following text, and these types of portals are considered as well.

Regarding the importance of introductory material, specifically for speeches, ancient rhetorical treatises have a great deal to say. According to the *Rhetorica ad Herennium,* for example, the purpose of the introduction or "exordium" to a speech is to make the hearer attentive and well disposed to the upcoming subject matter.[29] Some would contend that classical texts are not applicable to visual discourse, and it is certainly true that these texts were not designed to encompass visual communication. Still, it is the structure of the discourse that is of primary concern here: the introduction precedes the rhetor's main argument, thus providing the rhetor with an opportunity to shape or frame the argument in a way that makes it palatable to the audience. It seems reasonable to extend the same principle to a visual introduction. That is, an image that appears in an introductory role relative to a larger text has the potential to shape or frame the forthcoming argument in a way that makes it palatable to the audience.

The exordium to a speech is the earliest iteration of the "portal" phenomenon. It is also possible to conceive of a portal image as *paratextual,* from a semiotic perspective. Gerard Genette[30] conceived of the notion that introductory and peripheral materials contribute to the overall meaning of the main text. Visuals are not a point of emphasis in Genette's theory, but book covers, which typically contain images and minimal text, are mentioned as being a part of the paratextual material. Portal images, as paratextual, have the potential to influence and inflect the meaning of the texts that they precede. In sum, the placement of the image, regardless of what theoretical lens one prefers to use, gives the image its persuasive power.

From a document design perspective, the concept of a portal image can be likened to Karen Schriver's concept of a "stage-setting image."[31] To the existing types of relationships between words and images—redundant, complementary, and supplementary—Schriver added *juxtapositional* and *stage-setting.* In redundant relationships, images and texts convey the same message. Complementary relationships are characterized by images and texts that have different messages such that both are needed to understand the main point. In supplementary relationships, one mode is dominant, and the other elaborates or clarifies the main

point. Schriver described her concept of juxtapositional relationships between words and images as demonstrating a clash or tension; they are typically used in advertising to create a connection between a product and an object representing a desired outcome (for example, a romantic partnership presented as a result of using a certain brand of perfume). Her concept of stage-setting relationships, by contrast, seems geared toward facilitating understanding, as opposed to providing shock value, in the sense that they prepare readers for upcoming information. Here is how Schriver defined stage-setting relationships: "one mode provides a context for the other mode by forecasting its content or soon-to-be presented themes. A stage-setting text or graphic may enhance what follows it by providing a contextual framework in which the verbal content can be understood."[32] Schriver noted that it is possible for images and text to exhibit more than one relationship type, meaning that an image-text relationship can be both juxtapositional and stage-setting, for example.

Beyond mentioning the possibility of image–text pairings exhibiting different types of relationships simultaneously, however, Schriver did not elaborate on such possibilities. As it turns out, the image-text pairings in many of the cases in this book do fall on the boundaries of different relationships types. They are predominantly stage-setting images—hence the notion of a portal—but they are, in some cases, like advertisements that demonstrate a tension between visual and verbal content—a juxtapositional relationship. In my preface, I explained that I began this project thinking of science images as portals—as what Schriver referred to as stage-setting images, which are preparatory and helpful. However, by associating science with mystical themes, the portal images also represent a clash or tension, which, though useful in advertising, can have deleterious effects for science. The examples in this book can be seen as expanding on and complicating Schriver's insights about image-text relationships.

When serving in a stage-setting or introductory role, a visual, as opposed to text-based communication, presents communicators with unique affordances. With recent technological advancements, neuroscientific research has been able to explain how images are processed cognitively.[33] Images have been described in visual studies as being inherently "affect laden,"[34] because they are processed through emotional pathways in the brain.[35] For that reason, images have been found to be more memorable and more powerful than other modes of communication. One of the most compelling points to be taken from this body of research is that images have the capacity to say what words cannot.[36] In "The Rhetoric of Visual Arguments," J. Anthony Blair pointed to the capacity of images to communicate with more force and immediacy than verbal communication.[37] Advertisements and political cartoons, for example, often can get away with making statements nonverbally that would be considered socially less acceptable if stated

verbally. The research in visual studies has yet to be explored and applied in the context of communicating science to nonscientist publics. One area that has been explored—and that is applicable to the context of science communication —is visual communication through the news media.

The power of visuals that grows out of our cognitive processes has prompted communication theorists to investigate the use of images to "frame" stories in the news media. There is evidence that viewers remember images in news programs better than they remember verbally conveyed information.[38] The reason is that visuals, when presented with information conveyed in other modes, have a tendency to dominate awareness.[39] Images can thus be positioned to influence public perceptions of an issue or political candidate.[40] The notion that images can frame an entire case for consumers of information—because of their ability to convey ideologies[41]—substantiates the idea that certain images that appear before text have the capacity to influence viewers' perceptions of that text. The concept of a portal image that I am advancing is validated by these important findings in visual studies as well as by the functions of introductions established in the rhetorical tradition.

THE MYSTIFICATION OF SCIENCE

There is a contradiction in the limited literature on popular science images as to their inherent purpose. On one hand, science images are seen as a way of making science more accessible to the average citizen, thus democratizing knowledge.[42] On the other hand, science images are valued for their ability to create a sense of wonder and awe for uninitiated audiences; Huppauf and Weingart compare popular science images to fine art from the avant-garde period, saying that it is their "indeterminacy" that makes them so appealing and persuasive to nonspecialist publics. Similarly, Luc Pauwels's *Visual Cultures of Science* identifies popular science images as superficial "eye-catchers."[43] How is it possible that popular science images can simultaneously make science accessible for nonspecialist audiences and awe those same audiences with their indeterminacy? Accessibility, particularly when paired with the concept of democratization, suggests that some semblance of understanding is being facilitated by the images. Indeterminacy, by contrast, as Huppauf and Weingart put it, "stimulates imagination" and encourages free association.

Granted, visual compositions that contain culturally relevant symbols inspire us to create connections—both personal and on a larger social scale—to derive meanings from them.[44] We have a tendency to relate what we see to other images that we have already seen or to our own past experiences and cultural knowledge; this is a concept referred to as the "intertextuality" of an image.[45]

In their work on iconic photographs, Hariman and Lucaites describe intertextuality as "a field of multiple projections."[46] They explain that there are many "registers in play" in visual discourse, and "any of them could be activated by particular audiences."[47] Thus, all images are subject to indeterminacy and consequent openness to multiple, even conflicting, interpretations.

Still, there are options when it comes to the types of images used to communicate science and the ways in which they are positioned and contextualized. Communicators make countless choices when selecting, stylizing, and arranging images. For example, in the field of advertising, successful communication is entirely dependent upon learning the values and beliefs of a particular audience in order to tailor multimodal communication for that audience to achieve a specific purpose. To craft effective visual messages, advertisers consider the principles of visual design, often considered "universals." That is, when used properly, the techniques have been shown to produce desired effects in viewers.[48] For example, placing visual elements in prominent locations in a composition, such as the top of the page, gives them dominance in the composition, demanding more of the viewer's attention.[49] The order in which viewers take in visual cues depends upon their placement and level of dominance in a composition; the eyes are guided by lines or vectors, often invisible or implied, between objects in the composition.[50] Compositions that are asymmetrical or more crowded tend to appeal more to younger audiences, whereas compositions that are unified, balanced, and simple generally appeal more to older or professional audiences.[51] Knowledge of visual design gives advertisers the tools needed to sell products. But, notably, selling products is also about selling *attitudes*. Insights can be gleaned from advertising theory and practice to sell positive attitudes toward the scientific enterprise but also to bring more depth to nonexperts' understanding of the workings of the scientific enterprise. Ethical communication requires both aspects: entertainment and information.[52]

Images that stimulate the imagination and encourage free association at the expense of making a scientific subject accessible to uninitiated audiences are problematic, especially if they are being touted as educational images. The way to improve policy decision making (read: increase public support for science), according to the CUSP model of science communication, or Critical Science Literacy, is not to shower public audiences with random scientific facts or to "wow" the public with empty images but, rather, to explain how science is done. If images are to contribute to that effort, then they ought to be assessed according to how well they reveal the workings of some aspect of science. To secure the attention of audiences that are bombarded with countless other visual stimuli on a daily basis, popular science images, like other forms of popular science discourse (for example, newspaper articles), must also attempt to demonstrate

value or connection to subjects outside the scientific enterprise.[53] In order to reach these goals, images require some form of contextualization, often verbal or linguistic in nature. In other words, popular science images must be accompanied by text that is accessible to nonspecialist audiences. For portal images specifically, the image must lead audiences to text that is accessible.

The few extant studies of popular science images have focused on images that, by and large, follow these criteria, noting that popular images do not serve an epistemological function, like scientific visualizations, but instead are supposed to take on an educational function.[54] However, visual science communication over the past four centuries has not always been educational and informative. The chapters in this book consider cases in which science has been mystified in the public eye in various ways. Society simultaneously depends on science for solving problems and fears its majesty; scientists simultaneously resent nonexpert publics for not understanding and promoting their research and fear communicating with them directly because of potential rejection within the scientific community.[55] The statement that science is the new religion of the twentieth and twenty-first centuries[56] has become somewhat of a cliché. Dorothy Nelkin has called it "the scientific mystique."[57] William Doty uses the term "mythic frames of science."[58] Marcel LaFollette has explained it as "an instrument of faith" when political or religious "oracles" fail to supply answers.[59] The mystification of science in society, particularly regarding the treatment of science by the news media, has been studied most notably by Dorothy Nelkin. Unraveling the long history of science's ascent in society, Nelkin has claimed that "science remains idealized as an esoteric activity, a separate culture, a profession apart from and above other human endeavors."[60] There are consequences to this conceptualization of science in society, however.

In fact, according to Nelkin, mystifying science "obscures the importance of science and its critical effect on our daily lives."[61] Moreover, mystifying science "contributes to the obfuscation of science and helps to perpetuate the distance between science and the citizen."[62] *Images* of science can perpetuate this unfortunate distancing of science from society. In other words, the (mis)use of images to "wow" the public in the name of education can actually reinforce the mystification of science in society, which serves neither the scientific community nor citizens.[63] But, if used in a rhetorically effective way, images also have the potential to mitigate tensions between the scientific community and nonexpert publics. For these reasons, the persuasive capacity of popular science images is worth considering more closely.

Using Nelkin's characterization, the images featured in this book are classified under the umbrella of mystification. Each type of image mystifies science in the public eye in a particular way. One type of mystification involves the

invocation of mythic themes. Other forms of mystification that are considered in this book are the invocation of an ethos of superiority, the use of fantastical themes, and the celebration of indeterminacy. The forms addressed here are merely a starting point, as there are likely other forms that mystification can take. The mystification of science through popular science images happens to be a long-standing tradition, but that does not necessarily indicate intentionality on the part of the scientific community. Rather than focusing on motive, I am more interested in exposing cases of scientific mystification to bring more awareness to the consequences involved in image selection and contextualization.

This book attempts to answer the following questions: What themes emerge in the messages of portal images across time? How do image and text interact in these various cases? What operations do portal images perform that have remained constant over the centuries? What are the potential pitfalls of communicating science visually? What can be learned from portal images to assist in visual science communication today?

A good beginning in answering these questions is to consider the frontispiece as used in publications. Appearing in books before or with title pages, frontispieces served as visual introductions to the forthcoming scientific discourse. Frontispieces often appealed to readers' already-held knowledge of emblems and symbols to serve as one of the most obvious types of portal images into unfamiliar empirical texts. In this way, the aesthetically pleasing and allegorical images could function to legitimize new scientific knowledge before the field was socially, politically, and culturally accepted. Chapter 1 examines the complex relationship between a select group of frontispieces and the empirical texts that they preceded, demonstrating how popular science images had a tendency to mythicize science for uninitiated audiences.

By the late nineteenth century, frontispieces were going out of style, but the invention of the camera led to new forms of portraying science to nonscientist publics. Accordingly, photographic portraits of scientists circulated in popular media that participated in shaping public impressions of scientists and science. Following that, the first candid photographs of scientists working in laboratories were circulated for public consumption—a new trend made possible by the invention of the portable camera in the 1920s, which afforded photographers significant artistic license. Departing from formal portraiture, images of scientists often portrayed them as if they were busy working with impressive-looking equipment, creating the precedent for what we now think of as stereotypical images of scientists. The invention of photography is said to have contributed in part to the concept of "scientific objectivity" in the expert community, as Daston and Galison, among others, have argued, and this new technology also served to create an ethos of superiority around scientists for nonexpert communities.

Photographs thus also contributed to shaping early twentieth-century public conceptions of science, often mystifying science through its scientists.

Then, in the second half of the twentieth century, persuasive design strategies began to be used for popular science magazine covers. Magazine covers are an obvious example of portal images; it is the magazine cover, after all, that does the work at the newsstand of persuading passers-by to open the magazine and engage with the scientific content inside. It is interesting to observe the changes in design on the covers of *Scientific American,* a publication once respected by experts who sought to gain a wider audience for their research but now considered a popularization on the same level as, for example, *Discover.* What many have called the "downfall" of *Scientific American* can highlight the fact that visual design changes are directly related to changes in target audience. Also noteworthy in this regard are *New Scientist* and *Science Illustrated,* one well established and one very new popular science magazine, to identify recurring cover design choices—designs repeated ostensibly because they are most effective at engaging the broadest audiences with science. Ultimately, the techniques employed in these portal images mystify science by associating it with supernatural and fictional phenomena.

Science images on the Internet bring to light a current and ongoing issue with visual science communication. Specifically, award-winning science images from visualization competitions are notorious for traveling on the Internet without context, especially to blogs. One of the obvious consequences of images traveling without context is that they are open to misinterpretation, especially by nonexpert audiences. As Tufte and others in the field of information design have indicated, visuals without clear explanations are deceptive and even dangerous in the long run, if the aim is indeed to inform rather than merely impress. As part of this analysis, I consider the criteria for using images to both entertain and inform uninitiated audiences in today's digital environment. It should be noted that the visualization competitions investigated herein are run by well-respected scientific organizations, such as the National Science Foundation, with the aim of reaching out to nonexpert audiences. Their competition guidelines and mission statements are taken into account to reveal an inherent contradiction in their objectives. It is the indeterminacy of popular science images in this case that leads to their mystification in the public eye.

1

Frontispieces

••••••••••••••••••••••••••••••••••••

Science's Mythic Origin Story

S cience today has a reputation for operating smoothly and efficiently, such
that it might inspire little consideration of its earliest stages of development.
Nevertheless, centuries of disciplinary evolution, controversy, and technologi-
cal advancement have contributed to the operation of the scientific enterprise
today.[1] The term "science" was not coined until the 1830s; prior to that, the sci-
ences were known as natural or experimental philosophy, and scientists were
called "natural philosophers."[2] The discipline cohered in the seventeenth century
around the work of Sir Francis Bacon, who, in *The Advancement of Learning*
(1605), advocated for a new way of apprehending and communicating knowl-
edge about the natural world. Bacon's name is often invoked along with the
revolution that eventually led to the current model of scientific experimentation
and argumentation.

Natural philosophers were able to transition away from traditional prac-
tices of knowing and communicating about the world through the formation of
the Royal Society of London in the 1660s and its publication of the first scientific
journal, the *Philosophical Transactions*. Both the society and the journal provided
a forum for natural philosophers to share their experiments and findings. Their
break from tradition is described in detail by Sir Thomas Sprat in his *History of
the Royal Society* (1667). Sprat, following Sir Francis Bacon's charge to overhaul
the classical education system, argued, on behalf of natural philosophers, for
a return to "mathematical plainness" in their discourse and for an end to elo-
quence and misleading language.[3] Classical ideals and aesthetics were replaced,
in this field, by a privileging of technical discourse supported by logic and rea-
son. However, at the same time that natural philosophers were actively striking
out embellishment in their discourse, they were also perpetuating a tradition
that was ostensibly contradictory to Sprat's aims: the inclusion of engraved
illustrations, called frontispieces, in their books. Granted, one might argue that,

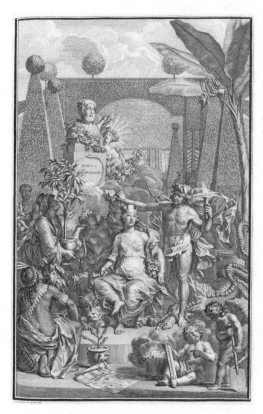

Fig. 2. Jan Wandelaar, Frontispiece to *Hortus Cliffortianus*, by Carl Linnaeus. 1738. Available from Wikimedia Commons, https://commons.wikimedia.org/wiki/File:Linnaeus_Hortus_Cliffortianus_frontispiece_cropped.jpg (accessed March 20, 2016).

given their education and the long-standing influence of the Renaissance, natural philosophers were classicists, at least in some sense, and so their decision to use classically themed frontispieces was not all that peculiar. Nevertheless, frontispieces can be considered subversive to championing "mathematical plainness" and striking out embellishment because they are art objects, typically layered with symbolic import, and, in some cases, they are aesthetically pleasing.[4]

Figure 2, for example, presents the frontispiece to Carl Linnaeus's *Hortus Cliffortianus* (1737). Linnaeus is best known for his system of binary classification for species, and he has been credited with developing the field of botany. The frontispiece shows a congregation of mythological figures, each with symbolic meaning derived from the classical allegorical tradition.[5] The background is a depiction of a garden, owned by George Clifford, that Linnaeus studied for several years. The results of his research were published in the *Hortus Cliffortianus*, the text following this classically themed frontispiece, delivered in the plain, mathematical style praised by Thomas Sprat. Linnaeus was not the only natural philosopher who commissioned an artist/engraver to design a frontispiece to appear at the beginning of a technical manuscript. The frontispiece to

Linnaeus's book, in addition to others, is considered in this chapter to provide insight into the curious choice of prefacing a departure from tradition with a traditionally styled visual.

Because of their aesthetic qualities, it would be easy to dismiss frontispieces as mere decorations, but their privileged position in the front of books makes them much more rhetorically charged than mere embellishments. Frontispieces were significant from economic and symbolic perspectives, and they were responsible for promoting the work of natural philosophers.[6] In extant scholarship on frontispieces, which generally take the form of case studies, frontispieces are frequently grouped according to their thematic qualities (for example, feminist symbols).[7] Though informative about the selected theme and its cultural context, these studies tend to separate frontispieces from the texts that they precede, which is problematic from a rhetorical perspective. An analysis of a decontextualized frontispiece—viewing it as an autonomous work of art—can result in limitless speculation about its visual composition that is not only unnecessary but fruitless, considering that it is bound into a book that grounds its implications. Moreover, a frontispiece dissociated from the text it precedes is, arguably, a frontispiece no longer. Even if, as in some cases, the illustrations diverged from the authors' intended specifications, the fact remains that they were physically bound into natural philosopher's books and were sometimes supplemented with explanatory captions or poems to guide viewers' interpretations.

Frontispieces are persuasive visual documents that—physically bound into the text itself—can be seen as a part of the textual prefatory material.[8] The purpose here is to complicate the role of frontispieces in characterizing the early scientific enterprise. I analyze some of the most well-studied frontispieces by art and cultural historians alongside natural philosophers' prefatory materials. Frontispieces are epitomes of portal images, as described in the introduction to this book. They were seen first, before any textual information, and set the tone for the rest of the reader's experience. Thus, frontispieces were positioned to potentially influence readers' perceptions of the scientific texts that followed them and to put readers into a frame of mind to better appreciate the arguments of natural philosophers. Most important, the frontispieces in this chapter accomplished much of their persuasive work by invoking classical mythological themes, one method of mystifying science in the public eye.

THE MYTHICIZATION OF SCIENCE

Beginning in the mid-sixteenth century, it was common for texts in all subjects to include engraved, full-page illustrations prior to the text, and thick catalogues have been compiled to account for them.[9] Frontispieces were bound into the

front of books in the final stages of book assembly on higher quality paper, appearing before any textual information.[10] From an economic perspective, frontispieces were a marker of prestige, both for the author and for the buyer of the book. In *Prints and Visual Communication*, William Ivins explained that books containing engravings and etchings were expensive to make and were almost always intended for wealthy, educated readers.[11]

Frontispieces, like that in figure 2, often featured classically themed, allegorical illustrations, thus introducing their affluent, educated readers to natural philosophy through mythological characters and symbols that would have likely been familiar to them. The technique of introducing audiences to new material with familiar or given information can be rhetorically effective; it is done to establish common ground with an audience by prompting a linkage between the familiar content and the new information.[12] In the cases examined here, the familiar material in early scientific books that was used to establish common ground was mythological in nature. In effect, frontispieces featuring mythological characters and symbols ascribed mythical qualities to the scientific texts that followed.

The process by which something develops mythic status is called "mythicization."[13] Although myths may have a place in our culture as being entertaining stories, myths have also been recognized for being powerful boundary markers within a community, determining who belongs and how to behave.[14] Myths, therefore, are rhetorical. In *Mythography*, William Doty described the rhetorical nature of myths as follows: "Representative mythological images and language are not neutral entities, but purveyors of a culture's worldview and ethics."[15] Frontispieces in early scientific texts that featured classical mythological figures and symbols appealed to audiences, then, by invoking shared cultural values, but they simultaneously contributed to the mythicization of science in society. In some cases, as in the frontispiece to Linnaeus's book, natural philosophers were literally cast as gods (more on that later). Mythicization is thus one form that efforts to mystify science for uninitiated public audiences can take. Ascribing mythic status to early scientific pursuits sets those pursuits above and apart from worldly concerns.

Although the focus here is on frontispieces containing mythological symbols, it is worth noting that not all frontispieces in early modern scientific books contained mythological symbols (and some books did not have frontispieces at all). Moreover, during the time period in which these frontispieces were published, classical mythology was akin to what we would think of today as "buzzworthy," that is, as culturally relevant and easily recognizable by broad audiences. In other words, I am not arguing that all natural philosophers purposefully mythicized their studies (although some did) but rather that, in keeping

with the tradition of including mythological frontispieces in their books, natural philosophers created a link between mythological content and their studies. That linkage, intentional or not, sent a particular message about the nature of early scientific pursuits that would have been different had the mythological frontispiece *not* been included. In sum, there are choices available to communicators in terms of both the inclusion of a portal image and the content of that image. The content of a visual that precedes a text becomes associated with the text.

This discussion of frontispieces proceeds chronologically, beginning with those bound into two of Sir Francis Bacon's texts, then the frontispiece from Linnaeus's *Hortus Cliffortianus* (1737), and, last, the frontispiece in Alexander von Humboldt's *Ideas for a Geography of Plants* (1807). These three represent different eras in scientific history and thus represent authors who faced different challenges in gaining acceptance for their work, who had access to different technologies, and who hailed from different countries.

SIR FRANCIS BACON'S *INSTAURATIO MAGNA* (1620) AND *SYLVA SYLVARUM* (1627)
••

Sir Francis Bacon, Lord Verulam is credited with beginning an educational movement that led to the creation of the scientific discipline. His *Instauratio Magna* (1620), or Great Instauration, articulates his new ideas on how knowledge ought to be gained and disseminated.[16] Although Sir Francis Bacon has a positive reputation in today's rendition of the history of science, when he first proposed his overhaul of human knowledge and learning, his ideas were not immediately palatable to supporters of the status quo. Bacon had to conjure a spirit of intellectual reform using the means available to him. The frontispiece to his *Instauratio Magna,* which would have secured the attention of readers prior to encountering the arguments contained within the text, likely contributed to his effort.[17]

Bacon commissioned the frontispiece for the *Instauratio Magna* (figure 3), and the engraver, Simon van de Passe, came from a well-known family of engravers; his work was prolific in England.[18] According to the historian Arthur Hind, van de Passe was known for meeting the specific demands of his publishers;[19] thus, it can be inferred that van de Passe carefully followed the instructions given to him by Bacon and his publisher when designing the frontispiece to the *Instauratio Magna.* It is difficult to determine whether and to what extent author and engraver communicated in this particular case. However, the themes represented by the symbols in the frontispiece align with the messages in Bacon's preface to the text.

The most prominent elements of this frontispiece are the Pillars of Hercules, also called the pillars of fate, with the ship sailing between them. Although

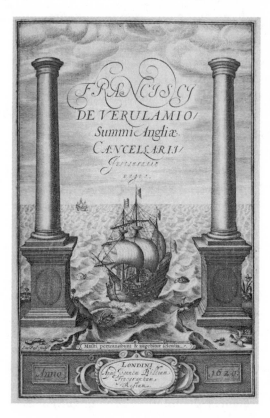

Fig. 3. Frontispiece to *Instauratio Magna*, by Sir Francis Bacon. 1620. Engraved by Simon van de Passe. Available from Wikimedia Commons, https://commons .wikimedia.org/wiki/File:Bacon _Great_Instauration_frontispiece .jpg (accessed March 20, 2016).

Bacon did not refer readers to the frontispiece explicitly in his preface, there are clear instances in which he invoked the images represented in it. For example, the first image that Bacon conjured in his preface, through a series of vivid metaphors, is of the pillars. He constructed an analogy using the image of the pillars to describe the failure of men to expand their intellectual horizons: "These [failings] are like pillars of fate in the path of the sciences, since men have neither desire nor hope to encourage them to explore beyond."[20] For Bacon's contemporaries, the pillars represented not only the boundaries of the known world but also the notion of limitless ambition, a symbolic tradition accredited to Emperor Charles V.[21] It was actually the humanist Marliano who invented Charles V's emblem, which was intended to symbolize his rule as it extended from Spain to the territories in the new world.[22] Bacon adopted the columnar device as well as the emperor's motto, "Plus Ultra," a retaliation against the Greek myth in which the Pillars of Hercules read "Non plus ultra," or "Nothing further beyond."[23] The Pillars of Hercules, which represented the boundaries of the known world in antiquity, constitute the main similarity between Marliano's emblem for Charles V and van de Passe's frontispiece.[24] In that sense, the frontispiece

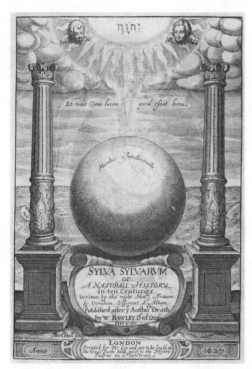

Fig. 4. Frontispiece to *Sylva Sylvarum*, by Sir Francis Bacon. 1627. Engraved by Thomas Cecill. Available from Wikimedia Commons, https://commons.wikimedia.org/wiki/File:Sylva_Sylvarum_Frontispiece.jpg (accessed March 20, 2016).

used mythic symbolism to present a visualization of Bacon's case against the stagnant learning in his time.

Bacon used the means available to him to convey visually what he hoped his project would achieve. That entailed commissioning a frontispiece by a reputable engraver and using symbols that would have been culturally recognizable to send a message about a new model of education: "Plus Ultra," or limitless ambition. Readers who recognized that visual message would enter the text with the message of limitless ambition in mind. A different visual would produce a different message. For example, the frontispiece to Bacon's *Sylva Sylvarum* (figure 4), published after his death by his editor, William Rawley,[25] is quite similar to the frontispiece to the *Instauratio*—the main difference is that a globe sits where the ship was. Though the pillars remain, and with them, their symbolic message, the globe changes the meaning of the image.

The globe is labeled "mundus intellectualis," or the world of human understanding; it might be inferred that the replacement of the ship with the globe is indicative of the progress that had been made since the intellectual ship left the land of Greek-dominated philosophy in the earlier frontispiece. Though there is little doubt that the sphere represents a globe, the shadowed part of the "mundus intellectualis" is etched with curved lines that give it an iridescent quality,

like a pearl. The pearl is a symbol of perfection, so perhaps it is no coincidence that this globe looks like a pearl displayed on a dish, as this would give the impression that Bacon's *Instauratio Magna,* with the final addition of the *Sylva Sylvarum,* has reached completion and perfection.

Further evidence for the deliberateness of Rawley's frontispiece selection is the fact that it was done by a different engraver. Thomas Cecill, an English engraver, was responsible for this one, not the previous Dutch engraver, Simon van de Passe, which means that the design was not simply recast by the same craftsman but deliberately copied by another. Many frontispiece illustrations during this time period were copied from already existing illustrations by a different artist, though some were engraved by the same artist who designed them.[26] Perhaps the most important part of this story is that Bacon did not intend to publish the *Sylva* at all, let alone commission the frontispiece, and this significant information can be found simply by turning to the preface of the work in question—Rawley's letter to the reader at the beginning of the *Sylva.* Rawley wrote, "I have heard his Lordship [Bacon] often say, That if he should have served the glory of his own Name, he had been better not to have published this Natural History, for it may seem an indigested heap of Particulars."[27] Rawley justified going against Bacon's wishes, taking it upon himself to publish the work, by claiming it to be a part of the larger body of Bacon's work represented in the *Instauratio Magna,* even though the experiments recorded were less than satisfactory:[28] "And as for the baseness of many of the Experiments, as long as they be God's works, they are honourable enough: And for the vulgarnesse of them true Axioms must be drawn from plain experience, and not from doubtful, and his Lordship's course is to make Wonders plain, and not plain things wonders."[29] Rawley as editor in fact argued in his preface for the connection between these two very disparate works in Bacon's oeuvre. The two texts do not share a clear connection or structure—the *Sylva* is a series of experiments that reads like an instruction manual,[30] and the *Instauratio* is a philosophical discourse. In any case, if Rawley's intention was to link the *Sylva* to the *Instauratio,* commissioning a frontispiece with an immediately recognizable composition was one readily apparent way to solidify the link between the texts.

Whereas the frontispiece to Bacon's *Instauratio Magna* set readers up to view the text through the lens of "limitless ambition" by including classical mythological symbols, the frontispiece to the *Sylva Sylvarum* also served a greater purpose than simply indicating the book's prestige and drawing a specific audience—it provided visual support for Rawley's argument to integrate the *Sylva Sylvarum* into the earlier *Instauratio Magna.* Classical symbolism was used in frontispieces to correspond to textual arguments contained within books, particularly within prefatory materials. Sir Francis Bacon actually created his

own myth for natural philosophy by appropriating symbols from the classical tradition and using them to subvert their original meaning. This case demonstrates how frontispieces can participate in the process of situating a text within a larger oeuvre, endorsing a project, and orienting readers to the coming arguments.

The design of Bacon's frontispieces is notably very simple—the level of detail can be attributed to the constraints of the image production process at that time. Frontispieces in the early seventeenth century, often called title pages because of the ability to include text with the images, were "woodcuts"; they were made by carving designs in relief into woodblocks and then inking the lines that stood up from the surface. The technique of engraving was not invented until later; it involved carving lines into metal or wood, and pouring ink into the grooves, which yielded a cleaner impression.[31] The more precision afforded to the engraver, the more detailed the frontispiece could be. Linnaeus's frontispiece attests to that fact; it is much more ornate and dense with mythical symbols.

LINNAEUS'S *HORTUS CLIFFORTIANUS* (1737)

Just as the frontispiece to the *Instauratio Magna* can be read in accordance with Sir Francis Bacon's preface, the frontispiece to Linnaeus's *Hortus Cliffortianus* (see figure 2) visually corresponds to his introduction and dedication sections, serving as a portal image into the text. However, the rhetorical situation changed a great deal between these two cases primarily because it is well known that Linnaeus, unlike Bacon, worked closely with his artist, Jan Wandelaar. Not only did Wandelaar create the allegorical frontispiece illustration, he also worked with Linnaeus on all of the scientific illustrations of plants inside the *Hortus Cliffortianus*. Given that Wandelaar worked under Linnaeus's guidance in creating the botanical illustrations to ensure that the depictions were accurate,[32] it would not be out of line to assume that Wandelaar designed the frontispiece under Linnaeus's guidance as well.

The *Hortus* marked the beginnings of Linnaeus's development of the famous system of binomial nomenclature to classify natural phenomena, which was more deliberately set forth in his later, and better known, *Systema Naturae* (1758). While employed by George Clifford—hence Hortus *Cliffortianus*—Linnaeus compiled this highly detailed catalogue to account for the plants in his magnificent gardens. It took him two years to classify the plants in Clifford's gardens to create the extensive list that composes the body of the text.[33] Because the body of the text is a catalogue of plants, readers must rely on Linnaeus's introduction and dedication sections to learn how the text should be read. These prefatory sections contrast sharply with the main text because they are not only

VERKLAARING

VAN DE

TYTELPRENT.

Dus bloeit de HARTEKAMP daar *Pyton* legt gevelt,

En kruiden, boom, noch menfch met zynen damp meer kwelt:

Dank zy het *Licht* der ZONN', 't welk nevens dat der MAANE

De moeder de AARDE ontdekt, opdat ze een doortogt baane

En, door haar *Sleutelen*, zich voor 't gewas ontfluit';

Dies ftort zy eenen *Hoorn* van zeldzaamheden uit:

Haar ciert een *Veftingkroon* waar meê zy zit te praalen

Op 't Vorftlyk *Dierenpaar:* Zy laat zich niet bepaalen

Aan 't geen natuur in elx faizoen of luchtftreek teelt;

Maar word door ARBEID en door KUNST geprangt, geftreelt

Tot *Water, Vuur* en *Glas,* de broejing en het luchten

De groei bevorderen aan planten en aan vruchten.

Dus kan EUROPE hier den *Ommekring* van 't JAAR

Braveeren met *Feeftoen* gevlochten by malkaêr

Uit de alleredelfte *Gewaffen, Vrugten, Bloemen*

Daar AZIE, AFRYKE en AMERIKA op roemen.

Dit tuigt inzonderheid de *Pifang,* welke Plant

Het eerft op deze Plaats gewyd aan Nederland,

Hier, nevens duizenden, Heer Cliffords yver loonen

En, door Linnæus Pen, zich aan de waereld toonen.

J. WANDELAAR.

Fig. 5. Jan Wandelaar, "Explanation of the Frontispiece." Poem to accompany frontispiece to *Hortus Cliffortianus,* by Carl Linnaeus. 1738. Available from Biodiversity Heritage Library, http://www.biodiversitylibrary.org/item/13838#page/2/mode/1up (accessed May 11, 2016).

instructive but also celebratory. It is clear from the prefatory material that Linnaeus sought to convince readers of the importance of studying plants, and the frontispiece most certainly participates in this botanical celebration.

There is a poem following the frontispiece with Wandelaar's name on it (figure 5) that both describes the visual content of the frontispiece and celebrates Linnaeus's overall project. That Wandelaar wrote a poem to provide context for the visual indicates that all of his artistic choices in creating the frontispiece were carefully calculated and thus deserve critical attention. It is important to note that, although the artist could have chosen to design a frontispiece more in line with his in-text scientific illustrations of plants, he instead designed a frontispiece that deliberately subscribed to the classical tradition of employing emblems or allegories to convey a message.[34] To be clear, Wandelaar and Linnaeus intended for readers to first encounter this mythological scene—as opposed to the anatomy of a flower or plant, for instance—before they read

anything, including Linnaeus's introduction. There are always rhetorical impli-
cations when such a decision is made.

It was fairly typical for frontispieces in natural philosophical texts of the
seventeenth and eighteenth centuries to subscribe to an allegorical style; Lin-
naeus's and Bacon's texts are in good company.[35] At least part of the reason for
this stylistic choice is that readers would have been familiar with the language
of emblems,[36] and they would have been engaged by such a vivid, detailed
scene. But Wandelaar's poem also provides some guidance for the identifica-
tion of symbols and characters. As already mentioned, Wandelaar's frontispiece
is a portrayal of George Clifford's garden, called Hartecamp. Clifford himself
appears as a statue near the upper left corner of the piece, presiding over the
scene below. A diverse group of allegorical figures, cherubs, plants, animals,
and scientific instruments crowds the foreground.[37] The artist's poem opens by
describing the scene as follows: "So Hartecamp flourishes, where the Dragon
lies put to death not any longer harming herbs, trees and men with its breath.
Thanks to sunlight, also to the moon, Mother Earth is revealed and opens her
bosom through her keys."[38] The dead dragon is laid out on the right side of the
composition, its face seemingly under the foot of the god Apollo. Several inter-
pretations likely exist for the symbolic significance of a dragon, but in this case
a dead dragon in a flourishing garden might have religious connotations—the
scene becomes almost Edenic, with the man and woman as the focal point, sur-
rounded by all of creation. The twist to the biblical narrative, of course, is that
the reptilian creature is slain, and the garden is permitted to thrive. Last, it is
not a figure from Christianity that is stepping on the dragon's head but rather
the god Apollo, who, scholars have noted, has the face of a young Linnaeus.[39]

Even with the strange amalgamation of religious and mythic symbols
in the frontispiece, a distinctly Christian religious narrative plays out in Lin-
naeus's dedication section. In the opening to the dedication section, Linnnaeus
explained: "When Man had been so marvelously created, endowed with senses
and the judgment to reason about his surroundings, was it for any other pur-
pose that the Creator placed him in the marvelous world, where nothing came
to the notice of his senses but natural objects, especially the wonderful plant-
machines, than that in awe before the lovely work he should marvel at the Mas-
ter, worship him?"[40] In this excerpt, it seems as though Linnaeus was deferring to
the Christian god by providing a narrative of the creation of the world, arguing
that, because God created plants before he created people, it is most natural for
people to study plants. Thus, Linnaeus took the arguments of religious propo-
nents and shifted them to support his studies. The visual narrative delegitimizes
arguments against natural philosophers being able to understand the workings
of nature by suggesting that Linnaeus, a natural philosopher, was capable of

bringing order and peace to God's creations through knowledge of them. Not only do humans have access to knowledge of the natural world, they also are able to use it in a way that promotes harmony between humanity and nature.

Other elements of the frontispiece can be read in accordance with Linnaeus's appeals to his audience in the prefatory text. To begin with, the other people in the composition all represent different continents—Asia, Africa, and America—that are presenting their botanical offerings to Europe, represented as the woman seated on the lion in the center of the illustration. This scene is conveyed textually as well; Wandelaar's poem explains that "Europe" receives "the most noble Crops, Fruit, Flowers / That Asia, Africa, and America can boast of."[41] The scene of Europe accepting the botanical offerings of the other continents also corresponds to the part of Linnaeus's dedication in which he describes the contents of the different "houses" in Clifford's gardens; these houses are categorized by the places of origin of the plants they contain, and the text lists plants from all of the continents represented by the allegorical figures.[42] By featuring Europe as the recipient of the other continents' offerings, the frontispiece is able to corroborate the message that Linnaeus has brought knowledge of the rest of the world to Europe through his studies of plants, making an argument for the legitimacy of botanical studies.

Like other natural philosophers at this time, Linnaeus had to legitimize his studies to skeptical or disinterested audiences. Here is how he characterizes his audience in the preface: "To-day men are slaves to various pleasures. . . . Some are in love with paintings and sculptured works of art, others with antique and outworn arms and armour . . . they busy themselves with a false reflection of beauty, while the fleeting hour passes; every man is rapt after his enjoyment. But for my part I would judge no pleasure to be more innocent than that which the first created man embraced, than that which supports the life which is so kind to mortals. Therefore let my pleasure be in plants!"[43] More important than the pleasure that plants can offer, Linnaeus then explains, is their necessity to the study of medicine. "Nowhere are there more errors, more deficiencies," he wrote, "than in this one branch! Nothing else is to blame but the neglect of medicinal plants, the neglect of botany."[44] The frontispiece, which of course precedes this argument, had the potential to put the reader in a sympathetic state of mind by portraying Clifford's garden as a mythical scene, perhaps persuading readers to share Linnaeus's sentiment that plants can indeed be a source of pleasure before he explains their necessity to the neglected study of medicine. It is somewhat amusing that, despite Linnaeus's judgment against men who are "in love with paintings and sculptured works of art," he nevertheless commissioned an aesthetically pleasing frontispiece of himself as a god to be the portal into his text.

All in all, this visually complex frontispiece serves an equally complex purpose. First, in portraying a harmonious creation scene, the frontispiece helped make readers predisposed to accept the coming argument in support of the neglected field of botany. Second, in portraying Linnaeus as Apollo overseeing the botanical scene, the frontispiece garnered respect for Linnaeus and his studies. Wandelaar's illustration thus added an element to Linnaeus's argument in the dedication that Linnaeus himself could not have carried out successfully—especially not in written discourse (that is, "I, Linnaeus, am a god"). His visual identification with Apollo in the frontispiece might have helped predispose readers to Linnaeus's arguments that appear later in the dedication. Finally, the allegorical scene likely provided a more engaging frontispiece than a scientific, technical illustration would have.

Although readers may have been familiar with the complex symbols represented in the frontispiece and thus would have been able to appreciate the visual message being conveyed, they would not necessarily have recognized its goal of getting them in the right frame of mind to read a scientific text. The frontispiece genre allowed for the delivery of implicit messages before authors addressed their readers in the text. Overall, the choice to convey a visual narrative about natural philosophy using mythological figures and symbols might have been a useful one, rhetorically speaking. Still, that does not change the fact that the choice also mythicized the scientific discipline in its earliest stages in order to garner support for it. The final case, addressed next, presents a similar situation—a natural philosopher who chose to include a mythical frontispiece before his technical manuscript—but there is evidence to suggest that the author sensed a tension between natural philosophy and classical aesthetics.

HUMBOLDT'S *IDEAS FOR A GEOGRAPHY OF PLANTS* (1807)

The German naturalist Alexander von Humboldt (1769–1859) made significant contributions to what is now the field of biogeography. The frontispiece for his *Ideas for a Geography of Plants* (1807) is unlike the other two just examined. The mythicizing work of the frontispiece is not mirrored in the text that it precedes, *Ideas for a Geography of Plants* (henceforth the *Geography*). This text has a brief preface that reads like a report of Humboldt's work to date and his travels through the tropics, and it does not point to the frontispiece at all; in other words, the text lacks a substantial introduction to read alongside the frontispiece. However, one year earlier, Humboldt had published a more poetic treatise called *Ideas for a Physiognomy of Plants* (1806),[45] previously delivered as a lecture at the Royal Academy of Science in Berlin.[46] The styles in which the two texts in question are written are completely different—even though the titles differ by

only one word. *Ideas for a Physiognomy of Plants* (henceforth *Physiognomy*) is characterized by elaborate, expository prose,[47] and the *Geography* is a rather dry, empirical text.[48] It is somewhat surprising that the latter contains a frontispiece and the former does not. The *Physiognomy* is seemingly the more artistic, poetic counterpart to the *Geography* and corresponds more naturally to the frontispiece illustration.[49] Unlike the *Geography,* the *Physiognomy* features rhetorical tactics that could have left readers attentive, receptive, and well disposed to an empirical study. That it was first delivered as a lecture indicates that the *Physiognomy* was conceived for a broad audience and could have served a promotional function for Humboldt's more scientific project—the *Geography*—prior to its publication. For the reasons mentioned here, I consider the *Physiognomy* as a part of the prefatory materials of the *Geography* and read the former alongside the frontispiece of the latter.

The frontispiece (figure 6) portrays Apollo unveiling a statue of the goddess of nature, known variously as Diana, Artemis, or Isis.[50] It was designed by the Danish neoclassical sculptor Bertel Thorvaldsen.[51] Like Linnaeus, Humboldt was well acquainted with the engraver of the frontispiece for the *Geography;* he had met Thorvaldsen when visiting his brother in Rome.[52] Thorvaldsen is known for his sculptures, not for drawings, and this could account for the image's lack of background detail or embellishment—it is essentially a sketch of two sculptures. A scholar of Thorvaldsen's sculptures, Else Bukdahl, has made the case that Thorvaldsen was concerned with coordinating the associations between "nature and the ideal" and "outer and inner nature" among other relations.[53] It seems that the tensions Bukdahl speaks of in Thorvalden's sculptures are represented in this frontispiece by the sculpture of Apollo, which closely resembles the *Apollo Belvedere,*[54] a symbol of ideal beauty, and the plain landscape on which he uncovers the goddess of nature.[55] Providing even more contrast to this symbol of ideal beauty is the nature goddess, a figure with multiple breasts and inscriptions of natural phenomena on her body. The unveiling of nature is a popular theme, but it is particularly significant that the goddess of nature's veil is completely removed by Apollo. This choice could suggest that more progress has been made toward understanding or knowing Nature and "her" powerful influences on humanity or that there is more confidence in natural philosophy to perform the unveiling.

Humboldt commissioned the frontispiece as a dedication to Goethe, as the two frequently corresponded about their mutual "philosophic and scientific interest in nature."[56] The stone tablet at the goddess of nature's feet displays the title of Goethe's "scientific" yet aesthetic work, *Die Metamorphosen der Pflanzen* (*The Metamorphosis of Plants* [1789]). According to Joan Steigerwald, Humboldt's *Geography* built on Goethe's *Metamorphosis of Plants* by adding "instrumental

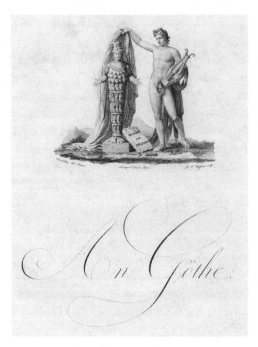

Fig. 6. Frontispiece to *Ideas for a Geography of Plants*, by Alexander von Humboldt. 1807. Designed by Bertel Thorvaldsen to be engraved by Raphael Urbain Massard. Available from Yale University Library Beinecke Rare Book Collections, http://brbldl.library .yale.edu/vufind/Record/3773339 (accessed May 26, 2016).

investigation" to the latter's emphasis on "aesthetic appraisal," and this explains the inscription on the stone tablet in the frontispiece.[57] Humboldt's portrayal of nature was thus informed by both an aesthetic and a scientific reading of it.[58] Steigerwald makes an important point, which is that the frontispiece concretizes the link between Humboldt's scientific work and the more aesthetic model through which Goethe studied nature.[59] Together, the *Geography* and its frontispiece reflect a tension between Enlightenment ideals and a more Romantic view of nature propounded by Goethe, Humboldt's longtime friend and mentor.

Humboldt sent the frontispiece to the *Geography* as a gift to Goethe, who called it "a flattering illustration that implies that Poetry, too, might lift the veil of Nature."[60] Goethe's reading of the frontispiece would not have surprised or confused his contemporaries.[61] Indeed, Humboldt created a link between the natural and metaphysical world in his *Physiognomy*, published a year earlier, that seemingly corresponds to the frontispiece's connotations; he explained to his readers, "This influence of the physical on the moral world—this mysterious reaction of the sensuous on the ideal, gives to the study of nature, when considered from a higher point of view, a peculiar charm which has not hitherto been sufficiently recognized."[62] In other words, Humboldt made the argument that the study of the physical environment is not only an empirical endeavor but metaphysical as well. By associating natural philosophy with the moral sensibilities

of his contemporaries, when their tendency was to dissociate the two, Humboldt could have possibly appealed to a broader audience.

According to Humboldt's biographer, Helmut De Terra, Humboldt sent a copy of the *Physiognomy* to Goethe with a letter, explaining, "While in the lonely forests of the Amazon, I often relished the thought that I might dedicate the first fruits of my travels to you. It is a crude attempt to treat physical and botanical subjects aesthetically."[63] This aesthetic treatment of the natural world is *not* present in the *Geography;* in fact, the aesthetically pleasing frontispiece is the only element of the *Geography* reminiscent of the aesthetic sensibility of the *Physiognomy.* The lyrical prose in the *Physiognomy of Plants,* at least in Otte and Bonn's translation,[64] is reminiscent of Linnaeus's Dedication to the *Hortus Cliffortianus,* and like Linnaeus, it becomes clear that Humboldt is trying to reach a broad audience, specifically "those who have never quitted our own hemisphere, or who have neglected the study of physical geography."[65] Both instructive and engaging, perhaps to multiple audiences with varying knowledge of his field, the text features juxtapositions of phrases that are overrun by current specialist terms not widely known (for example, "microscopic infusorial animalicules")[66] with flowing, vivid descriptions of nature, as when Humboldt wrote: "Indelible is the impression left on my mind by those calm tropical nights of the Pacific, where the constellation of Argo in its Zenith, and the setting Southern Cross, pour their mild planetary light through the ethereal azure of the sky, while dolphins mark the foaming waves with their luminous furrows."[67] Most of the *Physiognomy* follows the latter trend (that is, aesthetic descriptions), whereas even the preface to the *Geography* is lackluster. Because the aesthetic consciousness of the *Physiognomy* is absent in the *Geography,* it seems that Thorvaldsen's frontispiece illustration was intended to import this aesthetic awareness by proxy. It is understandable that Humboldt would have wanted to preserve—for the audience of the *Physiognomy* in general and for Goethe in particular—some semblance of his aesthetic appreciation for nature. In sum, attending to the context of the frontispiece—its placement within Humboldt's *Geography* as well as its relationship to the *Physiognomy*—brings to light the growing tensions between the scientific enterprise and the realm of aesthetics.

CONCLUSION

Even though they have become an archaic mode of visualization, frontispieces in early scientific books are just as much a part of the scientific tradition as the visualizations that attempt to accurately represent natural phenomena in scientific discourse. Frontispieces might appear to be merely decorative indicators of a book's prestige, but the reality is that these emblematic title pages are

compelling visual instantiations of prefaces. They are portal images, equipped with the potential to persuasively orient readers to the coming content. Considering frontispieces as portal images allows for a clearer understanding of their persuasive potential in each author's specific project. Frontispieces were purposefully bound into the front of books so that readers would encounter them first, and their meaning is derived from that special context.

Sir Thomas Sprat advised natural philosophers to depart from classical ideals in their work, yet they chose to subscribe to the tradition of including mythically themed frontispieces in their books. Whether consciously aware of it or not, authors may have chosen to use mythological symbolism to introduce their readers to a new, potentially controversial text with something familiar and "safe." It is, of course, impossible to say whether the relationship between the scientific enterprise and society would be different today if early natural philosophers had not included mythically charged frontispieces in their books. What can be said with certainty is that it was a choice to include frontispieces with mythological characters and symbols, and that that choice—though it may have been rhetorically effective for securing the attention of their audiences— contributed to the overall message that natural philosophy was an endeavor of mythic importance.

Without these frontispieces, the natural philosophers under discussion would not have so powerfully and blatantly conveyed to viewers such concepts as embarking on a path of limitless ambition, achieving perfection, understanding nature in its entirety—or even endowing natural philosophers with godlike status. Perhaps, to some, using mythical symbols to represent early scientific endeavors might seem somewhat innocuous—who cares that early science was mythicized? But, as scholars like Dorothy Nelkin and Marcel LaFollette have found, the mystification of science in the public eye does not serve science in the long run. Rather, it perpetuates the distance between scientists and citizens, which disenfranchises citizens and limits scientific progress. Granted, between the seventeenth and nineteenth centuries, when frontispieces were one of the available means of persuasion, the "public" audiences for science were relatively small and elite. Still, regardless of the smaller audience, frontispieces exemplify the beginnings of the tradition of visually mystifying science in the public eye. Certain persuasive elements of frontispieces have remained intact in twenty- first-century visual science communication, such as the use of well-known symbols on magazine covers to secure the attention of public audiences. Another aspect of visual science communication that has persisted from the time of frontispieces is the notion that science is performed by those who are "godlike" or "superior."

2

Portraits of Scientists at Work

····································

The Ethos of Superiority and Exclusion

While Carl Linnaeus was working on the *Hortus Cliffortianus* (see chapter 1), he had his portrait painted at George Clifford's garden (figure 7). The tradition of scientific portraiture overlaps historically with the tradition of including frontispieces in scientific books. Linnaeus's portrait is fairly typical of scientific portraiture in the eighteenth century: subjects commonly wore either their finest clothing or attire that would identify their vocation and were surrounded by prized possessions and/or objects of study to display their accomplishments. In this portrait, Linnaeus wears a Laplander costume and holds the plant that was named after him, the Linnaea borealis.[1] It should come as no surprise that there are no portraits of Linnaeus in the midst of studying plants in Clifford's garden; no mechanism existed in the eighteenth century to capture natural philosophers busily working. Painted portraits were not replaced by photographed portraits until the nineteenth century, and, even then, it was not immediately possible to take candid pictures of people in action.

So, whereas the portrait of Linnaeus is typical of scientific portraiture of the eighteenth century, the type of portraiture that is considered typical today, due to technological advancements, is much different. Photographed portraits of scientists that are circulating on the Internet today, such as the one shown in figure 8, typically portray them in a laboratory or busily working with complex scientific paraphernalia. The photograph of Madhu Singh, a research scientist at the University of Iowa, is one of many that can be found through Google Images by using the search term "scientist at work." The image comes from a website called *Science Daily*,[2] and it depicts Singh "at work in his lab."[3] Singh's portrait fits the template of most stock images of scientists, which depict them working in laboratory settings, wearing white lab coats, and holding up some kind of colorful liquid in flasks or beakers. As in painted portraits from the eighteenth century, the scientific objects surrounding scientists in portraits today, which

Fig. 7. Martinus Hoffman, *Carolus Linnaeus.* 1737. Source: Boerhaave Museum. Available from Wikimedia Commons, https://commons.wikimedia.org/wiki/File:Carl_linnaeus_boerhaave_museum.JPG (accessed March 20, 2016).

have been called "symbolic attributes" or "accoutrements," are a way of defining their identities as scientists.[4] Thus, in scientific portraits, scientific objects can work as metonyms to import the authority of the scientific enterprise into a photograph.[5]

The important distinction between early scientific portraiture and the typical photographed portraiture of today is that in the former the scientist is posed and looks at the viewer, whereas in the latter the scientist is depicted "candidly," as if busily working, and does not look at the viewer. This discussion revolves around that distinction, which has not yet been theorized in scholarship on scientific portraiture. What has been studied are the ways in which portraits in general create relationships between the photographed person and viewers.[6] For example, according to Kress and van Leeuwen, viewers interact with photographs that contain people in ways that mimic interpersonal relationships in real life. Factors that contribute to the creation of this relationship include the gaze of the person in the photograph—the "represented participant," in Kress and van Leeuwen's terminology—as well as the distance between the represented

Fig. 8. Madhu Singh. March 16, 2009. In "New Role for Immune System Pathway in Post-heart Attack Inflammation." *Science Daily,* www.sciencedaily.com/releases/2009/03/0903 09191509.htm (accessed May 12, 2016). Reprinted with permission from The University of Iowa Health Care.

participant and the camera and the angle from which the photograph was taken. Another significant point from extant scholarship is that portraits can be used to garner public support for the discipline and shape attitudes toward science. For example, in *Defining Features,* a study of scientific and medical portraiture over a 340-year time span, Ludmilla Jordanova explained that portraiture is responsible for creating public identities: she argued that portraiture "constructs not just the identity of the artist and the sitter, but that of institutions with which they are associated. Portraiture is just one highly artificial means by which, in some societies, individual and collective identities are forged."[7] Thus, portraits of scientists can function as portals for uninitiated audiences into the scientific enterprise. They can provide a glimpse into the behind-the-scenes work that scientists do, thereby characterizing science for nonscientist publics.

Portraiture has the potential to create *presence* for viewers, a concept advanced by Perelman and Olbrechts-Tyteca[8] but expanded by Gross and Dearin to encompass the entire constructed world that rhetors create for their audiences.[9] Importantly, Gross and Dearin's expanded notion of global presence can be more readily applied to visual persuasion.[10] *Presence* includes a persuader's

ability to create communion with an audience; Perelman and Olbrechts-Tyteca argue that this can be done if the speaker "endeavors to get his audience to *participate actively* in his exposition, by taking it into its confidence, *inviting* its help, or *identifying* himself with it."[11] Inviting audience participation and creating identification with the audience are elements of persuasion that are bound up with notions of accessibility and inclusivity. Translated into the visual realm of scientific portraiture, the level of inclusiveness of a portrait depends upon contextual factors (for example, subject matter, accompanying text, historical details) as well as how elements in the visual composition are manipulated.

The scientific enterprise constructed through early posed portraits is not the same scientific enterprise that has been constructed through "candid" photographed portraits. Candid photography was not possible until the 1920s when cameras were invented that could be transported easily without bulky equipment and had fast enough shutter speeds to capture people performing tasks.[12] Therefore, the construction of science privileged by photographed portraits today is relatively recent.[13] Consider the earliest iterations of what I term "scientist-at-work" photographed portraits. At the risk of sounding repetitive, there were illustrations and drawings of scientists at work prior to the twentieth century, but photographed portraits that created the idea that scientists were being photographed candidly were not possible until the invention of portable cameras in the twentieth century. They construct scientists and, by association, the scientific enterprise for nonexpert publics. A spotlight on the beginning of the tradition of photographed scientist-at-work portraits assists in explaining our current conceptions of what scientists "look like" and helps identify how these particular portraits may have contributed to the mystification of science in the public eye.

An appropriate site of analysis, then, is *Life* magazine, the first U.S. photojournalism magazine, launched by Henry Luce in 1936. With an estimated readership of twenty million by the 1950s and its coverage of all subject areas, *Life* was the primary dispenser of the news, visually, on a national scale before the invention of television.[14] *Life*'s purpose was to be a visual portal—whether into current events or into celebrities' activities—and to unite national audiences through a collective visual experience. The ways in which *Life* characterized science and scientists for a national audience—through portals formed by scientific portraits—is still relevant to today's climate of ambivalence toward the scientific enterprise.

EXISTING CATEGORIES OF PORTRAITURE AND THE SCIENTIST AT WORK

Portraits of scientists reflect certain attitudes about science and thus shape viewers' attitudes, depending on how scientists are portrayed. The only study to

create categories for scientific portraits is Jacobi and Schiele's analysis of how scientists are depicted in two French science magazines. They identify three "archetypal" images of scientists, each of which, they argue, "corresponds to a distinct set of attitudes towards the popularization of science."[15] The archetypal figures that they identify are the *mad scientist,* the scientist as *teacher of humanity,* and the scientist as *the ordinary mortal,* in which "the scientist gets down from a pedestal and mixes with the rest of us."[16] The last archetype is unlike the other two mentioned in that "it is rooted in a certain sensitivity to the anti-science current."[17] Notice that they do not create a category for portraits that depict scientists at work. Although Jacobi and Schiele actually include a photograph of a scientist "photographed unawares in the midst of his work," it is not possible to discern whether they group it into the archetype of the scientist as teacher or that of the mad scientist.[18] However, this type of portrait—the scientist-at-work portrait—demands a separate category. Not only is it ubiquitous, but it constructs science in a distinctive way. Like the authors of the other studies mentioned, Jacobi and Schiele discuss the ways that photographed portraits "socialize newly-acquired [sic] knowledge" through stereotypes and ultimately "authenticate" the scientists producing that knowledge.[19] The new category of the scientist at work ought to be considered through the same lens.

There are certain features that scientist-at-work portraits all have in common that contribute to their authentication of the scientific enterprise; in this category, scientists:

- appear to be working (that is, giving the illusion that the portrait is candid);
- avoid eye contact with the viewer; and
- interact with scientific equipment.

All of these choices involved in staging and selecting photographs culminate in specific rhetorical appeals to viewers and contribute to the construction of scientific ethos. A scientist-at-work portrait, specifically, is dependent on the illusion that the scientist is being photographed candidly. As portraits achieve much of their influence from the implicit relational dynamics that they construct between "represented participants" (scientists) and viewers,[20] this configuration sets up a unique relationship between scientist and viewer: it is impersonal, as if to communicate the message that the scientist is too busy to stop and look at the viewer. The scientist's gaze is perhaps the most obvious determinant of the type of social interaction encoded in a portrait.[21] In other words, ingrained knowledge of social interactions allows viewers to understand that the relationship constructed between a scientist in a portrait and themselves is entirely different

when the scientist is looking at the camera (that is, at viewers) and when that scientist is, for example, looking into a microscope. The scientist's gaze, or lack thereof, is one of the most significant determinants of whether the image will create presence for viewers—whether it will construct science as a culture of inclusion or exclusion.

Other factors that contribute to the ways in which science is constructed include the angle from which viewers see the scientist and surrounding objects or accoutrements, the placement of accoutrements in relation to the scientist, and the size of accoutrements within the frame of the photograph. Photographers can manipulate any and all of these variables to achieve maximum impact. One example that illustrates the importance of manipulating elements in the photographic frame is the famous image of Watson and Crick, positioned with a three-dimensional model of the double helix. The photograph that became famous is actually one of *eight* photographs taken that day in 1953 by Barrington Brown. In an analysis that considers all eight photographs, Soraya de Chadarevian demonstrates how objects or accoutrements function to both shape scientific identities and even to construct scientific discovery accounts. Some of the nonfamous versions of the photograph do not show the double helix, and de Chadarevian argues that "for Brown's photograph to take on the significance it did, it was important that it represented both the model and its makers."[22] She points out that it is just as likely that the model made Watson and Crick famous as it is that Watson and Crick made the model famous.[23] Even today the double helix is a symbol of genetics and of the two scientists who received credit for discovering the structure of DNA. In sum, the authority of science is conferred on the individuals via the scientific accoutrements that represent their scientific area of specialization, and many more options for the inclusion and placement of accoutrements became available with the innovation of candid photography.

The variables mentioned here (for example, accoutrements, the scientist's gaze) contribute to the ideologies imbricated in image construction, but there are other significant factors—beyond image composition—that contribute to viewers' experiences of scientific portraits. For these factors that are external to images, I turn to the notion of an "image vernacular," which Cara Finnegan has operationalized for rhetorically analyzing images in their historical contexts.[24] Representative examples of scientist-at-work portraits from *Life* magazine will demonstrate that, in contrast to other types of scientific portraits identified in scholarship, scientist-at-work portraits mystify science by valorizing scientists, cultivating an ethos of superiority, and creating a culture of exclusion around the scientific enterprise.

SCIENCE IN THE PUBLIC EYE

••

Photographic images are now generally understood to be persuasive communicative objects, and documentary photography has been studied as a tool for social reform, having the capacity to construct ideology.[25] Many photographs taken during the "golden age" of photojournalism, generally agreed to be between 1925 and 1950, are now considered iconic, such as Dorothea Lange's "Migrant Mother" (1936) and Alfred Eisenstaedt's "Times Square Kiss" (1945). In *No Caption Needed,* Hariman and Lucaites argue that iconic photographs, such as the ones just mentioned, reproduce ideology, communicate social knowledge, shape collective memory, model citizenship, and provide figural resources for communicative action.[26] However, at the time that *Life* was at its height of popularity, in the 1940s and 1950s, photographs were still received as representations of "truth."[27] Cara Finnegan has called the believed facticity of photographs the "naturalistic enthymeme," arguing that there was an overwhelming inclination to assume that photographs are "real" or "true" until proven otherwise.[28]

The naturalistic enthymeme can be traced back to the advent of photography (in the mid-nineteenth century), which played an important role in the professionalization of science. Photography transformed the sources of evidence and therefore of persuasion in many sciences, lending credibility to research by allowing for "accurate," "true-to-life" visualizations of natural phenomena, both visible and invisible to the naked eye. As soon as cameras became attachable to microscopes, not long after Daguerre's 1839 invention, scientists claimed that photographs of microorganisms served as unquestionable evidence in their research.[29] Most viewers and scientists thought that cameras could record evidence without the intrusion of human subjectivity. Changing visualization practices in the field of science have been studied most notably by Daston and Galison in *Objectivity.* The authors argue that, in the nineteenth century, the notion of objectivity replaced "truth-to-nature" as the predominant epistemology, characterized by "accurate" visual representations of natural phenomena that portrayed anomalies and flaws, as opposed to the idealized, standardized representations that filled the pages of earlier encyclopedias.[30] The obsession with objectivity eventually gave way to what Daston and Galison term "trained judgment" around the turn of the twentieth century, a shift that returned authority to the expert scientist to select what gets representation and what does not—an unambiguously rhetorical process that applies to all visualizations.[31]

Over the course of the nineteenth century and into the twentieth, science became an increasingly professionalized and specialized group of disciplines. Prior to professionalization, it was thought that those who made science their

vocation were "scientists," but most fields eventually became exclusive to experts who had received institutional training—a factor that contributed to the separation of science from society.[32] As scientific disciplines grew more specialized, and scientists became viewed as *experts*, journals were formed that were accessible only to experts in a given field.[33] These factors contributed to the "gap" between scientists and nonscientists that is so prominent today.[34] The expansion of literacy education and the birth of a mass market led to a more stratified audience for scientific discourse and a need for "popular" publications.[35] By the early twentieth century it was possible to make a clear distinction between "professional" and "popular" publications and "scientific" and "nonscientific" audiences.[36] Moreover, the depictions of scientists in these popular publications tended toward valorization, as the cultural historian Marcel LaFollette found in studies of mass media publications from the early twentieth century.[37] Similarly, Dorothy Nelkin found in her study of representations of scientists in the media that they are portrayed as "remote but superior wizards."[38]

These depictions of scientists arose after World War I, when they strove to promote their work as serving national interests and science for the first time became intertwined with politics and was held responsible for social progress.[39] Science became synonymous with efficiency and improvement—concepts associated with "modernity," according to the historian Peter Broks, which also carried with them a sense of powerlessness.[40] World War II only exaggerated earlier social tensions—that is, the expectation that science would save society and the fear that science would fail.[41] The relationship between science and society over the first half of the twentieth century has thus been characterized by cultural historians as having both fear and awe at its foundation. A mixture of trust in and collective ignorance about scientific methods is what Broks, following Anthony Giddens, referred to as "disembedded expertise"—the notion that scientists purposefully distanced themselves from the rest of the public to maintain their superior status, based in expertise, and to avoid being blamed for negative outcomes of scientific research.[42]

Along the same lines, Carolyn Miller has directed attention to the nuances of scientific ethos, arguing that scientific discourse utilizes a "narrow" or "constrained" version of ethos that privileges expertise over the other aspects of ethos, concerned with goodwill or moral fiber.[43] Furthermore, she explained, "An ethos of expertise—that is, an ethos grounded not in moral values or goodwill, or even in practical judgment, but rather in a narrow technical knowledge—addresses its audience only in terms of what it knows or does not know."[44] An ethos of expertise, then, overlaps with Giddens's notion of a disembedded system, which is dependent on public ignorance and leads to a type of trust that is ensconced in fear.[45] One of the drawbacks to this particular brand of ethos,

rooted in authority and expertise, is that "the rhetorical relationship becomes impersonal."[46] Tensions brought on by war and the exclusivity of the scientific enterprise in society led to a tendency for nonscientists to perceive science and scientists as different from—and superior to—ordinary people.[47] Valorizing scientists—placing them above "ordinary" citizens—contributes to the gap between science and the rest of society and thus the mystification of science in the public eye.[48] Portraits of scientists at work are visual instantiations of the textual depictions of an ethos of expertise, and they propagate—visually—the characterizations of scientists and science that LaFollette and Nelkin found in mass media publications.

THE WORLD OF SCIENCE IN *LIFE* MAGAZINE

At a time when science was a subject of public fascination and respect, the photographs in *Life* magazine promised to provide a glimpse into the discipline, allowing a national audience to see what science "really" looked like. Although scientist-at-work portraits did not necessarily originate with (and are not confined to) *Life* magazine, they are exemplified by and received wide distribution in this publication. The photographs circulated in *Life* magazine specifically have been studied as conveyors of ideology, creators of social norms, and shapers of public belief.[49] *Life* was at the forefront of constructing public perceptions on multiple subjects.[50]

In fact, Henry Luce's mission statement for *Life* magazine, printed in the first issue (November 1936), establishes the magazine's predication on what Cara Finnegan has called the naturalistic enthymeme:

> To see life; to see the world; to eyewitness great events; to watch the faces of the poor and the gestures of the proud; to see strange things— machines, armies, multitudes, shadows in the jungle and on the moon; to see man's work—his paintings, towers, and discoveries; to see things thousands of miles away, things hidden behind walls and within rooms, things dangerous to come to. . . . Thus to see, and be shown, is now the will and new expectancy of half mankind. To see, and show, is the mission now undertaken by a new kind of publication.[51]

Luce's mission statement all but elides the vehicle that enables viewers "to see, and be shown"—that is, the photograph itself. Note that he did not mention photography at all when he described the events and experiences to which readers would bear witness. There is nothing to suggest that the experience through which viewers would "eyewitness great events" was virtual. Luce endeavored to eliminate the construct from his mission statement: the photographs were

rendered invisible, and all that was left was the experience of seeing "reality." His mission, therefore, seemingly attempted to create science as a culture of inclusion—that is, viewers would be transported by the magazine into the scientific laboratory. Luce's mission promised to unite readers through a collective viewing experience of the fascinating and unknown.

Portrayals of science in *Life* were clearly meant to align with Henry Luce's vision for the magazine as a whole. Luce's perspective on the scientific enterprise is revealed in a revised version of his prospectus for *Life,* which he published after twelve issues of the magazine had been in circulation. In this "Redefinition" memorandum, Luce stated that he was not interested in "foolish" Science: "we have first of all to put up our sign: 'Honest Science Sold Here.' . . . Let us avoid foolishness or insignificance in Science and Art unless it is deliberately labeled as such."[52] Luce's mission statement and his commitment to portraying science honestly both operated within what Cara Finnegan has terms an "image vernacular." That is, they were situated in "the visual conventions and beliefs" of his time period, beliefs that were "absorb[ed] into our knowledge and experience."[53] Luce's mission statement and memorandum about science provide a glimpse into the "specific practices of reading and viewing" of his time,[54] and they suggest the ways in which scientists and the scientific enterprise might have been visualized by *Life*'s national readership: that is, as honest, true-to-life representations.

Life perpetuated beliefs about science through its portrayal of scientists.[55] Scholars agree that, because of Henry Luce's vision for the magazine and his hand-picked editors, who shared his conservative political standpoint, *Life* tended to present an idealized picture of American culture,[56] striving to form the broadest consensus possible through photographs.[57] A preponderance of the photographs of scientists in *Life* are scientist-at-work portraits—portraits that would keep the mysteriousness and inaccessibility of science intact. Thus, despite Luce's efforts to differentiate *Life* from other magazines of its time, the version of "honest science" that he offered was seemingly just a rebranding of the dominant cultural images of science propagated by other mass magazines of the same era.[58]

PORTRAITS OF SCIENTISTS AT WORK

Portraits of scientists at work appeared frequently in *Life* magazine's science stories.[59] Three representative photographs of scientists at work illustrate how compositional features—when considered through the lens of historically situated, prevailing perceptions of science—both construct relationships between scientists and viewers and implicitly characterize the scientific enterprise. To

Life's Science Stories Sample	
Total # of science stories with portraits of scientists	68
Science stories containing at least one portrait of a scientist at work	54
Science stories including more than one type of portrait	38
Science stories with **only one portrait of a** scientist → → →	32

Types of Portraits in Narrowed Sample (32)	
Scientists at work	22
Scientists posed with objects of discovery, etc.	7
Scientists posed in traditional portrait (no surrounding objects)	3

Table 1. On left, all science stories containing portraits of scientists; on right, narrowed sample of stories containing one portrait only (as opposed to multiple images of scientists in the same story). The representative examples analyzed in this section come from the twenty-two stories containing only one portrait (for which the editors specifically selected a photograph of a scientist at work).

contextualize the photographs, I include information from their accompanying articles and, in cases where it is relevant, the surrounding images of scientific phenomena.[60] These examples were selected from a pool of scientific portraits gathered by sampling *Life*'s "Science" section, from the magazine's inception, in November 1936, through 1960.[61] In this sample, there were a total of sixty-eight Science stories with images of scientists; stories without portraits were excluded. Some stories featured multiple types of portraits of scientists (for example, posing, working, surrounded by scientific objects), and some stories featured only one portrait of a scientist—but, as table 1 shows, regardless of the number of portraits per story, most of the stories in my sample have at least one scientist-at-work portrait. Thus, scientist-at-work portraits are by far the most prevalent type of portrait in this sample of *Life*'s Science section.

Stories for which the editor made a clear choice to depict the scientist in one way only are depicted in the extension of table 1 on the right. The images analyzed here come from that narrowed sample of thirty-two stories that contain only one image of a scientist.[62] In sum, most stories in the broader sample have scientist-at-work portraits, and even within this narrowed sample, an impressive two-thirds of the portraits are scientist-at-work portraits, suggesting that, more often than not, readers of *Life* magazine would not see scientists posing

Fig. 9. Fritz
Goro, "Physicist
M.W. Strandberg
adjusts micro-
wave reflector
at M.I.T." *Life*.
November 1945.
Reprinted with
permission from
Getty Images.

and looking back at them; rather, they would see scientists busily working on research projects.

In the first example (figure 9), from a story in 1945 titled "Microwaves: Exploration . . . Opens Up a Vast Territory for the Future," a physicist is depicted "adjusting a microwave reflector at M.I.T." Microwave radars were first developed by physicists in 1940 to detect enemy bombers and submarines during World War II.[63] In the immediate aftermath of World War II, when this story was published, scientists were still being recruited for operations research to ensure national security.[64] Read in the context of a very real need for reassurance about national safety, the image of the physicist and microwave reflector could be said to present science as a paragon of security.

Moreover, the immediate postwar era marked a shift to a "new culture," according to Carolyn Miller—one in which "big science" and "high technology" began to be conflated.[65] During this period, Miller explained, a "hierarchical model" of the relationship between the two entities prevailed, characterized by continuing "the long historical valorization of science over technology, . . . a rhetorical move that helps maintain the status of science and scientists."[66] A highly influential 1945 report titled *Science—The Endless Frontier*, written by Vannevar Bush, principal science adviser to the U.S. president, exemplified this

hierarchical model. In the report, Bush advocated for more government support of—but less government interference in—scientific research.[67] He was successful, by Miller's estimation, in part because he privileged science over technology, obscuring the ever-increasing role of technology in scientific research.[68] Bush's proposal was successful, according to LaFollette, because it "employed metaphors and ideas that epitomized Americans' trust in and expectations of science and scientists"—the report "embodied the prevalent cultural images of science."[69] In sum, conflating science and technology was a strategic move not only for securing funding but also for influencing public trust, at least under the hierarchical model.

Miller argued that it is problematic to conflate the rhetoric of science and the rhetoric of technology because of their fundamental differences (science emphasizes knowledge, whereas technology emphasizes practice)[70] but acknowledges that the treatment of the two entities in scholarship has made it difficult to separate them.[71] Arguably, it is the conflation of scientific and technological ethos that made Bush's report and other discourse—including visual discourse— persuasive at that time. The conflation of science and technology is apparent in *Life*'s portraits of scientists at work, and, in fact, these images use technology to valorize scientists and science, corresponding to the hierarchical model that Bush's report exemplifies.

In figure 9, the technology, the microwave reflector, is of such great magnitude that it towers over the scientist, who is portrayed as if he were actively working. The physicist occupies a tiny portion of the composition in the bottom-left corner, whereas the microwave reflector takes up at least half of the composition, extending upward into the sky, beyond the frame of the composition. The skewed balance of the elements in the composition leaves a great deal of empty space—strategically, above the physicist's head—that not only highlights the contrast in size between the scientist and reflector but could also suggest a certain limitlessness of scientific research. Moreover, the angle from which the photograph was taken gives viewers a clear sense of the shape of the reflector and its three-dimensionality, and it allows viewers to see the scientist working on the reflector, to see his hands making the necessary adjustments. Thus, although "high technology," presented metonymically through the reflector, looms large over the scientist, it is still being controlled by him; the scientist operates the complex equipment that, as the article describes, "opens up a vast territory for the future." Technology seemingly intensifies scientific ethos in this image and assists in reinforcing one of the dominant beliefs in circulation at that time that scientists are not ordinary people.[72] Of course, *Life* would not give representation to that which was easily seeable or pedestrian but rather aimed to show viewers what was extraordinary, what they otherwise might not see.

The sense of limitlessness conveyed by the large microwave reflector against an expanse of sky makes it an apt visual representation of what Perelman and Olbrechts-Tyteca, in *The New Rhetoric,* term "the argument of unlimited development"; arguments of this nature "insist on the possibility of always going further in a certain direction without being able to foresee a limit to this direction, and this progress is accompanied by a continuous increase of value."[73] Had the physicist been posed with the microwave reflector, perhaps in front of it and looking at the camera, the dynamic nature of science would not have come across visually, and neither would the scientist's direct role in shaping its results, conveyed by the vector made by his arms and hands leading to the reflector.[74] There are many options available to photographers (and later, editors) in terms of balancing elements in the photographic composition. In this example, the arrangement of elements in the composition does not invite readers to identify with the physicist or experience his work with him. Rather, the message seems to be that the physicist is unavailable because he is hardworking and responsible for contributing to the unlimited progress of scientific research and national security efforts.

In some cases, the impersonality of science is so strongly conveyed that it is as if the scientist had become an extension of whatever technology is depicted with him. Like the portrait of the physicist and microwave reflector, the image shown in figure 10, from 1950, is also representative of the stories in which a giant apparatus is given visual salience in the composition and a tiny scientist is making adjustments. But in this case, the technology takes up the entire composition, and the scientist is depicted as though he were a component of the equipment—he becomes one of the details, a part of the scientific landscape. The story to which the image belongs is titled "World's Hottest Furnace: Concave Mirror Focuses Sun's Rays to Produce Highest Controlled Temperatures Reached by Man." Essentially, the scientist's placement in the image provides evidence for the size of the furnace and even, perhaps, evidence that humans were responsible for creating a structure that is awesome and complex. The superlatives in the title not only correspond to the photograph of superlative science but continue into descriptions in the article itself. For example, the furnace produces "heat so great that it reduces flame-proof firebrick to incandescent gravy" and "brings test materials to extreme temperatures within a few seconds."[75] Descriptions in this brief article are almost entirely focused on the destructive capacity of the furnace—as in reducing bricks to "gravy"—as well as the potential usefulness of the furnace to society: it might be able to test materials that could improve jet engines.[76]

As far as figures 9 and 10 are concerned, the scientists' ethos can be said to benefit from the technology that is under their jurisdiction. The "World's

Fig. 10. Howard Sochurek, "Concave mirror focuses sun's rays to produce highest controlled temperatures reached by man." *Life*. November 1950. Reprinted with permission from Getty Images.

Hottest Furnace" example seems to belong to a popular category of the scientist identified by LaFollette as "creator/destroyer," an image that is linked to "a realization that each new advance carried the potential for *both* benefit and harm."[77] Science is both destructive and beneficial to society. Science is both frightening and awe-inspiring. These tensions are part and parcel of an enterprise in which ethos is limited to expertise—one that relies on both trust and ignorance.[78] Arguably, the conflation of technology and science only exacerbates the issue: "as technology gets larger, more complex, and more pervasive, it seems to undercut its own justification: Rather than making us feel we have more control, it makes us feel we have less."[79] When the element of technology is added to the domain of science, the ethos of expertise becomes even more pronounced. The scientists in the images discussed so far are not inviting viewers to identify with their work or acting as if they intended to engage viewers in their tasks. Rather, because scientists are portrayed as if they were the midst of working on, for example, a brick-melting, substance-disintegrating furnace, these images likely serve to create a culture of exclusion.

Fig. 11. Al Fenn, "Bubble blowing for business: an Illinois professor makes a scientific study of gaseous bubbles." *Life*. September 1955. Reprinted with permission from Getty Images.

Not all science stories in *Life* are focused on propagating the idea of science as simultaneously creative and destructive. Many of them link scientific research to practical applications in the business sector, a theme that corresponds to another of LaFollette's findings: that is, scientists were considered praiseworthy if they both devoted hard work toward an "unlimited scientific vision" and possessed "a practical business sense."[80] Figure 11, from a 1955 story titled "Bubble Blowing for Business," is exemplary of that dual commitment to science and business. To arrive at that message, though, the story that accompanies the image takes a familiar and fun activity—bubble blowing—and makes it a scientific and therefore "serious" endeavor; the very brief article opens like this: "Bubbles, normally the pleasurable preoccupation of burlesque audiences and champagne sippers, are a serious matter for Robert C. Kintner, professor of Chemical Engineering."[81] The article then goes on to describe the chemical engineer's methods for gathering data that would benefit the oil industry. Here, the distance between scientists, who are busy and hardworking, and ordinary

people is reinforced by the scientist taking the fun out of a familiar pastime. The message seems to be that science and scientists make even the accessible inaccessible.

Granted, this image is unlike the other portraits mentioned in that the scientist is not much smaller than the scientific objects, nor is he blending into the compositional landscape. Rather, this portrait focuses attention on the scientist, which might make it seem as though he is relatable. Contributing to that possibility is the fact that, in this particular case, viewers actually see most of the scientist's face, whereas in the other examples the scientist is in profile. Preventing the possibility of a reciprocal relationship, however, is the fact that the scientist is slightly turned away from the viewer and toward his experiment and that he does not make eye contact. Moreover, the scientist is photographed from a low angle, scripting viewers into the scene as looking up at him, putting him on a metaphorical pedestal and thereby diminishing the possibility for relatability while also increasing the perceived value of his work.

Value, according to Perelman and Olbrechts-Tyteca, can be fashioned rhetorically in several ways, but, in explaining their locus of quality, they stress the importance of uniqueness in carrying out the notion that something is of value: "a unique quality becomes the means for winning the approval of the majority. Even the multitude appreciates that which stands out, that which is difficult to attain."[82] Aristotle in *On Rhetoric* sums up this idea succinctly: "And people value what no common person does; for these deeds are more praiseworthy."[83] Thus, LaFollette's finding that the overwhelming public perception of scientists is that they are different—and different specifically because of their expertise—is significant in being bound to timeless beliefs about what is considered valuable. Scientist-at-work portraits place emphasis on the uniqueness and complexities of scientific research to create value for nonscientist audiences, but they do so at the expense of "relatability" and accessibility.

Common themes exist among these scientist-at-work portraits. First, in all cases, the portraits give the impression that the scientist is in the midst of working, that he is being photographed candidly. Second, and relatedly, the scientist never makes eye contact with the viewer (i.e., never looks at the camera). Third, scientists always work with an apparatus, representative of "high technology," but the type of apparatus and its positioning in the composition change in each case. In other words, in many scientist-at-work portraits, high technology and big science are conflated, visually: the big machines of the 1940s and 1950s appear in *Life*'s Science section, and scientists are at the helm. Images of technology, along with the other elements of scientist-at-work portraits, reify the ethos of expertise surrounding scientists and science, even if such images are supposed to make science inclusive to nonexpert viewers.

CONCLUSION

One of the major affordances of (some types of) portraiture is the potential to create presence for an audience. Henry Luce's mission statement for *Life* aligned with this notion: "To see, and show," Luce wrote, "is the mission now undertaken by a new kind of publication."[84] He promised viewers that they would "see the world" and "eyewitness great events."[85] He went so far as to eliminate the construct or vehicle—the photograph—that allows viewers to bear witness to events, leaving them with the impression that they would experience reality, period. The mission statement thus positioned *Life* as a portal into other realities, science being one of them; it could be said to create presence in the global sense put forth by Gross and Dearin—that is, viewers would be transported by the magazine "to live in a world made significantly different by the persuader."[86] Portraiture, it seems, manipulates photographic elements in a visual composition so as to characterize and create the "world" of science. However, *Life's* portraits of scientists, like the magazine's portraits of political figures or celebrities, may have been *intended* to provide viewers with access into an otherwise inaccessible realm, but scientist-at-work portraits, far from facilitating accessibility and inclusivity, set up a figurative "access denied" sign in front of the scientific enterprise.[87]

Making the world of science visible to nonscientists is not the same as making the world of science present or accessible. The elements that preclude the representative portraits analyzed here from facilitating such inclusivity are, predominantly, lack of eye contact and looming technological equipment. When scientists do not look at viewers, it is as if, Kress and van Leeuwen explain, "a real or imaginary barrier [had been] erected between the represented participants and the viewers, a sense of disengagement."[88] When scientists are simultaneously overshadowed (physically) by technology and yet in control of it, their ethos—rooted in expertise—is magnified. Such features, when understood in the historical context during which *Life* was at the height of its popularity, can provide even more insight into the dominant public perceptions of science and scientists gleaned through textual artifacts.[89] The combination of complex technological equipment and lack of eye contact, and the resulting imaginary barrier and sense of disengagement, makes portraits of scientists at work visual instantiations of an ethos of expertise, established through exclusion and exclusivity. At the same time that this ethos, partially derived from "high technology," brings value to the scientific enterprise, as mentioned earlier, it sacrifices inclusivity. When communicating science to uninitiated audiences in a multimodal environment, presence has an inverse relationship with value that is derived

from an ethos of expertise: as more value is placed on expertise, more distance is created between scientists and nonscientist audiences.

The visual messages conveyed by scientist-at-work portraits, reinforced by captions and accompanying text, may be expressed in the following ways: scientists do impressive and important work because they both design and control complicated equipment and do what other people cannot do; ergo, scientists are special and unique. By extension, science is impressive and important because it involves complex equipment that only experts can understand and control; ergo, science is inaccessible to nonscientists. Scientist-at-work portraits were more likely to reinforce the dominant public perspectives of science in the 1940s and 1950s, which were overwhelmingly characterized by difference, prestige, and elusiveness.[90] Depictions of scientists in these venues tended toward mythologizing their pursuits and were grouped by LaFollette into such categories as wizards, heroes, and experts.[91] The expert image of the scientist, according to La-Follette, "served inadvertently to erect barriers of authority between readers and scientists."[92] The "myth of differentness," which she said might have even been encouraged by scientists to maintain their status in society, resulted in "promoting awe, respect, confidence, even a little fear, in public attitudes to science."[93]

Today, elementary school students' perceptions of what scientists look like, gleaned from such experiments as "Draw a Scientist," are overwhelmingly negative, as Michael Brooks explained in a 2012 article in *Wired* magazine, "Why the Scientist Stereotype Is Bad for Everyone."[94] Brooks argued that scientists have created a culture of exclusion around the scientific enterprise and that the problem stems from "the myth the scientists have created around themselves."[95] The result is that students are reluctant to engage in science education. Brooks's opinion is that scientists "need to step out of the lab and into the classroom."[96] Seemingly, his opinion aligns with Jacobi and Schiele's concept that the image of scientists as ordinary mortals assists in times of public disengagement with or fear of science. A scholar of science images, Kathryn Northcut, has suggested that pictures of scientists can help to "humanize science for public audiences," as "the public desires a narrative, with scientists fully characterized as humans."[97] The archetypal image of scientists as ordinary mortals, identified by Jacobi and Schiele, is likely to provide that humanization through narrative.[98] To position science as a culture of inclusion, certainly a different archetype of portrait from the scientist at work is required. But the scientist-at-work portrait has a long-standing tradition, as evidenced by *Life* magazine's "candid" portrayals of scientists in the 1940s and 1950s. Scientist-at-work portraits might appear to be portals into the mysterious and unknown realm of the laboratory, but in actuality viewers are allowed only to look from the threshold, so to speak, as opposed to being invited into the scene.

3

Popular Magazine Covers

••••••••••••••••••••••••••••••••

Supernatural Science Sells

I mages of scientists working in the laboratory, discussed previously, contrib-
uted to the notion that scientists are separate from—that is, above—society
and "ordinary" citizens. That perception persists, according to Dorothy Nelkin,
who has written, that "scientists still appear to be remote but superior wizards,
culturally isolated from the mainstream of society."[1] The "scientific mystique,"
as Nelkin refers to it, also applies to the ways in which scientific research is
covered in the media. But, do the media simply reflect public perceptions of the
scientific enterprise, or are media sources responsible for shaping them? Nelkin
concedes that, although public perceptions tend to align with media messages,
it is difficult to determine which entity is responsible for shaping our dominant
images of science. Still, she argues, when it comes to policy decisions, "It is the
media that create the reality and set the public agenda."[2] Popular science maga-
zines can be included under the umbrella of "the media" and thus contribute to
cultural characterizations of the scientific enterprise.

Books, as the saying goes, ought not to be judged by their covers, but
magazines depend on people judging their covers to stay in circulation. In *The
Magazine from Cover to Cover,* Johnson and Prijatel describe the magazine cover
as "the most important editorial and design page in a magazine. The cover, as
the magazine's face, creates that all-important first impression. . . . Editors, art
directors, publishers, and circulation directors spend hours trying to select the
perfect cover for each issue—one that sells out at the newsstands and creates a
media buzz."[3] From their description, two points must be made: first, magazine
covers, as the "faces" of magazines, are portal images in that they persuade pro-
spective readers to open the magazine and engage with the interior contents;
second, magazine covers are rhetorical—they are the products of editors' and
art directors' choices about such elements as layout, color, types of images,
and amount of text. Science magazine covers are complex, persuasive visual

documents that are responsible for making potential audiences receptive, attentive, and well disposed to scientific content.[4] Whether viewed on the shelf with dozens of other titles or viewed on a website, the covers of magazines are seen by everyone, even if the interior contents are not. Therefore, whether or not viewers or passersby engage with the interior contents of the magazine, the magazine cover still acts as a portal, but with higher stakes—a portal into "Science." That is to say, magazine covers bear the burden of defining what science looks like for broad public audiences.

Every issue of a magazine defines its subject matter for its intended audience first through its cover image and its descriptive cover lines. Given that magazines publish several issues a year, often weekly or monthly, there are ample opportunities for visual definition and redefinition of the main subject, whether it is "good housekeeping" or what it means to be "wired." Looking at large swaths of a publication's covers over time can provide more insight into how it defines its main subject than looking at a single cover because trends emerge in an analysis of several covers that would be indiscernible from a single one.[5] Three popular science magazines—two well-established publications and one newer one—illustrate the options that are available for engaging viewers and simultaneously defining the scientific enterprise visually. Not all popular science magazines take the same approach to cover design, nor do they all attempt to reach the same audience, but one aspect that they all have in common is the burden of selling science in order to sell copies.

As with the previous examples of portal images in this book—frontispieces and images of scientists working—magazine covers make use of culturally relevant imagery and symbols to capture the attention of viewers. Frontispieces, the engraved illustrations in the front of natural philosophy books, featured mythological characters and objects with which their audiences would have been familiar and so began a long history of mythologizing the scientific enterprise. Portraits of scientists at work valorized scientists and set them above and apart from "ordinary" citizens—another form of mystifying science in the public eye. Magazine covers also contribute to the mystification of science, albeit in a different way. Consider, for example, the cover of *Science Illustrated* in figure 13. A vibrant image of an explosion accompanied by the sensational cover line "Earth on Fire" garners the most attention out of all of the visual stimuli packed onto this cover, and the scene defines science visually for its broad intended audience. The style and placement of elements on this cover are discussed at length later.

I use the example of *Science Illustrated* here to make the point that popular science magazine covers, perhaps because they are first and foremost responsible for selling magazines, often mystify science by venturing into the realm of

fiction or fantasy. In the introduction to this book, I mentioned Schriver's concept of juxtapositional relationships between words and images, which create a clash or tension and are typically used in advertising. Because popular science magazine covers are a form of advertisement, it is unsurprising that they not only are what Schriver has called stage-setting images but also exhibit juxtapositional qualities; in other words, science fictional images, which clash with the ideals of the scientific enterprise, are used as portals into supposedly scientific content.

Looking back at how popular science magazines evolved into the vibrant, flashy specimens we see in stores and online today gets at the core of why science has become subject to sensationalism. Scientists lament the sensationalism of their research in popular articles,[6] but the images that front or accompany those articles tend to fly under the critical radar. These images contain messages about science, too, and, as I have stated throughout this book, images tend to be more memorable than words alone.[7]

The three magazines under scrutiny here show different aspects of the rhetorical work performed by magazine covers. *Scientific American* is first in line for analysis because it illustrates change over time—a rhetorical trajectory of cover composition and style coinciding with a change in target audience. Unlike other popular science magazines, *Scientific American* has a story; it underwent changes in management and audience that led to its "downfall,"[8] and these changes were manifested on its covers. *Science Illustrated* is next because its covers have several communicative nodes, a quality that facilitates an in-depth discussion of the organizational and stylistic choices that are available to magazine editors. Last, *New Scientist,* a magazine that touts its credibility and claims to present readers with the latest research from a wide range of scientific subjects, is not above sensationalizing science. *New Scientist,* published weekly, is an example of how magazine editors and art directors occasionally recycle certain tropes to visualize diverse subject matter—a practice that can be subversive to that scientific subject matter. It is worth considering potential consequences of mystifying science with fictional images on popular science magazine covers.

WHAT'S IN A COVER?

When a scientific article is accommodated for nonexpert audiences, according to Jeanne Fahnestock, it shifts genres from forensic rhetoric to epideictic rhetoric—from validating scientific observations to celebrating scientific discoveries.[9] In accommodations for nonexperts, unhedged claims are made frequently because the goal is to make science relevant and noteworthy. In research reports, however, unhedged, high-level claims are inappropriate because arguments must

conform to standards already set in place and monitored by a system of peer review.[10] Little attention has been paid to the covers of expert versus nonexpert publications, which also reflect the intended audience and offer insight into the *visual* rhetorical techniques that are deemed appropriate for different audiences. Magazine and journal covers, whether for experts or nonexperts, have been modernized by the same advances in print technology described earlier (that is, photomechanical reproduction), and, later, by photo-editing software.[11] Specialized journals and popular magazines alike have benefited from and capitalized on these technological advancements, but there are still marked differences in their cover styles.

If scientific publications were to be conceived of on a continuum, a popularization like *Science Illustrated* would be on one end, and on the opposite end there would be elite publications like the *Journal of the American Medical Association* (*JAMA*) and *Science*. The latter contain peer-reviewed papers that are read by a small group of practitioners and experts, whereas the former contains brief stories (interspersed among highly stylized images) that have neither citations to original scientific research papers nor pertinence to recent scientific discoveries. If presented with *only* the covers of *Science* and *Science Illustrated* side by side, most viewers would probably be able to guess at the intended audiences of these publications. *Science* features what magazine editors refer to as a "poster" cover—one main cover image and no cover lines.[12] *JAMA* also features a poster cover, and, in fact, its covers mainly display fine art pieces, framed by a white border.[13] *Science* typically displays scientific phenomena on its covers, unframed (that is, the image extends to the edges of the cover). Despite their different approaches, the covers of these expert publications are austere, simple, and uncluttered—qualities that, Johnson and Prijatel claim, demonstrate sophistication. These types of covers aim to elevate their respective fields culturally.

Although poster covers can still be found on some popular magazines, they have become a rarity.[14] This is probably because the more cover lines a magazine has, according to journalism experts, the better it sells.[15] Cover lines are the brief, memorable captions corresponding to articles inside the publication.[16] Magazine covers that have multiple cover lines and multiple images, like the *Science Illustrated* cover, are called "multi-theme, multi-image," and these represent the most cluttered approach, as well as the least sophisticated.[17] Publications like *JAMA* and *Science* can get away with dismissing the conventions of competitive cover design since they, and other peer-reviewed publications, have a more or less stable readership of experts in their fields. They do not need to compete for readers. Popular science magazines *do* need to compete for readers, and that competition has seemingly gone hand in hand with fictionalizing science. The question is: Why does competition for sales necessitate fictionalization? A bit of

background on the evolution of popular science periodicals and science popularization in general can offer some insight.

A BRIEF HISTORY OF POPULAR SCIENCE MAGAZINES AND "THE GAP"

Popular science periodicals arose out of a need for mediation between an increasingly professional and specialized scientific community and a growing, educated middle class.[18] Gatekeeping practices, such as the peer-review system and the formation of scientific societies, contributed to the professionalization of the scientific enterprise.[19] In the early nineteenth century, periodicals encouraged amateur participation in science, but beginning around the 1860s popular periodicals deemphasized amateur participation and emphasized—or celebrated—professional science.[20] In other words, audiences stopped being invited to participate in science and started being asked to watch from the sidelines while "experts" with specialized training demonstrated how science was done.

Historians of science have noted that the number of popular publications not only doubled around 1860 but also shifted their mode of address to nonspecialist audiences such that they became spectators rather than participants.[21] Moreover, according to Whalen and Tobin, while science periodicals were all started by private editors who were personally invested in cultivating a scientific community, they were eventually taken over by mass publishing companies, which portrayed science as "isolated and radically apart from commonplace reality."[22] Thus, the "gap" between the scientific enterprise and society was opened up due to such factors as the professionalization of science, the growth of a mass audience, and the corporate takeover of scientific popularization.

The latter is perhaps most responsible for developing the notion that science needed to be advertised to nonscientist audiences. That is to say, the primary goal of large publishing companies was to sell magazines, regardless of their subject area, meaning that spreading awareness of science was a side effect rather than a priority. Using advertising language, Peter Broks stated in *Media Science before the Great War* that "In popular periodicals science itself was presented as a commodity, a product not a process, to be consumed not participated in."[23] Peter Bowler wrote that "Science became popular when its presentation came in a format with which people could identify."[24] Bowler zeroed in on the qualities that appealed to mass audiences for science: discovery, excitement, and a narrative framework. The "new journalism" of the 1880s, characterized by shorter paragraphs and more illustrations, likely changed readers' expectations for the way they received information.[25] Finally, as discussed previously, photomechanical reproduction, which allowed for images to be published on

the same page as text, also changed the way that science could be conveyed to mass audiences. By the middle of the twentieth century, magazines also had to begin competing with television, which became the primary means of transmitting information visually, and magazine editors were tasked with finding more effective ways of persuading people to engage with their products. For example, they began using bolder graphics and more cover lines to compete with all of the other visual stimuli bombarding readers daily.[26] Not making scientific concepts appealing would mean certain failure.

It was not only competition from new media that changed the face of magazine covers, however. In the twentieth century, the divide between scientific communities and society became even more pronounced, according to the philosopher of science Bernadette Bensaude-Vincent, because of the valorization of scientists and the representation of science in journalism. First, the widening gap was in part due to twentieth-century physics during the Cold War, argued Bensaude-Vincent, "when research policies were no longer under the control of public opinion," and all branches of science were associated with physics, and all scientists were viewed as "super heroes."[27] Significantly, Bensaude-Vincent also pointed to science journalists as being responsible for creating the notion that science is inaccessible to the average citizen. Twentieth-century popularization, she argued, is an entirely separate entity from nineteenth-century popularization because twentieth-century journalists endowed science with "quasi-supernatural power," which in turn depreciated nonscientists. So, although nineteenth-century popularization did encourage a divide between science producers and science consumers, it was not until the twentieth century that the public was presumed to be knowledge-deficient and incapable of comprehending science. Bensaude-Vincent claimed, "Never before had the public been disqualified and deprived of its faculty of judgment to such an extent."[28]

If public audiences could no longer be trusted to comprehend and judge scientific issues, it follows that they could not be trusted to appreciate science, which explains the marked differences now in cover style between expert and nonexpert publications. As Dorothy Nelkin put it in *Selling Science:* "Popular magazines began portraying science in nearly mystical terms as an awesome and remote activity performed by omniscient individuals."[29] According to these assessments of science popularization and journalism, the trend to fictionalize the covers of popular science magazines makes sense: a public that lacks faculties of judgment cannot be trusted to engage with scientific issues. Science has to be sensationalized in order to gain traction in public venues. It is a vicious cycle because, to quote Nelkin again, "by neglecting the substance of science . . . the press ultimately contributes to the obfuscation of science and helps to perpetuate the distance between science and the citizen."[30]

THE "DOWNFALL" OF *SCIENTIFIC AMERICAN*
••

Scientific American was, at one time, a unique publication in that it was appreciated by both experts and nonexperts—it was a venue for scientists to earn wider recognition for their discoveries that had already gained them acclaim in expert circles. An invitation from its editors, Piel and Flanagan, to write an article for *Scientific American* was considered an honor and a great opportunity for scientists to gain a broader, even public, readership for their work.[31] The articles in *Scientific American* were written in a scientific style that was often challenging to work through. Then, in the 1990s, "something happened": the quality and style of writing declined and the articles began to have less depth and scope.[32] The point of focusing on *Scientific American* first, before the other magazines, is to take stock of the ways in which a change in audience affects a change in visual mode of address.

The success of *Scientific American* in its heyday is credited to its publisher, Gerard Piel, as the magazine's circulation neared one million during his tenure. But the competition with other popular magazines and the loss of advertisers— a plight faced by many science magazines in the late 1980s—likely contributed to a decrease in circulation and sales.[33] As a result of financial pressure, the magazine's founders, Piel and Flanagan, retired from their posts as publisher and editor, respectively, in 1986, and sold the magazine to the German publishing megalith Verlagsgrouppe Georg von Holtzbrinck.[34] The sale meant that *Scientific American* became part of a larger conglomerate not seriously devoted to scientific concerns. It is generally agreed that, in the years after it was sold, *Scientific American* suffered a decline in status—in the credibility of information contained within the glossy packaging—and began to resemble a popular science magazine.[35]

The covers of *Scientific American* chart a clear path along the "publication continuum" I mentioned earlier, as they became increasingly cluttered and sensational in the late 1980s and into the 1990s. Internet archives have made back issues of popular magazines accessible to anyone, and they also make it possible to view swaths of covers all at once.[36] Early *Scientific American* covers were similar to the covers of journals aimed at audiences of scientists, such as *JAMA* and *Science,* which set an aesthetic standard of simplicity that culturally elevated the scientific enterprise; the timeline in figure 12 depicts changes in *Scientific American*'s cover design over time. The first cover, from 1956, is representative of the magazine's once austere design, characterized by a single image framed by a white border and very few (if any) cover lines listed under the title. In September 1987, a year after it was sold to von Holtzbrinck, *Scientific American* broke

Fig. 12. Cover Design: Change over Time. A timeline of *Scientific American* cover images: June 1956, September 1987, September 1992, May 1999, and April 2011. Image designed and created by the author.

a trend going back more than thirty years of only featuring a single, very brief cover line and began including cover lines underneath the title in addition to the description of the illustration at the bottom right. This format was retained through most of the 1990s, with the exception of "special issues" and "special reports," which occurred one or two months out of the year and contrast sharply with *Scientific American*'s typical template of an illustration framed by a white border. These few special issues presaged what eventually became the standard design of the magazine, though, at the time, the publishers were ostensibly testing the impact of a bolder approach.

The special issue covers were characterized by several bold cover lines, and the main image was no longer framed by a white border. For example, the main cover lines on the 1992 cover are in a font much larger than the cover lines on issues following the standard design template at the time. A list of secondary cover lines runs down the left side of the cover, and these lines make use of buzzwords. Buzzwords are employed by editors because they demand attention due to their cultural, political, temporal significance.[37] Between 1996 and 1999, these design anomalies became the norm for *Scientific American*. First, more cover lines were added to form a cluster at the top-right, across from the title, and there was a new, different-colored band across the top, featuring even more cover lines. Gradually, the cover lines became larger and more cinematic and dramatic (for example, "Predicting Destruction by Monster Waves," which smacks of science fiction, not science news).

In 1999, *Scientific American* changed its face most drastically, permanently breaking from the tradition of the white border so that the title became a part of the image, sometimes even covered by it. For example, in the May 1999 issue, a tidal wave obscures the second half of the title, which is somewhat shocking, given the previous tradition of keeping the title in an area separate from the cover illustration. The cover lines are no longer small and clustered at the top— they are very large and bold and generally run down the entire left side of the page. Buzzwords and slang terminology are ubiquitous in the cover lines, as in "Black Holes: Direct Proof at Last" and "Prehistoric Killer Kangaroos." Contrast that with the earlier tradition of a single cover line or word that barely described the image or even the cluster of cover lines in small italics at the top, attracting little attention. The new style was magazine-stand ready: the cover lines could be seen from far away, they tended toward the realm of science fiction, and the images were flashy and vibrant and practically jumped off the page.

Johnson and Prijatel remind us that flashy covers with many cover lines sell better at the stands, but they do so at the expense of sophistication. Whereas early *Scientific American* covers elevated the scientific enterprise, in keeping with the style of *JAMA* and *Science,* the need to sell more magazines entailed

casting a broader net, which, apparently, in the eyes of the editorial board, entailed transforming the covers into dramatic science fiction. In a 2007 press release, *Scientific American*'s then-new president, Brian Napack, articulated what he saw as the goals of the covers: to bring the magazine "out of the ivory tower," to meet the increasing demands of the digital age, and to effectively reach target audiences by redesigning the magazine.[38] The magazine's archives show a continuation of the trend begun in 1999, with buzzwords galore and giant cover lines that migrate across the covers' surfaces. But after years of stylistic changes, in 2007 *Scientific American*'s circulation still trailed behind its competitors', *Discover, Popular Science,* and *Wired.*[39]

Noticeable changes in cover style occurred again in 2009 after the magazine was sold by Verlagsgrouppe Georg von Holtzbrinck to Nature Publishing Group (NPG). While the images remained bold and flashy, the number of cover lines was significantly reduced from the previous decade. In 2011, the covers featured even fewer cover lines, the header disappeared, and a drop-down banner occupied the top right corner, keeping the cover lines not pertaining to the main image corralled instead of distributed across the page. The somewhat simpler style was essentially an updated version of the pre-1996 covers, with cover lines that were contained and less visually demanding. It is perhaps unsurprising that NPG would decide to remodel the magazine's exterior to represent its brand (the journal *Nature* is, alongside *Science,* the premier publication for scientific research). While "selling" science with fantasy is still very much a reality for a magazine intended for a broad audience—in the example, we see what looks like a black body bag erupting fire—the visual changes on the covers of *Scientific American* indicate that the strategies employed toward this end can vary.

A 2009 press release from NPG regarding the merger stated, "The two iconic brands of *Nature* and *Scientific American* will position NPG to be the most authoritative and comprehensive science media group, spanning from consumer to scholar, from high school student to researcher."[40] According to the press release, the merger was also expected to create more marketing opportunities for advertising and to develop a more effective online presence. In theory, the merger was promising—a well-respected scientific organization taking initiative in the realm of public outreach. However, this type of merger has been attempted before, and not successfully: in the 1980s the American Association for the Advancement of Science (AAAS) tried publishing the *Science 80s* series, an accommodation of its main publication, *Science*. AAAS ended up selling the magazine to *Time* in 1986, right before the magazine folded, prompting a *Science 86* staff writer, William Allman, to charge that "scientists have declared that they don't want to be a part of 'the task of informing the public about science.'"[41] NPG's influence seems to have been positive for *Scientific American,* given its

self-reported circulation statistics.[42] However, even after the reputable scientific organization took over publishing the magazine, its covers continued to feature sensational, fictional imagery. The same publisher of expert and nonexpert discourse, NPG, decided to continue the trend of pandering to nonexpert audiences with fantastical images (such as volcanic body bags), rather than trusting these audiences to subscribe to a magazine with actual scientific images on its covers.

SCIENCE ILLUSTRATED OR NOT-SCIENCE ILLUSTRATED?

The case of *Scientific American* is unique because of the profound changes in genre and target audience that it underwent when it was sold to different publishing groups. In contrast, *Science Illustrated* was always intended to reach the broadest possible audience, as will become evident through a tour of its covers. *Science Illustrated* was launched in the United States in 2008 by Bonnier Corporation, adding to its long list of magazine publications, which includes *Sport Fishing, Parenting, Skiing, Destination Weddings & Honeymoons,* and *Working Mother,* to name a few.[43] Suffice it to say that the corporation is not invested in science alone. And the extent to which it is actually invested in science or public outreach, as opposed to its obvious investment in magazine sales, is difficult to determine.

The magazine's mission statement, reminiscent of *Life* magazine's mission statement, given previously, claims that *Science Illustrated* "delivers the world" to its readers. Here is the magazine's editor in chief, Mark Jannot: "Launched in 2008, *Science Illustrated* is the magazine for intellectually curious men and women with a passion for science and discovery. In this age of accelerating change and discovery, to understand science is to understand the world. *Science Illustrated* delivers that understanding—delivers the world—to the entire family."[44]

Jannot's promise to deliver the world to the whole family is not the only promise that *Science Illustrated* is expected to fulfill; Bonnier's website promises "to report on the world of science in a way that's dynamic, engaging and accessible for all," and the *Science Illustrated* "Subscribe" webpage promises to "make the world of science come alive like never before" thanks to "bold graphics, colorful photography, and fascinating stories."[45] Cover lines and images may change from issue to issue, but the template of *Science Illustrated*—multiple images and cover lines—has remained fairly consistent. One example will suffice for this publication, which presents an extreme case of sensationalizing the scientific enterprise and facilitates an understanding of the range of stylistic and organizational choices available to editors. Consider figure 13 again, which is very typical of *Science Illustrated* covers in terms of its compositional layout.

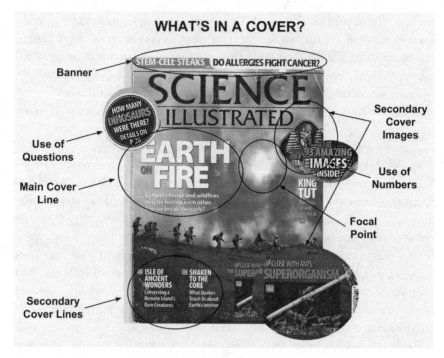

Fig. 13. What's in a Cover? A deconstruction of *Science Illustrated*'s November/ December 2010 cover. Image designed and created by the author.

Even though, at first glance, the elements on this cover seem randomly sprayed across the composition, from a design perspective the arrangement of elements is very deliberate and serves a persuasive purpose.[46] It is difficult to determine a focal point on this cover—a place in the visual composition to which the eye is drawn first—because of the sheer overload of visual stimuli, but for some readers it could be the bright spot just off-center, radiating up into the title. Whatever the focal point might be (it may differ depending on the viewer), the gaze is compelled to continue zigzagging across the visual composition to take in the other images and cover lines. In *A Primer of Visual Literacy*, Donis A. Dondis channeled insights from the rhetorical tradition into the analysis of visual composition, arguing that editorial choices are purposeful and executed to control viewers' responses.[47] One of those choices pertains to the placement of elements in a visual composition; in the case of the *Science Illustrated* cover, these elements are positioned along a series of (invisible) diagonal lines. Dondis, advising from a graphic design and art historical background, reinforced the importance of diagonal lines (as opposed to horizontal or vertical) for creating a dynamic composition that attracts visual attention.

The main image on the cover, demanding attention first, is the apocalyptic scene containing the bright focal point, which is yellow in the color version; the image is accompanied by the main cover line, which is much larger and bolder than all of the others: "Earth on Fire."[48] There is a smaller, supplemental cover line beneath this one, but there are larger, bolder visual stimuli that would likely demand attention first; readers might delay reading supplemental cover lines until they have experienced the more demanding images. For example, pulling the eyes diagonally across the page from the main cover line is a bolded diamond-shaped frame containing another illustration, an elaborate Egyptian sarcophagus; the corresponding cover line confirms that it is King Tut's, and the lines underneath, even tinier than the others, may again be delayed until other larger elements are apprehended. Pulling the eyes downward diagonally are the other major cover lines because they are the same color as the caption "King Tut."[49] Yet another illustration, emerging out of a framed rectangle at the bottom of the cover, might draw the eyes next. Once the gaze has made its rounds, so to speak, the finer details can be taken in, such as the secondary cover lines and the smaller elements of the illustrations. Readers can also note page numbers for all of the cover stories that caught their attention. There are still other elements on the cover as well, such as the circular stamp near the magazine title referring to dinosaurs and the double-colored band across the top of the cover with two more bolded cover lines, neither of which corresponds to any cover images. Bombarded by so many visual elements, potential readers might find it difficult to avert their gaze before taking in at least some of the more prominent stimuli.

That is, of course, the point. In the advertising world, finding techniques that prompt viewers to spend as much time as possible on a single advertisement is the main goal. The longer a viewer takes to appreciate an advertisement, the better; this process is referred to as "elaboration." According to the advertising theorists McQuarrie and Mick, there are certain rhetorical strategies that encourage viewer elaboration, such as leaving out information in an ad or conveying information in an unusual or unexpected way. Viewers can thus participate in the meaning-making process, which, they argue, "can be powerfully persuasive."[50] The surplus of text and images on *Science Illustrated* covers seem to be a ploy to get viewers to elaborate, or spend more time processing everything that they see. Moreover, the use of buzzwords provides clues as to the information inside the magazine without giving everything away. Last, the main image of an explosion in conjunction with the cover line "Earth on Fire" is not only hyperbolic but also metonymic, as the scene of a single location in flames is intended to stand in for the entire earth. These advertising design techniques tend to operate beneath the surface—which is to say that viewers are

not given verbal instructions for how to analyze the magazine cover—and that is what makes them all the more persuasive.

In addition to the sheer number of stimuli on the cover, there is also the purposeful placement of each element that assists in harnessing the gaze. I have mentioned the power of diagonal lines at moving the eye across the composition. For further insight into the significance of positioning elements along diagonal lines, we can turn again to Dondis, who began with the smallest, most basic visual element, the dot, and worked through more complex elements such as line, shape, direction, and ultimately, movement.[51] Relying on tenets of Gestalt psychology, Dondis explained that "Complexity, instability, irregularity increase visual stress and consequently attract the eye."[52] The diagonal line is "the most provoking visual formulation" because it throws off our inherent sense of balance and equilibrium.[53] In the *Science Illustrated* cover, the invisible diagonal line is featured prominently. The focal point of the main image (the yellow burst of light) is the same color yellow as the cover lines that are sporadically placed around the perimeter of the cover, and the eye is drawn by imaginary diagonal vectors connecting these matching yellow elements. In the same way, there is an orange-pink frame around King Tut that visually "rhymes" with the cover lines diagonally above and below it, and the diagonal lines create a triangle around the focal point. Of all the basic shapes, the triangle is the one that creates the most action and tension in a composition.[54] The viewer's gaze zigzags around the composition according to this invisible structure, but the dynamic composition is unified by other design elements, such as the color coordination. A visual composition that contains multiple communicative nodes (images and cover lines) must have both structure and "stress" to be cohesive. In this case, the tension created by stressed, dynamic elements within the composition is ostensibly stabilized by a unifying color palette.

There are still other stylistic variables that merit consideration, such as the manipulation of color saturation. Mass publications tend to use intensely saturated colors, which affect the modality or "realness" of the composition. "Modality" is a term that Kress and van Leeuwen used to refer to the socially determined construct pertaining to the truth value or credibility of statements —verbal, textual, or visual.[55] In general, photorealism is the standard for assessing the level of realism of a visual composition, and, therefore, it has the highest modality. However, the standards for assessing what is considered to be the "most realistic" differ depending on the purpose of the image. For example, scientific visualizations do not always look exactly like their referents—that is, they are not photorealistic—but they are still considered to be the most realistic depiction of their phenomena.[56] Scientific visualizations are often stripped of any unnecessary detail and can require a great deal of expertise to decipher,

but these austere images are considered more "real" by scientific criteria. Kress and van Leeuwen explained that scientific visualizations are viewed through a technological coding orientation.[57] In a technological coding orientation, images with full color saturation tend to have the lowest modality. By contrast, in "sensory coding orientations," which are used to view food advertisements, full color saturation conveys higher modality.[58] We expect supersaturated images of food that we can practically taste off the page, and color is a source of pleasure in this case. The illustrations on the covers of *Science Illustrated,* despite the "science" in the title, are intended to be viewed not through a technological coding orientation but through a sensory coding orientation, like food advertisements. These vibrant, hyper-real illustrations would not be considered realistic by the standards of photorealism, let alone by the standards of scientific visualizations. Hyper-real cover illustrations are essentially scientific advertisements. Thus, the mode of publication compounds the issue of fictionalized content.

In addition to color saturation, the style of the cover lines contributes to the overall visual message. Johnson and Prijatel wrote that "a reader will buy a magazine for a single cover line."[59] So, in the off-chance that the flashy cover illustrations fail to persuade readers to buy a copy, there is still hope because of the cover lines. The most popular persuasive strategies for cover lines include using buzzwords and numbers (especially odd numbers) and asking questions.[60] *Science Illustrated* editors use all of these strategies on all of their covers, and we can look again at figure 13 to see the strategies at work. Buzzwords on this cover include "stem-cell," "cancer," "superorganism," and "climate change." It is noteworthy that these buzzwords are located around the perimeter and are peripheral to the main illustration—they truly are intended to catch readers who are about to fall off the *Science Illustrated* bandwagon. Next, there is a random odd number: "93 Amazing Images Inside!" over the image of King Tut. Finally, there are two questions: "Climate change and wildfires may be fueling each other. Can we break the cycle?" and "How many dinosaurs were there? Details on p. 28." All of the visual elements on the cover are coordinated in such a way as to create a unified visual message: "This is science, illustrated."

According to Marcel LaFollette, to keep their positions, magazine editors must create messages that conform to their intended audiences' beliefs about science, regardless of whether those beliefs are accurate.[61] The very necessity of selling magazines, then, seems to entail perpetuating inaccurate depictions of what science is. *Science Illustrated* is aimed at an audience that wants to see the "earth on fire" and is not concerned with the accuracy of that phrase. The magazine provides an apt example of the persuasive techniques that are used to define science visually so as to sell it to a broad audience. Viewers may be engaged by the bold visuals and equally bold claims on the covers of *Science*

Illustrated, but, at the same time, they are being disqualified from actual science. These covers send the message to viewers that they cannot be trusted to engage with actual scientific phenomena and that they must instead be pandered to with apocalyptic scenes and science fictional bugs.

BODILESS HEADS ON THE COVERS OF *NEW SCIENTIST*

New Scientist was one of the few popular science magazines, according to Peter Bowler, that was able to compete with television media by featuring vivid illustrations.[62] *New Scientist*'s mission has remained consistent since it was launched, in 1956; it advertises itself as the only popular science magazine that shows the social and cultural implications of scientific advancements. Touting the magazine's credibility, *New Scientist*'s website lists several news and media sources that have referenced the magazine as a reliable source of information.[63] The magazine's mission statement claims that it "covers the social and cultural impacts and consequences of scientific and technological discovery."[64] Thus, the magazine has chosen to distinguish itself from other popular science magazines by highlighting its ability to show its target audience how the latest scientific and technological discoveries affect them personally. What exactly differentiates a "new" from an "old" scientist? According to the mission statement, *new* scientists are interested in how science influences society and culture. The very title *New Scientist* is reminiscent of early-nineteenth-century inclusiveness, the era of the amateur scientist; it suggests that all readers of the publication are scientists—that they are participants in the scientific enterprise. However, as the following analysis of *New Scientist* covers demonstrates, a philosophy of inclusiveness is not indicative of actual inclusiveness.

Perhaps because *New Scientist* attempts to show its target audience how the latest scientific and technological discoveries affect them personally, its cover illustrations have tended to be anthropocentric, as opposed to featuring scientific or natural phenomena.[65] One anthropocentric image in particular has recurred with alarming frequency on the covers of *New Scientist:* a human head portrayed without a body. As *New Scientist* is *not* a magazine that specializes in neuroscience or psychology but rather engages with a variety of scientific subfields, the human head trope is all the more curious. I looked at three decades of *New Scientist* covers to assess the popularity of the bodiless head trope and the subjects with which the heads are associated, information that is discernible from the cover lines.[66] I have selected representative examples to demonstrate how *New Scientist,* despite its credibility claims, participates in the visual fictionalization of the scientific enterprise, with the bodiless head trope being one compelling example.

Fig. 14. Darren Hopes,
Artwork appearing on
the cover of *New Scien-
tist,* February 12, 2000.
Reprinted with permission
from the artist, Darren
Hopes, athomeinspace
.com.

Close-ups of heads are so pervasive on the covers of *New Scientist* that they can be classified into subgroups: simplistic cartoon images, photorealistic people, and photorealistic human faces merged with cranial features that are unquestionably *not* human.[67] The latter provide the most fodder for analysis, as they present a jarring fusion of realistic human features and biologically incompatible nonhuman features. Heads that blend human with nonhuman features can be further classified into subgroups on the basis of what is happening in, on, or around the heads; these situational features add another layer of implausibility to the images, firmly placing the magazine cover art in the realm of fiction and fantasy.

An example of a human head fused with nonhuman features that is intended to represent the field of neuroscience is shown in figure 14. This image, by the artist Darren Hopes, which shows a woman in profile with white flowers growing out of her head, appeared on the cover of *New Scientist* in 2000. On the *New Scientist* cover, the image is accompanied by the cover line, "Brain Gain: How to Make New Nerve Cells Bloom." Taken together, cover line and image create a metaphor: nerve cells are flowers. Metaphors are ubiquitous in communicating

science to nonscientist audiences, as Heather Graves demonstrated in *Rhetoric in(to) Science*.[68] But metaphors also have the potential to complicate rather than clarify scientific phenomena. This is because one of the distinguishing features of metaphors—that they can be extended or elaborated—is not easily controlled, especially in a static visual on the cover of a magazine. On the *New Scientist* cover, the quality of the light emanating from these flowers and the densely packed red centers at the base of her head suggest that we are witnessing the flowers in the process of growing and spreading across her cranium. Because the image seemingly depicts the flowers in a state of growing, as opposed to a finished cranial garden, it could give the impression that the human is being overtaken by foliage. Certainly, a transformation is taking place, and there is no indication of its end point. The image itself, then, depicts a ceding of humanity to plant life.

When the image is evaluated in conjunction with the cover line, its meaning is somewhat constrained, as Barthes would say. The cover line pertains to increasing intelligence ("brain gain") by creating new nerve cells in the brain, but the operative word is "bloom." In other words, the cover image is entirely dependent upon the word "bloom" to be understood—it is a tenuous connection at best between image and cover line: flowers bloom and nerve cells "bloom." A different word could have been selected for the formation of new nerve cells in the brain: grow, form, generate, manifest. But instead, the word bloom was chosen, perhaps to allow more flexibility in cover design. It is also possible that the cover was selected prior to the main story, and the cover line had to suit the image. Whatever the case may be, the image of plant life taking over a human head is not relevant to neuroscientific research; it is neither realistic nor metaphorical in an epistemic way.

Returning to the concept of a visual metaphor, the image in conjunction with the cover line encourages viewers to "map" concepts from the domain of plants onto the domain of people, as the linguists George Lakoff and Mark Turner explain in *More Than Cool Reason*.[69] People often "map" concepts differently, as the whole purpose of metaphors is to prompt us to see images and concepts from fresh perspectives.[70] The *New Scientist* cover leaves open a wealth of possibilities for mapping concepts from the domain of people onto the domain of plants. For instance, flowers are planted as seeds; likewise, we might extend the metaphor to nerve cells to say that they could be "planted" in our brains for intellectual purposes, as suggested by the cover line "brain gain." Furthermore, we could say that flowers sprout and bloom out of the ground only when certain conditions are met (when they are watered and receive sunlight and so on); likewise, we might extend the metaphor to nerve cells to say that they require external stimuli to "bloom" and realize their full potential. The point is that the

Fig. 15. Christos Magga-
nas, "Evolution." Created
2000. Appeared on the
cover of *New Scientist,*
January 13, 2001. Re-
printed with permission
from the artist.

metaphor chosen for the cover might prompt elaborations and facilitate com-
parisons that are not factual or productive to an understanding of nerve cells.

Many of the bodiless heads on *New Scientist* covers are used to represent
neuroscientific topics, but some of them do not, as is the case with figure 15, an
image by Christos Magganas that was selected for a 2001 *New Scientist* cover.
The main cover line indicates that the illustration is meant to symbolize the
concept of evolution: "Fast Forward: Why human evolution may be speeding
up." Arguably, any number of illustrations could have been used to symbolize
the concept of evolution, but *New Scientist* again chose the trope of the bodiless
head. The woman on this cover appears to be morphing into several different
creatures at once; she has a thick seam running down the middle of her face,
razor-like spikes protruding from the top of her head, and reptilian skin creep-
ing up around her neck. Morphing, a common trope in science fiction, is thus
equated with evolution on this *New Scientist* cover. Moreover, because the head
is transforming into not one but multiple creatures, she resembles the Chimera
from Greek mythology, a creature that possessed physical qualities of a few dif-
ferent animals. The Chimera was supposedly a female monster and was consid-
ered an omen of natural disasters. Given the Chimera's meaning, an interesting

subtext can be appended to the message transmitted in the cover line: not only is human evolution speeding up, but it is heading for disaster. Or, taken from a definitional standpoint, today the word "chimera" refers to something that is fantastical or imaginary. Ultimately, the cover image suggests that evolution is a fantastical or imaginary concept, a message that would support certain religious factions' arguments that evolution does not exist. Thus, the choice to include a chimeric, fantastical image to symbolize the concept of evolution might actually be subversive to the scientific perspective on the subject of evolution.

One more point is worth making here: the scientific concept of evolution necessarily involves the body as a whole,[71] and so an image that maps animal body characteristics onto a human head is particularly inappropriate to the subject matter at hand. That *New Scientist* chose to use the "head" approach regardless of these incompatibilities suggests that the concept of an autonomous human head presents some kind of extrinsic appeal. Not only does a human head represent neuroscientific research, as in the first example, but also it can be counted on to spark interest in a variety of subjects, including evolution, multitasking, the five senses, addiction, and even quantum computing. Why is a human head without a body so compelling?

One reason could be that we still know so little about how the mind works. In *Brain Culture*, the rhetorician Davi Johnson Thornton pointed out that the human mind has been characterized by neuroscientists as the next "frontier" that is waiting to be conquered.[72] A special issue of *Rhetoric Society Quarterly* on "Neurorhetorics" attested to the persuasiveness of popular neuroscience in our culture, which, I argue, is epitomized by the image of a human head. Jordynn Jack the coeditor of the special issue, wrote in the introduction that "In the academy, as well as in popular culture, the prefix 'neuro-' now occurs with startling frequency."[73] Neuroscience is a relatively new scientific subfield that has undergone recent technological advancements; it also represents a new domain of science: the human mind. Within the framework of this book, two other "domains" of science have been addressed: the natural world (see chapter 1 on frontispieces) and the science laboratory (see chapter 2 on portraits of scientists working). But we are no longer fascinated by Erlenmeyer flasks and Bunsen burners. We want to see our minds, to understand ourselves, and, according to Thornton's assessment of neuroscientists' predictions, to unlock the rest of the universe.[74] *New Scientist* capitalizes on our curiosity about the human mind by recycling the image of a head without a body; the editorial staff simply changes the style of the head, objects around it, and cover lines.

Not only do the autonomous heads visually epitomize popular neuroscience, but also they present a visual instantiation of a common fallacy employed in popular neuroscientific discourse. In *Nature Reviews Neuroscience*, Eric

Racine, Ofek Bar-Ilan, and Judy Illes defined and elaborated on three "neurofallacies" that they found in newspapers and popular magazines. Neurofallacies are overstatements of the power of neuroimaging technologies that propagate misconceptions. The authors advised scientists to be cautious about the claims that they make for ethical reasons. Neurofallacies and the misconceptions that they substantiate, Racine and his coauthors argued, can impede scientific research, "as researchers are not isolated from wider social and cultural beliefs about the brain."[75] One of the neurofallacies discussed in their study is "neuroessentialism," which equates human identity and subjectivity with the brain.[76] Verbally, the fallacy might be stated, "You are your brain."

By featuring human heads without bodies, flanked by cover lines that make claims about the human condition, *New Scientist* is presenting its audience with the fallacy of neuro-essentialism in visual form. The bodiless head trope, with its fusion of human and nonhuman features, works rhetorically to connect humanity or humanness with any "scientific" subject. But, because it is only a head and not a human body, "humanness" is being reduced to the mind. The bodiless head image, then, not only fictionalizes scientific discourse on the brain but also propagates the fallacy that people are indeed reducible to their brains. Therefore, the case of the bodiless heads on *New Scientist* covers presents an example of how images on magazine covers can contribute to the mystification of a particular branch of science in society—in this case, neuroscience. These covers visually introduce *New Scientist* readers to scientific concepts by both presenting them as science fiction and misrepresenting the capabilities of neuroscience.

CONCLUSION

Magazine covers are quite literally portals into further discourse, but popular science magazine covers are also portals for nonexpert audiences into "Science," broadly construed. They serve the important function of visualizing science—and defining science visually—for readers, even if it is in an attempt to persuade them to engage with the interior contents (that is, sell the magazine). It is very true that we judge magazines by their covers, and magazine editors know this, which is why they invest time and money in presenting cover images that secure the attention of broad audiences.[77] Popular science magazine covers make use of culturally relevant symbols in order to send messages about science, but, in so doing, they also send messages about the status of science in society.

The story of *Scientific American*'s change over time, manifested on its covers, isolates features of covers that have been deemed most effective at engaging nonexpert publics: put bluntly, science fiction sells. *Science Illustrated* covers make use of the "busiest" layout, packed with nodes of collective social intrigue

to sensationalize science. The *New Scientist* heads capitalize on the cultural fascination with human-centered science by presenting surrealistic visual compositions that evoke science fiction. Whether it is intentional or not, all three of these publications, despite their diverse audiences and purposes, create a culture of exclusion around the scientific enterprise. The message conveyed by their covers is that actual science is out of the reach of nonscientists. At the same time that covers sensationalize science in order to sell it, they also work to disenfranchise nonexpert audiences—they tacitly claim that these audiences would not be willing or able to engage with science if it was not sensationalized. To be clear, I am not suggesting that science fiction as a genre is problematic; rather, I am arguing that using science fictional images as portals into what is supposed to be actual scientific information is problematic. Fictionalizing science contributes to the mystification of science in the public eye, reinforcing the divide between the scientific enterprise and society.

Earlier I briefly described the genealogy of the "gap" between scientific communities and nonexpert publics. Currently, there is a great deal of negativity surrounding the difficult task of public outreach. The latest trend is the notion that scientific research can be "framed," a topic published on extensively by communication professor Matthew Nisbet, who aims to help scientists more effectively appeal to wider public audiences.[78]

4

Portals on the Web

......................................

Science-Art Competitions and a
Celebration of Indeterminacy

I n 2010, *New Scientist* magazine ran a blog called "Art Meets Science," featuring the perspectives of artists and scientists on the potential benefits of blending the two fields. The pieces in the series engage C. P. Snow's famous "Two Cultures" lecture implicitly or explicitly as they attempt to justify aesthetic interventions into scientific discourse, particularly for the purposes of communicating with nonexpert audiences. One piece in the series looks at the possibility of an emerging *third* culture, brought on by digital communication. The writer of the piece, Stephen Wilson, director of the Conceptual Information Arts program at San Francisco State University, argued that "better information dissemination has popularised science and humanities for non-specialists" and that a digital third culture "might be emerging to heal the rift between sciences and the arts."[1]

The emergence of digital culture has led to new trends in science communication with nonexpert publics. A piece in the journal *Science* titled "Science Communication Requires Time, Trust, and Twitter" attests to the shifts in mode of address as well as in audience expectations. In the article, Elizabeth Landau, a writer and producer for CNN.com, explained that visual communication is "almost as important as the headline, sometimes even more so" in selling science stories.[2] The *New York Times* science reporter James Gorman has argued that replacing "boring" interviews with captivating images "might help to raise public awareness of the importance of the work."[3] Public support is essential to the funding of basic scientific research. Reliance on the visual to secure public support, however, is not without its complications, especially in a digital environment.

Previously, images were considered that were used as portals into scientific discourse but that were not necessarily "scientific." Frontispieces in early

modern natural philosophy books, for example, often featured mythological characters and symbols, whereas the interior pages of such books featured technical drawings. Portraits of scientists working in the laboratory often showcased complex scientific equipment, but these images would not have appeared in scientific journals. Last, popular science magazine covers tend to feature stylized, fictional content, as opposed to scientific visualizations. Scientific visualizations that have been aestheticized for public consumption are of interest here.

There are differing perspectives on the role that art ought to play in scientific discourse, as evidenced by the *New Scientist* blog series "Art Meets Science." For example, on one hand, an art curator argued that art is valuable to science because "People often find it easier to connect on a purely aesthetic level. There is something about beauty—not only conventional beauty, but also ugly beauty—that can be arresting enough to make you absorb things in a different way."[4] On the other hand, a physicist cautioned, "In an art-science collaboration, it is important that the artist does not impose a view on the science."[5] One of the most notable pieces in the series is an interview with University of Oxford art historian Martin Kemp, who explained how art and science became severed in the nineteenth century when there was a drive to define them as "separate professional entities."[6] A benefit that can arise from reuniting the two cultures, Kemp suggested, is that artists (and, presumably, those who view their work) will see that "science is deeply imaginative, social, partial and extraordinary."[7] *New Scientist's* series is illuminating because of the range of perspectives it represents, but there is one perspective that is particularly troubling. Without leaving any grey area, the writer and artist Jonathon Keats opined, "Good scientists demystify the world in which we live, whereas good artists engage the sciences meaningfully by means of remystification."[8] Sadly, it is this perspective that seems to win out in terms of how popular science images are circulated in digital culture. The mystification of science can occur through aesthetically pleasing and indeterminate images that travel online without sufficient contextualization. In particular, one sees this in the emergence of the twenty-first-century science-art competition.

The first competition under scrutiny is the National Science Foundation's (NSF) annual visualization competition. Since 2003, the NSF has been soliciting visually stunning submissions from scientists and scientist/artist collaborations.[9] The NSF's mission statement for the competition takes an optimistic view of the capacity of popular science images to engage and inform nonexpert public audiences; the mission statement describes the competition images as if they were portals into science for uninitiated public audiences: "Illustrations provide the most immediate and influential connection between scientists and other citizens, and the best hope for nurturing popular interest. *They are a necessity for*

public understanding of research developments."[10] Simply positioning science images in an introductory role (in which they create an "immediate and influential connection") for public audiences, however, does not guarantee portal status. Portal status is achieved when images in an introductory role, in conjunction with accompanying text, attempt to initiate audiences into a particular field's values and concerns.

Although the NSF's mission statement and concept for the competition suggest that the images could be portals into science for nonexpert publics, the treatment and delivery of images on the competition website do not align with the NSF's stated intentions.[11] The NSF's visualization competition is particularly worthy of consideration because the NSF, as a national organization, sets the bar for visual science communication for the larger scientific community. That said, I also examine science-art competitions that have been started at universities across the United States and in Britain and that model themselves after the NSF's competition.

ART AND SCIENCE, SCIENCE AND ART: MYSTIFICATION THROUGH INDETERMINACY

The history of digitally altering scientific visualizations for the express purposes of entertaining public audiences and securing support for scientific research is relatively brief. There are cases in which a scientific visualization has created a stir—the invention of the X-ray was formidable in its own right, and Watson and Crick's three-dimensional model of the double helix has an important place in public memory. But digital technology has led to a new era of purposeful aestheticization of scientific images.[12] The types of images addressed here are reliant on technologies and software that are relatively new, such as Photoshop. Moreover, the broad reception of these aestheticized images is dependent on the ever-increasing speed and reach of Internet communication.

In the introduction to this book, I mentioned that rhetoricians have been interested in how images contribute to knowledge creation and have sought to point out the ways in which visualizations are as integral to scientists' arguments as textual discourse.[13] Popular science images are not as well understood.[14] Science images aimed at audiences of other scientists change purposes when they are aimed at audiences of nonexperts.[15] The change in purpose is inevitable because science images require expert training in order to understand and use them;[16] nonexpert audiences lack this training, and so the images cease to fulfill their original function and instead promote awe and wonder at science.

When these science images are aestheticized, given the recent trend to merge science and art, their indeterminacy and possible disconnection from actual science are even more pronounced.[17] In other words, science images,

especially when circulated outside their original contexts, become characterized by their indeterminacy. Sociologists of science Huppauf and Weingart have argued that images of science have a tendency to resemble avant-garde art all on their own.[18] Gross and Harmon agree, arguing that "the untutored can discern no meaningful patterns in cloud and bubble chamber photographs; for such naïve onlookers, these photographs may as well be examples of abstract art."[19] Gross and Harmon's theory of verbal-visual interaction offers valuable insights; as they explained, "we *perceive* an object or event, we *identify* its structures and components, we *interpret* them, we *integrate* these interpretations into an argument and/or narrative that supports a scientific claim."[20] Whereas the first two processes can occur in the absence of verbal cues, at the stage of interpretation, textual content becomes essential for novice viewers.[21]

In this way, the images discussed here are distinct from the other types of images addressed in this book so far: whereas frontispieces, portraits, and magazine covers precede or are accompanied by text but assume an influential role over that text, aesthetically pleasing scientific visualizations serve different functions depending on whether they receive adequate contextualization. That is, aesthetically pleasing scientific visualizations without adequate contextualization serve the function of promoting awe and wonder because of their indeterminacy, and the very same visualizations with adequate contextualization can serve the function of both entertaining and informing audiences. It is a matter of appropriate captioning in a digital environment.

What ought to be the relationship between images and accompanying text in this case? Recalling that Schriver mentioned the possibility that images and texts will fall on the boundaries of different types of relationships, the competition images might be classified as stage-setting images that would also benefit from text that serves a supplementary role. In other words, the image is the "dominant mode" and the text "reinforces, elaborates, or instantiates the points made in the dominant mode (or explains how to interpret the other)."[22] The text can, for example, explain the purpose of the image, emphasize important details, and even point to controversies in the scientific community.[23] The consequence of inadequate captioning, according to Greg Myers, is that viewers might misinterpret images and their purposes; not only does the caption "tell us what we are seeing," but it "leads us through the thicket of gratuitous detail to the shapes that are supposed to be meaningful."[24] Scientific organizations have the opportunity to craft a "narrative that supports a scientific claim," as Gross and Harmon put it, to surround their images, as opposed to allowing viewers to free-associate on the basis of aestheticized images and minimal textual cues. Because the images from science-art competitions travel online, their original text is responsible for setting the groundwork for reception in alternate contexts.

As Susanna Priest contended in *Investigating Science Communication in the Information Age*, "much of science communication will capture audiences only if it also meets other needs—if it entertains as well as informs."[25] I argue that this dual objective for communicating science to nonexpert publics is a first step: to be successful, popular science images must entertain and inform. More elaborate criteria are still needed, however, and, as digital media are a relatively new territory for scholarly exploration, there is not yet a solid set of criteria for evaluating digital images. For a starting point, I look to the extant scholarship on popular science images, which provides a foundation for evaluating the science-art images, and lay out a possible framework in the epilogue.

PORTAL POTENTIAL UNREALIZED: THE NATIONAL SCIENCE FOUNDATION'S VISUALIZATION COMPETITION

When images travel from their points of origin on the Internet, issues arise regarding accuracy, meaning-making, and actual versus intended audiences—questions that should be particularly pressing to scientific organizations that have an online presence. I evaluate the NSF's visualization competition, considering the images in conjunction with their captions. After briefly stating what the captions accomplish in their current state, the rhetorical work that they perform, I then offer a critique of the competition's practices. I should note that, in my visual analyses, I do not claim to offer the final word on what the images "mean" to everyone; on the contrary, I acknowledge that people perceive images differently, and my aim is to both show possible interpretations and be transparent in my approach.

Beginning in 2006 (see figure 16), first-place visualizations were printed on the cover of *Science* magazine[26]—that was the reward promised to scientists and artists who participate in the Challenge. In 2014, AAAS was replaced by *Popular Photography* as the cosponsor of the competition, and the title was changed to "The Vizzies." Instead of appearing on the covers of *Science,* award-winning images can now earn a place on the cover of *Popular Photography,* a magazine that is published by the megalith Bonnier Corporation. In what follows I consider the competition prior to the change in cosponsor, although the stated purpose of the competition has remained the same: to bridge the gap between the field of science and the so-called general public[27] by encouraging and rewarding the creation of aesthetically pleasing images that also serve a supposedly didactic purpose:

In a world where science literacy is dismayingly rare, illustrations provide the most immediate and influential connection between scientists

and other citizens, and the best hope for nurturing popular interest. Indeed, they are now a necessity *for public understanding of research developments.*

The National Science Foundation (NSF) and *Science* created the International Science & Engineering Visualization Challenge to celebrate that grand tradition—and to encourage its continued growth. The spirit of the competition is for communicating science, engineering and technology *for education* and journalistic purposes.[28]

As the italicized portions of the text indicate, there is a clear intention to "educate the public" along with "nurturing popular interest." Granted, the idea that "the public" can be "educated about science" is inconceivable, given the complexity of the sciences and the stratification of nonexpert audiences—and this argument has already been made by science communicators.[29]

NSF's criteria for judging images are available on the competition website,[30] and their brevity and lack of depth point to a need for a more cohesive framework for visual analysis. There are three criteria listed: *visual impact, effective communication,* and *freshness/originality. Visual impact* is defined in accordance with the artistic tradition, referring to elements of visual design such as composition, balance, line, and tone, but it does not operationalize these terms. The criterion of *freshness/originality* is defined in vague terms as an image "having a voice" and "telling a compelling story." The definition of *effective communication* begins to address important issues, given the intended audience: "A successful entry communicates in a clear and understandable manner, using plain language throughout, both written and spoken, in the entry itself and its accompanying text."[31] On the whole, more detailed criteria would help position popular science images as portals into science for uninitiated public audiences. The first three award-winning *Science* cover images (from the 2006, 2007, and 2008 competitions) are analyzed here in an effort to expose the reality behind the façade: that the treatment of these images does not align with the stated purpose of the competition. Successfully transforming scientific visualizations into portals for nonexpert audiences requires adequate contextualization.

Beginning in 2006, when award-winning images could earn a place on the cover of *Science* magazine, there were also brief *Science* "special feature" articles devoted to all of the award-winning images for that year. The very first Visualization Challenge image to be featured on the cover of *Science* in 2006 (figure 16) appears to be a group of metallic or glass figurines on a reflective surface. In the special feature article in *Science,* the cover image is revealed to be a depiction of five "mathematical surfaces." The writers of this feature article proudly say of this image, "It is beautiful. It can capture the imagination of nonscientists."[32] But

Fig. 16. "Mathematical Surfaces." Cover of *Science*. September 22, 2006. Created by Luc Bernard and Richard Palais. Reprinted with permission from AAAS and the artists.

the importance for nonscientists in understanding five oddly shaped metallic-looking figurines, or "mathematical surfaces," is never explained—nor is the innovation in the algorithm generating this image ever cited.

These cover images might appeal to the typical *Science* reader, but the writers of the Visualization Challenge guidelines explicitly say that the images are intended for *non*scientist audiences. The NSF and *Science* claim to have the education of nonscientists at the core of their competition, even though this audience does *not* constitute the general readership of *Science*. That audience is composed of experts and practitioners of related professions across the sciences. Therefore, putting award-winning images intended for nonexperts on *Science* magazine covers is not the most effective venue for public outreach (which may explain the recent switch to *Popular Photography*), but the competition organizers do release the images to more popular venues. Problems arise, however, with the contextualization of the images in both *Science* and in the new venues.

Obviously the *Science* cover illustrations are presented without explanatory captions, but genre conventions dictate that cover images be explained inside the magazine, whether accessed in print or online. That anchoring text in the source, *Science* magazine, then provides the fodder for accommodating the images in other venues when the images travel online.[33] Without such primary contextualization, an image is unlikely to receive more or better contextualization when it travels to other venues. The examples of the mathematical figures cover illustration and the award-winning cover illustrations from the subsequent (2007 and 2008) competitions illuminate this problem.

The special feature articles in *Science* magazine devoted to the Visualization Challenge that correspond to the award-winning images tend to be both brief and uninformative. For example, in the special feature corresponding to the five shiny figurines, the author very briefly explain that they represent mathematical

functions that we cannot see.[34] Although the article is written in a style that accommodates nonscientist readers, there is no explanation of what these functions are—neither scientific explanation nor accommodated elaboration can be found here. And while it is implied that the mathematical figures are in some way valuable because they are not typically visualized at all, let alone in a computer graphic that shows sophisticated imaging of reflective surfaces, the article does not explain why the visualization was worth doing. Thus, the article does a disservice not only to the nonexpert audiences it seeks to reach but also to the artists who created the image.

Part of the reason for the inadequate explanation is that the Visualization Challenge covers shared the special feature article with *all* of the award-winning images from that year's challenge—the images did not receive individualized treatment. As there were five different categories of visualizations and three different awards per category in 2006, the amount of textual explanation devoted to each image was minimal. As a result, the special feature articles typically did not offer any exigence for the images depicted—that is to say, they failed to connect the images to actual scientific breakthroughs or current events that would foster public understanding or even engagement. One of the Visualization Challenge judges cited most frequently in the special feature articles, Felice Frankel, admires the ability of these images to "create curiosity."[35] The problem is that there is not a full-length article or reference to other sources to satisfy readers' curiosity about the cover illustration. The brief description provided, grouped with descriptions of the other "Challenge" winners, does not address the issue of why general audiences *should* be interested in or curious about, for example, mathematical surfaces.

When the image travels to other venues of publication online, it has the potential to be recontextualized; it has the potential to be accommodated, explained in a new way that emphasizes the value of the image to nonscientist audiences. Two venues to which the mathematical surfaces traveled are *Plus,* an online mathematics magazine, and "Science Dude," an Orange County newspaper column.[36] The *Plus* article leads mathematically inclined readers to a more thorough explanation of the surfaces. However, *Plus* magazine may be too specialized for nonexpert audiences, as it concludes with a statement about the "general public" as separate from its own readership: "these sorts of visualizations have an important role to play both within the mathematical community, and in helping that community reach the general public."[37] As with the initial *Science* special feature article, reaching the general public is not on the agenda for the *Plus* article. What the Plus article does provide, however, is a better example of contextualization for the image—what the *Science* special feature article could have contained.

Fig. 17. "Chondrus Crispus." Cover of *Science*. September 26, 2007. Created by Andrea Ottesen, PhD, CFSAN, FDA. Reprinted with permission from AAAS and the artist.

To find an attempt at truly public outreach, one might turn to a publication like the *Orange County Register,* which is read by a wide audience of scientists and nonscientists alike (at least, in Orange County). The "Science Dude" column has the capacity to capture the interest of the general public, the NSF's intended audience. There is an opportunity here to explain what the mathematical surfaces are and why people should care about them.[38] Unfortunately, the short two-hundred-word article, half of which is quoted directly from the *Science* article, simply congratulates the mathematician and graphic designer who created the visualization; seemingly, the image won an award not because of its potential appeal to nonexpert audiences but because it shows state of the art digital visualization. Still, the point to be taken is that the *Orange County Register* article refers back to the *Science* article, indicating that the source article must be thorough if the images are to have any chance of being accommodated for nonexpert audiences.

The mathematical surfaces in figure 16 are just one example in a trend of Visualization Challenge images that do not receive adequate contextualization. The *Science* covers representing subsequent Visualization Challenges differ in content, complexity, and reception in other venues, but they all illuminate the operation and limitations of the Challenge. In the case of the 2007 cover illustration (figure 17), for example, there is less of an issue explaining the content of the image in the *Science* special feature, perhaps because of its relative simplicity, and more of an issue justifying its relevance to the field of science.

After appreciating the image's simplicity and symmetry, one can open the magazine to find out that it is a photograph of *Chondrus crispus,* or Irish sea moss. And, turning to the special feature article, one learns that the beautiful symmetry of this sea moss is an artificial construct—that the photographer, Andrea Ottesen, went to great lengths to press the curled ends of the seaweed

down with stones and then to let it dry for two days before photographing it.[39] Ottesen is quoted in the special feature article, explaining that "If you pull *Chondrus* out of the ocean, it's folded on itself—really curled up."[40] One must ask, then, at what point a scientific visualization ceases to be scientific in the sense of accurately depicting an object as it exists in nature. Interestingly, Felice Frankel is also quoted in the feature article about Ottesen's artistically rendered sea moss, recounting the judges' initial reactions to her photograph: "There was this gasp when this photo came up on the screen. We shouldn't forget that we don't need [complex equipment and techniques] to create beautiful representations."[41] Her comment attests to the persuasive power a beautiful visual can have over an audience: in a special feature article from the previous year, Frankel urged the other judges to think critically about "what makes an *honest* and success-ful representation and raising our standards."[42] The Irish moss on the cover of *Science* is certainly beautiful, but it is not an *honest* representation of the seaweed found in nature, as Ottesen explains that she manipulated the moss to achieve the aesthetic effect of radial symmetry. In selecting the image for representation in a scientific competition, the NSF arguably bears responsibility for answering questions such as the following: What is the point of having manipulated the image other than to create a more aesthetically pleasing photograph? What ends does changing the seaweed's appearance achieve for science? To make an informative as well as aesthetic display, the NSF could have depicted the beauti-ful, symmetrical image of the moss next to an image of it as it appears in nature.

Aesthetic alterations, as in the case of the Irish moss photograph, denote a highly rhetorical process. That is, certain elements of a scientific object (or process) are emphasized, while other elements are excluded, in order to make a visual statement. The message delivered by the Irish sea moss, for example, might be expressed as follows: "Natural objects can be simple and beautiful." The image of the sea moss is deemed valuable, according to the special feature ar-ticle, because of the work that went into manipulating the plant to achieve radial symmetry and the notion that the photographer has captured natural beauty. Her artistic skill is celebrated more than the scientific content of the image, but both deserve celebration. It could be said that the type of science promoted by the mathematical figures and sea moss reaches back to the trend of early natural history picture collections, a science of inventorying natural kinds. Otherwise, the way in which the NSF presents this image has very little scientific merit in terms of demonstrating research developments.

Just as the 2006 cover illustration of mathematical surfaces traveled to other venues of publication, so too did the Irish sea moss. The two cases are quite simi-lar: because the *Science* special feature article did not explain the significance

of the cover illustration and rather focused on its aesthetic appeal, the popular venues did not explain the relevance of the image to science, but they did associate the visual with a general scientific ethos. The image of the Irish sea moss appeared on TreeHugger.com, a blog devoted to sustainability and "green news"; on *Smithsonian* magazine's blog; and on *National Geographic's* "Best Science Images of 2007."[43] The author of the TreeHugger post, "Kelp Takes Our Breath Away," described the image as "fractal" and "otherworldly."[44] The *Smithsonian* blog set up a textual comparison between what the moss really looks like and what it looks like in Ottesen's rendition, a step in the right direction: "The slimy, glistening mass of seaweed washed up on a sandy beach seems light-years distant from this feathery, dendritic image of Irish moss."[45] But beyond their unique explanations of what makes this photograph visually appealing, these websites simply reproduced the information from the *Science* special feature article, offering no new insights as to what the general public might learn about Irish sea moss. For example, is this species of moss endangered, or does it play a unique role in the food chain? Besides its visual appeal, why did it earn a place on the cover of *Science*?

The science journalist Alan Boyle also wrote about this *Chondrus crispus* image in "Cosmic Log," a blog run by MSNBC devoted to science news, where a nonscientist might expect to learn something new about the subject matter of the award-winning photograph. However, instead of discussing the subject of Irish sea moss, Boyle focused on the "wow factor" of the image itself. He wrote, "Can you find beauty by looking up someone's nose, or inspecting a slimy mass of seaweed, or following the flight of a bat? Scientists can, and the proof is found in this year's annual competition for the coolest images in science and engineering."[46] Therefore, the "coolest images," not their further implications, were the subject of this article. Here is what Boyle wrote about the Irish sea moss: "Ottesen . . . snagged a bunch of the seaweed known as Irish moss from the Nova Scotia coast—then stretched it out, dried it and snapped a beautiful picture showing the plant's complex structure."[47] Boyle's "Cosmic Log" article did not offer any further insights into the potential role that these award-winning visualizations could play in the public's understanding of scientific research.[48]

The 2008 Challenge cover, which I am unable to reproduce here,[49] presents a different predicament from either of the other two cover illustrations in that it does not represent the winning visualization in its entirety; rather, what appears to be a bunch of blue cauliflower-shaped blossoms tangled up in vines turns out to be just a small detail from a larger composition titled "'Mad Hatter's Tea,' From Alice's Adventures in a Microscopic Wonderland," a combined effort

of the freelance illustrator Colleen Champ and the photomicrographer Dennis Kunkel.[50] Perhaps the cropped section of the image was chosen because of its standard elements of aesthetic appeal—a likeness to abstract art and a strong pattern of repetition. The *full* illustration (shown inside the magazine) is very cartoon-like; one would not expect an illustration like it to appear on the cover of *Science,* which is perhaps why it was cropped down extensively for the cover. Pictured in the full illustration are two beetles sitting at a picnic table having tea in a very whimsical looking field under a purple-hued sky. Champ and Kunkel's award-winning visualization received more attention in other venues than the cover illustrations from the previous two years: *The Huffington Post* and MSNBC both covered the full version of the illustration (albeit briefly), inviting blog postings that reflected peoples' desire to see more images like the "Mad Hatter's Tea."[51] Viewers posted comments such as these: "Those are really cool"; "I want to see more pictures!"; and "Stunning new imagery."[52] Some viewers were more specific about the aesthetic appeal of the images: "the rich and subtle colors; the anthropomorphic context with a dash of humor; great photography."[53] These blog posts and viewer comments attest to the fact that science images can and do appeal to nonscientist audiences in a variety of ways. The issue remains that they do not lead to any substantive information about how science works, given the types of responses they elicited. In other words, the NSF does not contextualize the images so that they can contribute to promoting scientific research. And, given the parameters set up in this book, the competition images cannot be considered effective portals, even though they seem to have all of the makings of portal images.

It is easy to claim that a visualization is designed to "communicate science" to public audiences, as the NSF does claim in its mission statement, but unless the relevance of the image to the audience is explained, it is not fostering "public understanding of research developments"; it is perpetuating a lack of understanding. In other words, the only thing that these science-themed images communicate is that subjects treated by science can be stunning from the perspective of aesthetics, but this impression could also unwittingly communicate that science it is beyond the reach of nonexperts. It seems that the more beautiful the images are, the more unapproachable they become. Nonscientists can look, but they cannot touch. Because the award-winning visualizations are imbued with scientific ethos but are only tangentially scientific and are primarily aesthetic, they could not possibly be expected to communicate science or contribute to "public understanding of research developments." It is all the more pressing for national organizations to set an example of responsible visual science communication because they are the role models for smaller-scale science-art competitions.

THE CONSEQUENCES OF SETTING A BAD EXAMPLE:
SCIENCE-ART COMPETITIONS IN ACADEMIA

Many university-sponsored science and art competitions that were quite obviously modeled after the NSF's started up in the United States and abroad. There is growing interest in the scientific community in ways to communicate visually, especially by using computer visualization techniques. Some of the science-art competitions I discuss in this section have garnered attention outside their institutions' walls and received recognition on well-populated science blogs. Whether or not they find fame outside their institutions, these smaller-scale competitions are still publicized in their local communities. Arguably, smaller-scale science and art competitions are in an even more influential position than competitions run by large scientific organizations because they are poised to reach out to and generate interest from community members who have closer ties to the participants; thus, they craft a particular image of the scientific enterprise from the bottom up.

Clemson University is one example of an institution that began a competition by taking a leaf out of the NSF's book. "Science as Art: A Visualization Challenge" was launched by the university in 2006, the same year *Science* magazine started featuring award-winning visualizations from the Challenge on its covers, which then spread across the Web. According to the main webpage, the images solicited by Clemson's competition come from "laboratories, workspaces, learning environments," and they are intended to be "powerful and inspiring."[54] According to the competition organizers, "Images that researchers produce as a part of their endeavors can be truly outstanding in terms of artistic beauty as well as inherent scientific merit."[55] Moreover, on the main page there is a quotation from Einstein about beauty and intrigue: "The most *beautiful* experience we can have is the *mysterious* . . . the fundamental emotion which stands at the cradle of true *art* and true *science*."[56] Thus, framing the competition is the notion that, through a merger of art and science, mystery and beauty are realized.

Clemson has its own equivalent of the "challenge synopsis" provided by the NSF's website and its own mission statement, but the overarching goal remains the same: to foster public interest in scientific research. The competition mission is described as follows: "Visual representations of scientific discoveries and concepts provide a valuable connection between scientists, artists and the general public."[57] Visual representations of "scientific *discoveries* and *concepts*," as opposed to visual representations of just "science," promise a thoroughness that is not realized in the captions for the images, as I will show in what follows.[58] The

Fig. 18. Lee Sierad, "Thrombousthai." 2010 Clemson University Science as Art Competition. Reprinted with permission from the artist.

lack of precision in the area of contextualization is not surprising, given Clemson's role model, the NSF's Visualization Challenge. The influence of the larger competition on the smaller is evidenced by Clemson's "Guidelines" webpage, which asks potential participants to first "see the NSF Science Visualization 'Frequently Asked Questions' website for more specifics."[59] Like the larger Challenge, Clemson's competition has several different categories for submission: illustration, photography, informational graphics, 3-D, painting, and noninteractive media.[60] All of the images have a place on Clemson's website, awarded or not, and all of them are accompanied by brief textual descriptions, previewed by placing the cursor over the thumbnail and shown in full when the specific image is clicked on. However, these descriptive captions, written in language easily accessible to a broad audience, generally skimp on information.

Take figure 18, titled "Thrombousthai,"[61] for example, which won first place in the photography category in 2010. This image, by then-doctoral student Lee Sierad, is reliant upon the following caption: "A partially activated platelet investigates the terrain . . . Every time you cut yourself, platelets help stop the bleeding. Suspended in action, this platelet has begun morphing from its quiescent state into a fully activated platelet that will release many clotting factors into the blood stream. These factors make it possible for the paper-cut you received yesterday to stop bleeding and become little more than a minor inconvenience today, reminding you of the impressively intricate design of our bodies."[62] On a positive note, the activation of platelets is well described for a general audience, addressed directly to them and put into a "real life" context ("the paper-cut you received yesterday"). But, the image itself—the amorphous shape, the texture of its background, the method by which the photograph was taken, and even the title of the image—is left unexplained by this caption.

Notice the first sentence, however. What seems to be the beginning of the explanation of the image itself is followed by an ellipsis, as if the description has been purposefully truncated for Clemson's website. There is no option to click for a longer description. For some reason, it has been omitted from general viewing, and so the image and its caption are in a permanent state of disjuncture. Though viewers can "share on twitter" and post about the image on Facebook, both linked at the bottom of the webpage, they are not told what exactly they are looking at, and nobody else on these social networking sites could have known, either, if viewers did indeed spread the word.

Because these social networking cites require joining or logging in to see whether people did share their thoughts about "Thrombousthai," it is not always possible to learn what viewers found visually appealing about this award winner. It would not be difficult to speculate about what qualities earned this image a first-place award. Much like the Irish sea moss in the NSF competition, the free-form shape almost glows against a dark background, creating a distinct contrast, contrast being a visual quality that generates intrigue. Even more captivating than the sea moss composition, this composition shows the platelet shape against a background that conveys movement: the wavy lines underscoring the platelet indicate movement on a downward diagonal. And the platelet itself, because of its curved extremities and the play of shadows on its surface, also looks as though it was caught mid-movement. A still image that is able to convey both three-dimensionality and movement is bound to be captivating. However, after appreciating the visual appeal of this image, viewers might wonder about the significance of the flecks, and there are no clues provided as to the significance of the scale.

Although mystery and beauty might be enough to "connect" with the "general public," as Clemson states on its main webpage, the brief caption that accompanies the image can secure only a superficial connection. And, although Clemson offers viewers the option to spread the word about their "Science as Art" competition on social networking sites, their winning images have not received recognition outside Clemson-affiliated websites. It seems that the impact of this competition has remained relatively localized, though the sponsors of the competition—Clemson University Research Foundation (CURF) and the Department of Engineering and Science Education at Clemson—have the option to broadcast their competition to a larger community via blogs. Princeton University, for example, takes matters into its own hands when it comes to advertising its visualization competition outside the local community.

Begun in 2005, Princeton's "Art of Science" competition has several sponsors within the institution from both the scientific and the artistic realms: the School of Engineering and Applied Science, the Princeton Plasma Physics

Laboratory, and the Arts Center all support the exhibition, which "explores the interplay between science and art."[63] Submissions come from departments across Princeton's campus from undergraduates, graduate students, faculty, research staff, and alumni.[64] The competition website is not as intricate or informative as Clemson's, and the guidelines and rules are not posted for viewers to see. However, Princeton's "About" webpage promotes the competition differently from either Clemson's or the NSF's challenges; according to Princeton organizers, the science is given prominence over the art and the motive for public outreach: "The 45 works chosen for the 2010 Art of Science exhibition represent this year's theme of 'energy' which we interpret in the broadest sense. These extraordinary images are not art for art's sake. Rather, they were produced during the course of scientific research. Entries were chosen for their aesthetic excellenceas well as scientific or technical interest."[65] There is no mention of creating bridges between the scientific community and the general public in the competition description, and there is no equivocation about the scientific merit of the awarded images—these are not representative of "art for art's sake" but rather were "produced during the course of scientific research." To be sure, Princeton is taking a step in the right direction by truly fusing science and art. In other words, Princeton is *not* enlisting scientists to conjure up aesthetically pleasing images divorced from scientific research. Moreover, the competition organizers develop a scientific theme for each year's competition to give focus to the images, rather than having a series of random visualizations from all subfields. Given these positive qualities, one might expect the images to be fully explained by rich textual descriptions, especially since the gallery of thumbnail images tells viewers to click on each image "to learn about the science behind the art."[66]

Three images are awarded a prize from Princeton each year, instead of the several first, second, and third place awards given out by the other two competitions discussed so far. All of the images on Princeton's website, awarded or not, are given a brief textual description, most of which are disappointingly uninformative. The image that won first prize in 2010, titled "Xenon Plasma Accelerator" (figure 19), by Jerry Ross, who was at the time a Plasma Physics Laboratory postdoctoral intern, is appealing because of its simplicity and symmetry (like Ottesen's sea moss photograph).

In this particular case, however, viewers do not learn what type of image they are looking at—is it a photograph? The description calls it a "picture":[67] "A picture of a Hall-effect thruster (plasma accelerator) plume. The Hall thruster is an electric propulsion technology that uses magnetic and electric fields to ionize and accelerate propellant. In this image the plasma accelerator is operating on xenon propellant."[68] This description, besides being very brief, provides a stark contrast to the description of the Clemson platelet image (figure 18) in that it

Fig. 19. Jerry Ross, "Xenon Plasma Accelerator." 2010 Princeton University Art of Science Competition. Reprinted with permission from the artist.

is not accommodated to a nonexpert audience. For instance, the audience for this caption is expected to know what a plasma accelerator does, what xenon propellant is, and what ionization by magnetic and electric fields entails. Of course, Princeton's competition does not purport to cater to "the public," as do the other two competitions. Its target audience is the scientific community at large, evidenced by the "press" link on its website detailing the proliferation of its award-winning images across the scientific blogosphere.

Some science blogs have featured news of Princeton's "Art of Science" competition and replicated the images. A bit of sleuthing reveals that Princeton has supplied the information to these blogs themselves, taking matters into its own hands to advertise its scientists' work. For example, at the end of the article on PhysOrg.com, there is a disclaimer that admits that the article was "Provided by Princeton University."[69] The authorless article provides a slightly more accommodated explanation of Ross's Plasma Accelerator: "The glowing plume we see in this photo is generated by a Hall-effect thruster-an electric propulsion technology that uses magnetic and electric fields to ionize and accelerate a propellant (in this case xenon) to produce thrust. These devices are used for a variety of space craft applications such as satellite stabilization."[70] In addition to the increased readability of the sentences in this description of the image, there is also a nod toward contextualizing the image—that is, mentioning what its broader implications are ("space craft applications").

Princeton's competition organizers have obviously done their work to circulate news of their event to scientific audiences in the blogosphere, but their images have found their way to other, nonscientifically run blogs as well, and the brief captions are unsuitable for broader audiences. One blogger actually reproduces the three award-winning images from Princeton's competition but entirely omits the captions; at the end of the blog post are links to the original

competition website and to a "physicsworld.com" blog post for those who wish "to read some extra information."[71] The "extra information," if readers follow the link, is not "extra" at all—in fact, the blog provides less information about the images than Princeton's writers.[72] Another blog, "io9," which "covers science, science fiction, and the future," reproduces the descriptions from Princeton's webpage.[73] The io9 blog post highlights the aesthetic appeal of the images over their scientific merit: it is titled "Black holes and xenon accelerators you'll want to hang on your walls." However, there is something to be said for the blog format: the people who commented on the post seem knowledgeable about the potentials of the plasma accelerator, posing questions such as, "So as far as practical applications are concerned this would really only be useful for sustained space flight?"[74] In other words, the blog format allows for discussions among community members.[75] Other inquiries and answers appear on this blog's discussion thread, showcasing the potential for blogs to facilitate productive discussions across Internet communities. These discussions, opening up the content of the image to further elaboration and speculation, also showcase the inadequacy of the original description of Ross's image provided by the Princeton competition organizers. It is probably fair to say that Princeton is using the competition for institutional self-promotion, rather than for public engagement with science.

Other universities besides Clemson and Princeton have hosted scientific image competitions; for example, the State University of New York at Oswego had its first "GENIUS Olympiad science and art competition" in April 2011, and the University of Florida had its third annual "Elegance of Science" art contest in February 2011. Across the Atlantic, the University of Nottingham hosted a "Science Image Competition," sponsored by SIGNET and the Center for Plant Integrative Biology (CPIB), in May 2011. Although the images from this competition did not travel through the blogosphere, the scientific organizations that sponsored the competition did reach out to the public, boasting on their webpage, "Over 200 members of the public voted for their favourite science image."[76] The descriptions for the award-winning images provided on the webpage, however, were not constructed for a nonexpert audience. For example, the first-prize image by Martina Marangoni from Biomedical Sciences, titled "Fluorescent neurons reveal their secrets," had the following caption primarily written in an expert register:

> YFP fluorescent neurons in the cortex layer V of an R6/2 mouse at 3-month age. R6/2 transgenic mice, model of Huntington's disease, were crossed with YFP-H mice that express a yellow fluorescent protein (YFP) in a subset of neurons. Fluorescent neurons can be traced

over long distance, from the cell body and dentrites to the axon. Anti-huntington aggregates immunostaining reveals the presence of big intra-nuclear aggregates and small extracellular aggregates. The image was acquired, in collaboration with Tim Self from ICS, with confocal imaging using a LSM 710 Laser Scanning Microscope.[77]

The image itself is similar to the "brainbow" image that received a great deal of media attention a few years before the University of Nottingham's competition for its depiction of neurons in mice in a way that resembles a fluorescent rainbow. The "over 200 members of the public" who voted for their "favourite images" in the University of Nottingham's competition obviously were voting on the basis of aesthetic criteria as opposed to scientific criteria, which is not clear from the caption. Presumably, the image's catchy title about neurons revealing their secrets is the only text that community members relied on during the voting process. The wild splotches of color that decorate the composition make it visually arresting. In this case, perhaps more than in any of the others, the mythos of Science is irresponsibly reinforced by scientific organizations to enlist public support for research, and no context is provided to explain the significance of the images to nonexpert audiences.

CONCLUSION

I have been asked whether scientific organizations' visualization competitions are producing what Nathan Yau refers to as "data art," and, at the time that I was asked this question, I had not yet come across his work. Now, having read Yau's *Data Points: Visualization That Means Something*, I can say that many of the award-wining visualizations do constitute "data art"—but only because the concept is very broadly defined; the lack of clear boundaries makes it seem as though all visualizations are welcome in the category, as long as someone has decided that they exhibit some aesthetically pleasing qualities. I will defer to Yau here: "Now enter the right side of the spectrum, where the imagination runs wild, data and emotion drive together, and creators make for human connection. It's hard to say what data art is exactly, but the work is often less about decision making and more about a relationship to the numbers—or rather what they represent—to experience data, which can feel cold and foreign. Data art is made of the stuff that analysis and information graphics could often use more of."[78] Although Yau does not provide a clear-cut definition of data art, he makes the point that "a visualization work can be art and factual."[79] I take this to mean that data art is a category of visualizations that are both aesthetically pleasing and informative. My interpretation is corroborated by his comment that "Although

these works were made for an art exhibit or to decorate people's walls, it's easy to see how they could be useful to some."[80] Yau's struggle to define "data art" supports one of the key arguments here, which is that a set of criteria is still very much needed in the realm of visual science communication.

The problems with these particular visualization competitions are that the award-winning images do not demonstrate relevance to science, demonstrate relevance to public audiences, and/or have informative and accessible captions to take with them to other venues. As to the first issue, the competition organizers missed a valuable opportunity to engage broad audiences with actual issues in science because of the types of images that they rewarded. For example, the NSF gave an award to an image of Irish sea moss, which was prized for the simplicity of its visual appeal, not for its scientific merit. Despite the competition's alleged mission to "communicate science" to nonscientists, it is not clear what exactly Irish sea moss would communicate to nonscientists about the current state of scientific research and development. The issue described here is thus a definitional fallacy: judges rewarded images on the basis not of clear scientific merit but rather, primarily, of aesthetic merit. An image that might exhibit both scientific and aesthetic merit, for example, is one of cancer cells reacting to the latest treatment that has been developed. Such an image might be used to restore faith in the power of scientific research and development, following Huppauf and Weingart's argument that science images participate in shaping public attitudes toward science. The content of the images, in other words, should be as important in the judging process as the execution of the images and the overall finished products: the competition judges could more clearly define—and abide by—a set of criteria devised by scholars of visual science communication. The second issue, relevance to public audiences, pertains to contextualization. Aesthetically pleasing scientific images aimed at nonexpert publics can serve as portals but, to be functional portals, they must make science explicitly relevant to the intended audience. Last, because these images derive much of their appeal from their indeterminacy, the text that accompanies them carries more of the burden of communicating relevance than it does in the other examples in this book. Without sufficient contextualization, these aesthetically pleasing images rely solely on their indeterminacy for their appeal, thereby mystifying science for uninitiated publics.[81]

The last point to make pertains to the spread of information online. The examples of award-winning images analyzed here did indeed spread to science blogs and online newspapers. However, given the capacity of content to spread online, images could earn far more recognition if competition organizers made use of the available means of persuasion for online discourse. The media studies scholar Henry Jenkins coined the term "spreadability" to refer to the ways in

which discourse gains a broad reception online. Jenkins explained that information no longer spreads in a top-down fashion only but, rather, according to a hybrid model that also includes the needs and wants of individuals and communities. According to Jenkins et al. in *Spreadable Media,* when people choose to share material, they make a series of culturally situated decisions: "Is the content worth engaging with? Is it worth sharing with others? Might it be of interest to specific people? Does it communicate something about me or my relationship with those people? What is the best platform to spread it through? Should it be circulated with a particular message attached?"[82] In other words, scientific organizations like the NSF could benefit from learning more about their intended audiences, the conversations they are having about both science and nonscience-related issues, and crafting captions for images that amalgamate scientific conversations and conversations that their intended audiences are already having.

Given the technologies available, aesthetically pleasing scientific images *could* be portals—upgraded, modernized versions of the portal images discussed throughout this book. The point of a digital portal image is to go beyond surface-level, aesthetic appeal and to lead viewers into the territory of scientific subject matter. Popular science images on the Web are not making use of the available means of persuasion and therefore are not being used to their fullest potential. Instead, the scientific community has circulated aesthetically pleasing images without a clearly articulated message tailored to nonscientist publics that both accounts for their values and promotes the science behind the images. By allowing these images to travel without context on the Internet, competition organizers are propagating the notion of science as having a mythic ethos rather than making it more approachable to nonexperts. The indeterminacy of such images mystifies science in the public eye, furthering the separation of science from society. In the epilogue, I offer commentary on creating spreadable media as well as criteria for developing scientific portal images that reflect the values of both scientific communities and the publics they seek to engage.

Epilogue

•••••••••••••••••••••••••••••••••••••

For the past few years, Google has featured variations on its homepage "doodle" such that the letters in "google" become integrated into a visualization commemorating a famous person or event. When Internet users place their cursors over the doodle, the name of person or event being celebrated pops up in a text box. If users want more information about said person or event, they can click on the Google doodle and will be transported to another webpage containing an informational article, or some other sort of textual description. On the occasions in which the Google doodle becomes a commemorative or celebratory visual, it serves as a portal image in exactly the sense that I have been using that term throughout this book: it is a captivating image that leads viewers to further information about a particular subject. It has the potential to frame viewers' interpretations of the person or event that it represents and put them in a particular state of mind to receive textual information about the subject. Moreover, in a digital environment, portals have the capacity to reveal information in stages: first, viewers see the image alone; then they can obtain a title for the image by hovering over it; and finally, they can learn much more about it if they click on it and allow themselves to be transported to another webpage containing textual information. Rather than contributing to the mystification of science in the public eye, scientific portal images, such as those awarded in science-art competitions, could function in much the same way as the Google doodle and lead viewers to further, relevant scientific content.

The consequences of mystifying science in the public eye have been studied in relation to textual genres by scholars in fields such as rhetoric, history, communication, and science and technology studies (STS). Mystifying science continues to position it in "a realm apart," as Sarah Perrault put it in *Communicating Popular Science,* and doing so only creates more distance between science and society.[1] Perrault devised a way of mitigating the gap by relying on a new model for communicating science: Critical Understanding of Science in Public (CUSP). In her analyses of popular science texts, Perrault concluded that "science can,

in fact, be presented in a way that does justice to the complexities of the issues while also making them accessible to nonspecialist readers."[2] CUSP attempts to overhaul past models of communication that feature top-down approaches to "educate the public" in science. It is similar to what Susanna Priest advocated for in the *Bulletin of Science and Technology in Society*: "Critical Science Literacy." Both frameworks strive to create a culture of inclusion rather than exclusion around the scientific enterprise. The goal is to make scientific processes more transparent to uninitiated publics so that they can make more informed policy decisions.

Images have yet to be studied within the context of CUSP model communication, but this book takes strides in that direction. I have argued that portal images have as much potential to do harm as they have to do good, in terms of their contribution to mystifying science in the public eye. However, with a set of criteria in place, communicators could be poised to use images more responsibly and respectfully. At the very least, taking stock of past practices, as this book does, can provide insight into the ways we choose to use images today. In particular, images can be more purposefully positioned as portals for uninitiated audiences into unfamiliar discourse. To accomplish this aim, communicators would have to select images that are relevant to current scientific research and link them to accessibly written text that elaborates on both scientific and social exigencies.

CRITERIA FOR EVALUATING PORTAL IMAGES

Though few in number, the existing rhetorical studies of popular science images have alluded to criteria for effective visual communication with nonexpert audiences, and, when synthesized, they provide fodder for a framework to evaluate scientific images that are specifically aimed at these audiences. Three case studies in particular—all of which have been mentioned in this book—informed the criteria set forth here. First, in a study of images in E. O. Wilson's *Sociobiology,* Greg Myers considered how collections of science images and their accompanying text can be persuasive and powerful for nonscientist audiences. Second, in a study of museum exhibits, Jeremiah Dyehouse alluded to criteria for informative, educational science displays that serve both the scientific enterprise and uninitiated audiences. Dyehouse applied Jeanne Fahnestock's concept of visual rhetorical figures to museum displays to demonstrate how series patterning can encourage nonexpert audiences to accept scientific conclusions. The third case study that can assist in evaluating portal images is Kathryn Northcut's "Images as Facilitators of Public Participation in Science," in which she provided the criteria required for images to invite non-scientist audiences into scientific

discourse communities. Although it is not explicitly mentioned in their work, all of these cases—a "museum-like collection of images" (Myers);[3] an actual museum display (Dyehouse); and "widely-seen [sic]" images of scientific discoveries (Northcut)[4]—present what could be conceived of as portal images. That is, the cases are concerned with images in the service of science that function to introduce uninitiated public audiences to scientific information. In all of the cases, images are situated to persuade nonexpert audiences to engage with science, and they are used to both entertain and inform.

Combined, the insights of these scholars indicate that popular science images, to function in an informative as well as an aesthetically pleasing capacity, must do the following:

1. Demonstrate relevance to science;
2. Demonstrate relevance to public audiences; and
3. Be accompanied by informative and accessible captions.

These criteria should sound familiar because I used them to assess the images from science-art competitions in chapter 4.

Relevance to Science

Images should demonstrate relevance to scientific research if they are to be considered effective portals. Regarding museum displays, for example, Dyehouse noted that science visuals have the capacity to "articulate a complex position" on a scientific issue, provide contextualization for that issue, and present science as a human activity (as opposed to an error-free process).[5] The displays that Dyehouse examined are designed to show disagreements in the scientific literature so that visitors can be informed about how ideas in the sciences are disputed.[6] Northcut also posited that images can open the door, so to speak, to scientists' arguments on a given issue and allow publics "to examine, if not judge, the trustworthiness of scientists and their arguments."[7] These qualities contribute to the information value of an image to public audiences. Without resources to examine and judge the images as well as their surrounding arguments, audiences are positioned as outsiders; thus, to be effective—that is, to provide access to uninitiated audiences—the portal image must first demonstrate relevance to scientific research.

Relevance to Society

Images should demonstrate relevance to nonexpert audiences by making connections to daily life experiences. In "Accommodating Science," Fahnestock referred to this concept of appealing to an audience's already held beliefs and values as an "application" appeal. It is one of two appeals that Fahnestock found

to be used most frequently in accommodated articles, and it ought to apply to images of science aimed at nonexpert audiences as well. For example, in analyzing Wilson's *Sociobiology*, Myers pointed to the persuasiveness of images that allow viewers to create linkages between the "authority of science" and their everyday experiences. He wrote that "the work we must do to put all those pictures together is what makes the story they tell seem so powerful."[8] More than simply creating meaningful experiences for viewers, images of science can empower nonexperts, according to Northcut, who advocated for closing the gap between publics and experts to improve policy decision making.[9] She wrote, "Images can contribute significantly to public understanding about such complex issues, compelling the public to want to engage in the conversation."[10] Without a clear indication of social relevance, a scientific image is defined as being above or apart from society, positioning audiences as outsiders; thus, to grant access into scientific issues, the portal image must also have relevance to issues of value to nonexpert audiences.

Informative and Accessible Captions

Captions should be written in an accessible way (that is, minimal and/or well-explained technical terminology) so as to allow nonexpert audiences to assess the scientific arguments surrounding the represented phenomena, or they should provide viewers with the option to access further information about the subject. Accessibility is taken for granted by Dyehouse, Myers, and Northcut in their separate analyses—in all of their cases, it is ostensibly a given that captions are aptly "accommodated" for uninitiated audiences. In the cases I presented in chapter 4, however, it is clear that accessible captions are not guaranteed. Without accessible captions, a scientific image positions nonexpert audiences as outsiders who cannot understand what they are looking at; thus, to grant nonexpert audiences access to information, portal images must be accompanied by captions that clearly explain the represented phenomena and/or direct them to further information.

MAKING USE OF THE AVAILABLE MEANS OF PERSUASION: SPREADABILITY AND DIGITAL CULTURE

The historical examples of portal images in this book all made use of the available modes of image reproduction and visual communication of their time periods. In the eighteenth century, Carl Linnaeus made a decision that presages the NSF's decision to create a science visualization competition to reach out to nonscientist public audiences. Linnaeus wrote in the preface to the *Hortus Cliffortaus* that it was a shame more people did not pay attention to the study of

botany; plants, he argued, are important to everyone—not only do they aid in curing diseases, but they are beautiful. And, in keeping with the tradition of his time period, he included an elaborately designed frontispiece—a visual instantiation of the argument contained in his written preface—to orient readers to the coming material. Whether or not Linnaeus and his contemporaries were able to articulate a theory about the persuasiveness of visuals to serve as portals into written discourse, their choice to include frontispieces in their books is a sign that they were at least aware of the potentials of visual persuasion. The very notion of a frontispiece indicates that an image, seen first, can put readers in a particular frame of mind to receive the written discourse.

Digital communication has transformed the use of portal images in a way that previous advancements in technology did not. For example, reflecting on an earlier discussion, as significant as the invention of photography was to the communication process—creating the illusion of "being there," creating a shared viewing experience for mass audiences, reflecting cultural values—photography did not give a voice to the masses. But in the realm of digital communication, viewers are can be creators, commentators, and shapers of information. Viewers, in essence, determine whether an image is a portal in an Internet venue by deciding either to click on that image or to click to a different conversation. An effective Internet portal image, then, can be a portal in two senses: first, in the sense that has been defined in previous chapters—as an introduction to a larger concept or body of knowledge, an orientation mechanism—and, second, as a literal portal—a hyperlink to further content. Captions on the original website can entice viewers to click on the visual portals by beginning to weave a narrative of scientific conversations and culturally relevant information. With an overabundance of information and an array of visual stimuli, a Web environment makes visual communication a higher-stakes game; to gain the attention of viewers, a portal image has to both abide by the expectations for online communication and stand out as an artifact worth spreading.

Media studies scholars have already predicted that our culture will become increasingly tethered to technological devices and Web platforms that incite public participation.[11] In order to keep up with public demands and expectations for digital communication, the scientific community will have to learn to abide by what Howard Rheingold termed "'netiquette" in his book *Netsmart*. Essentially, this means learning the social codes and rules, implicit and explicit, of various social media platforms. According to Jenkins, Ford, and Green, creating content that is "spreadable" should be the ultimate goal for entities wishing to promote their agenda. Content is spreadable, the authors assert, "when it acts as fodder for conversations that audiences are already having."[12] Likewise, ease of access is paramount. Information must be accessible to the audience through

the use of what Jenkins, Ford, and Green termed "the integrated system of participatory channels and practices."[13] Cultural practices have evolved alongside audience expectations, as sharing technologies have become more available and user-friendly; more people now have access to and know how to use social media platforms and can participate in circulating material. Embracing participatory culture means, for example, increasing audience's capabilities for commenting on images and responding to their comments and questions.

Despite differences in time period, image reproduction technologies, audiences for science, and science as a discipline, the images addressed in this study were positioned as portals into science for uninitiated audiences—that is, they were in a position of primacy, relative to text, and served in an introductory capacity. In the best-case scenario, portal images would publicize scientific research developments and create meaningful connections between scientific communities and society. The reality, as depicted earlier, is that these introductory images, more often than not, contributed to the mystification of science in society.

Images that are valued for their aesthetic qualities alone, that have ties to science only by virtue of their emergence from a scientific organization, are not portal images. Rather, they are representative of an older school of thought, which is antidemocratic in that it depends on the public's lack of expertise to "wow" them into supporting scientific research. Such an approach upholds a hierarchical model of communication, keeping the divisions between scientific communities and nonexpert publics intact, and thus impedes progress. It serves no one. If visual science communication is to become useful—that is, if it is to be used to alleviate divisions rather than exacerbate them—a set of best practices is required that elevates public participation, values public input, and makes the world of science relevant and transparent in the process. The persuasive power of images can be harnessed to demystify science in the public eye.

NOTES

INTRODUCTION

1. Huppauf and Weingart, *Science Images*. This edited collection contains essays representing all of the science image categories Huppauf and Weingart identify in their introduction. These studies present apt starting points for further research.

2. Ibid., 6.

3. Ibid. Huppauf and Weingart set up a taxonomy of public science images in their Introduction. They, too, make the distinction between visualizations and images aimed at broader public audiences.

4. Baigrie, *Picturing Knowledge;* Ellenius, *The Natural Sciences;* Fahnestock, *Rhetorical Figures;* Gross, "Toward a Theory"; Gross and Harmon, *Science from Sight;* Lynch and Woolgar, *Representation in Scientific Practice;* Pauwels, *Visual Cultures;* Rudwick, "The Emergence." Of these studies, Gross and Harmon's *Science from Sight* offers the most comprehensive framework for analyzing scientific visualizations in expert texts, solidifying the fact that visualizations are essential components of scientific argumentation.

5. Gross and Harmon, *Science from Sight;* Fahnestock, *Rhetorical Figures.*

6. Ceccarelli, "The Rhetoric of Science and Technology." "Internal" and "external" rhetorics of science are Ceccarelli's terms.

7. See, for example, Barton and Barton, "Modes of Power"; Dragga and Voss, "Cruel Pies"; Manning and Amare, "Visual-rhetoric Ethics"; Rawlins and Wilson, "Agency and Interactive Data"; Tufte, *Envisioning Information.*

8. Tufte, *Beautiful Evidence;* Tufte, *Envisioning Information;* Manning and Amare, "Visual-rhetoric Ethics."

9. Frankel, *Envisioning Science.*

10. Bizony, "The Great Divide," 43.

11. National Science Foundation, "About the Visualization Challenge."

12. Strain, "Caption."

13. Often, the term "the gap" is used to refer to the problematic relationship between science and society. The term is traced back to C. P. Snow's famous Reed Lecture: Snow, "The Two Cultures."

14. See, for example, Christensen, *The Hands-On Guide;* Kahlor and Stout, *Communicating Science;* Russell, *Communicating Science.*

15. See, for example, Borchelt and Hudson, "Engaging the Scientific Community"; Davies, "Constituting Public Engagement"; Priest, "Critical Science Literacy."

16. See, for example, Borchelt and Hudson, "Engaging the Scientific Community"; Davies, "Constituting Public Engagement." See also Kohut et al., *Scientific Achievements*. The Pew Research Center Poll on Science and Society conducted in 2009 relied on a twelve-question quiz to determine how much of "the public" is "scientifically literate." These questions ranged from subjects like "how a laser works" to whether or not electrons are smaller than atoms (Kohut et al., *Scientific Achievements,* 50). What is more, the Pew Research Center asked Alan I. Leshner, chief executive officer of the American Association for the Advancement of Science (AAAS), to write a commentary on the poll's findings, and, in it, deficit-model rhetoric abounds: "As scientists we must resist the urge to wring our hands in defeat or recoil at evidence of the public's lack of understanding about science" (56). Granted, Leshner made his remarks four years prior to the publication of the CUSP model. However, his comments were also published long after the Deficit model had already been repudiated and replaced by what is often called Public Engagement with Science. In the article in *Science Communication,* the theorist Sarah Davies confirms that, as of 2013, the shift away from the deficit model in the scientific community "has not been a homogeneous move" (690).

17. See Perrault, *Communicating Popular Science,* and Priest, "Critical Science Literacy," respectively.

18. Hill and Helmers, *Defining Visual Rhetorics;* Grabe and Bucy, *Image Bite Politics.*

19. Barry, *Visual Intelligence;* Grabe and Bucy, *Image Bite Politics.*

20. See, for example, Barthes, *Image Music Text;* Mitchell, *Iconology.*

21. According to research in visual literacy, however, that simply is not true. Visuals are processed cognitively, and work has been done to demonstrate their persuasive capacity. See especially Barry, *Visual Intelligence,* and Barry, "Science and Visual Communication." See also Stephens, *The Rise of the Image,* and Grabe and Bucy, *Image Bite Politics.*

22. Barry, *Visual Intelligence;* Grabe and Bucy, *Image Bite Politics;* Stephens, *The Rise of the Image.*

23. This is an issue discussed extensively by Barry, *Visual Intelligence.*

24. See, for example, Dyehouse, "'A Textbook Case'"; Northcut, "Images as Facilitators"; Huppauf and Weingart, "Introduction."

25. There are books that consider the merger of art and science from art historical and sociological perspectives, such as Ford, *Images of Science;* Ellenius, *The Natural Sciences;* and Baigrie, *Picturing Knowledge.* These studies, though important in their own right, do not consider how popular science images are persuasive on behalf of science. Most recently, Huppauf and Weingart's collection, *Science Images and Popular Images of the Sciences,* takes a range of perspectives on both popularizations and visualizations in research reports. From a specifically rhetorical perspective, there are case studies of popular science images, most notably from Myers, "Every Picture Tells a Story"; Northcut, "Images as Facilitators"; and Dyehouse, "A Textbook Case." These case studies take current (as in twentieth century on) subjects into consideration. Their work is foundational to this book, which attempts to make a contribution to the nascent body of literature on popular science images by sampling them from the seventeenth century to the twenty-first.

26. Barthes, *Image Music Text*, 38–41.

27. Kress and van Leeuwen, *Reading Images*, 17.

28. As of this writing, there is not, to my knowledge, a theory on effective captioning of images.

29. The *Rhetorica ad Herennium*, composed in the first century B.C.E., is the earliest Roman treatise on rhetoric. Its true author is unknown, but the text was long attributed to Cicero. The *Rhetorica ad Herennium* provides a thorough overview of "best practices" for constructing an exordium tailored to different situations and types of audiences. For example, in "difficult" cases that often alienate the audience, the rhetor has to gain the audience's sympathy before deploying the main arguments; in "obscure" cases, the audience is typically uninformed or the subject matter is beyond its grasp, and the rhetor's task is to explain the essence of the case briefly and in simple language before delving into the subject matter. See [Cicero], *Rhetorica ad Herennium*.

30. Genette, *Paratexts*.

31. Schriver, *Dynamics*, 424–25.

32. Ibid., 424.

33. See, for example, Damasio, *Descartes' Error*.

34. Grabe and Bucy, *Image Bite Politics*, 6.

35. Barry, *Visual Intelligence;* Grabe and Bucy, *Image Bite Politics;* Stephens, *The Rise of the Image*.

36. Hill and Helmers, "Introduction" to *Defining Visual Rhetorics*. For more on visual arguments, see the issue of *Argumentation & Advocacy* (1996) that is entirely dedicated to the argumentative capacity of images. It is worth noting that there is disagreement over whether visuals can make arguments. Those who claim that images cannot make arguments believe that images cannot inherently contain propositional material as well as evidence (see, for example, Gross, "Toward a Theory"). Truly, it comes down to how one defines "argument." Those who believe that visuals are capable of argumentation and persuasion take a looser view of what an argument is. For example, Wysocki and Lynch, *Compose, Design, Advocate*, take the position that arguments are any acts of motivated communication that prompt some type of change in an audience, be it a shift in perspective or a desire to take action.

37. Blair, "The Rhetoric of Visual Arguments," 53.

38. Grabe and Bucy, *Image Bite Politics*, 54.

39. Ibid., 55. The concept is referred to as "visual primacy."

40. Coleman, "Framing the Pictures"; Grabe and Bucy, *Image Bite Politics*. These scholars cite Entman's definition of framing: "Framing is the process by which some aspects of an issue, event, or person are emphasized over others in such a way as to promote a particular causal interpretation, problem construction, or moral evaluation" (Grabe and Bucy, 98).

41. Messaris and Abraham, "The Role of Images." The authors argue that "The special qualities of visuals—their iconicity, their indexicality, and especially their syntactic excplicitness—makes them very effective tools for framing and articulating ideological messages" (220).

42. Dyehouse, "A Textbook Case"; Myers, "Every Picture Tells"; Northcut, "Images as Facilitators."

43. Pauwels, *Visual Cultures of Science,* 19.

44. Kress and van Leeuwen, *Reading Images;* Hill and Helmers, *Defining Visual Rhetorics.*

45. Hill and Helmers, *Defining Visual Rhetorics,* 9. The authors cite Genette, *Paratexts,* for this concept.

46. Hariman and Lucaites, *No Caption Needed,* 371.

47. Ibid.

48. See, for example, Brierly, *The Advertising Handbook;* Wells et al., *Advertising Principles & Practice.*

49. See, for example, Wells et al., *Advertising Principles & Practice,* 373–75. The principles of visual design, as they conceive of them, are "direction, dominance, unity, white space, contrast, balance, proportion, simplify." Others, such as Lester, *Visual Communication,* have labeled the principles differently, but, ultimately, the ideas remain intact.

50. See, for example, Dondis, *A Primer of Visual Literacy;* Kress and van Leeuwen, *Reading Images.*

51. Lester, *Visual Communication,* 178–82.

52. Priest, "Reinterpreting the Audiences." Priest argues that "much of science communication will capture audiences only if it also meets other needs—if it entertains as well as informs" (230). What is at stake in communicating science, she argues, is "no less than the future of humanity, in some cases, and in others no less than the character of future human society" (231).

53. See Fahnestock, "Accommodating Science," for her discussion of the "wonder" and "application" appeals used in accommodations of scientific research papers.

54. Gigante, "Accommodating Scientific Illiteracy"; Dyehouse, "A Textbook Case"; Myers, "Every Picture Tells"; Northcut, "Images as Facilitators."

55. LaFollette, *Making Science Our Own;* Nelkin, *Selling Science.*

56. See, for example, Doty, *Mythography;* LaFollette, *Making Science Our Own;* Nelkin, *Selling Science.*

57. Nelkin, *Selling Science,* 15–30.

58. Doty, *Mythography,* 92–93. Drawing attention to how science has achieved its privileged place in society, Doty explains, "When operating as a worldview, modern science rests upon a foundational (Cartesian) mythic story of reality, although this 'God's truth' story *claims* to be anything but mythical. We are so impressed with our scientific advances that we soon label as 'primitive' or 'unsophisticated' any viewpoints that call the underlying mythic frames of science into question" (92–93). In other words, science has maintained its privileged status by undercutting all ideologies that would reveal its mythicization.

59. LaFollette, *Making Science Our Own,* 16.

60. Nelkin, *Selling Science,* 30.

61. Ibid., 15.

62. Ibid., 30.

63. Ibid. Nelkin makes this point clear regarding how science is framed in the media.

1. FRONTISPIECES

1. A substantive introduction to the history of science is Bowler and Morus, *Making Modern Science*. For more specific disciplinary conventions, such as the evolution of the scientific article, see, for example, Gross, Harmon, and Reidy, *Communicating Science;* Cantor and Shuttleworth, *Science Serialized.*

2. William Whewell coined the term "science." Bowler and Morus, *Making Modern Science,* 4–5.

3. Sprat, *The History of the Royal Society.*

4. Schiebinger, "Feminine Icons"; Sheriff, "Decorating Knowledge"; Shteir, "Iconographies of Flora"; Steigerwald, "Figuring Nature."

5. Dickenson, *Drawn from Life,* 170–71.

6. Remmert, "'Docet parva pictura'"; Kaoukji and Jardine, "A Frontispiece."

7. Schiebinger, "Feminine Icons"; Shteir, "Iconographies of Flora." Whereas some studies acknowledge the persuasive power of a visual in an introductory position and its ability to convey information about a text faster than printed words (for example, Kaoukji and Jardine, "A Frontispiece"; Remmert, "'Docet parva pictura'"), these studies still tend to view frontispieces as detachable from their texts.

8. As mentioned in the introduction to this book, frontispieces would be considered "paratexts" in Gerard Genette's framework: Genette, *Paratexts.*

9. The catalogues are helpful for locating rare frontispieces in this vast genre that spans countries and centuries. See, for example, Johnson, *Catalogue,* vii.

10. The engraving process made it possible to reproduce these visualizations in every copy of the book. For more information about the engraving process, see Adhémar, *Graphic Art;* Ivins, *Prints;* and Zigrosser, *The Book of Fine Prints.*

11. Ivins, *Prints,* 18.

12. Burke, *A Rhetoric of Motives.* Burke's concept of identification requires the establishment of common ground with an audience, which would amount to starting with given information. Regarding visual communication, see Kress and van Leeuwen, *Reading Images.* Kress and van Leeuwen demonstrated how advertisements are situated such that given information appears on the right and new information appears on the left side of the composition.

13. Doty, *Mythography,* 18.

14. Jasinski, *Sourcebook.* Jaskinski explained, "Myths function as reference points or cognitive coordinates for the members of a culture or community" (383); Rawlins, "Mythologizing Change."

15. Doty, *Mythography,* 51.

16. The *Instauratio* was supposed to have six parts, but only the first two were completed, the first part being an extended version of Bacon's earlier *Proficience and*

Advancement of Learning (1605) and the second part being the *Novum Organum,* which comprises several aphorisms concerning the interpretation of nature. See Simpson, "Francis Bacon,"

17. Corbett and Lightbown, *The Comely Frontispiece,* attend to the symbolic import of Sir Francis Bacon's frontispieces from an historical perspective. The authors propose an overall meaning for the frontispieces; however, they do not consider the frontispieces in relationship to Bacon's own prefatory material.

18. Hind, *A History,* 138.

19. Ibid. As Hind put it, van de Passe was "ready to supply, in [his] modest but sound manner, any demands the publishers might make" (138).

20. Bacon, *Novum Organum,* 7.

21. Tanner, "Charles V and the Order of the Golden Fleece," 155–47; Corbett and Ligthbown, *The Comely Frontispiece,* 186–87; and Rosenthal, "Plus Ultra," 217.

22. Corbett and Lightbown, *The Comely Frontispiece,* 186.

23. Rosenthal has shed light on the origin of Charles V's motto and also has offered commentary on its usage after him. He wrote, "It would seem that Charles' motto had become a universal symbol for limitless ambition." See Rosenthal "Plus Ultra," 217.

24. See Tanner, "Charles V," 155. For a discussion of this motto "Plus Ultra" see Corbett and Lightbown, *The Comely Frontispiece,* 186–87.

25. Rawley was entrusted with Bacon's work after his death and was responsible for both publishing the *Sylva* and overseeing the frontispiece design. For more information on Rawley, see Rees, "Introduction," lxxiii–lxxxiii.

26. Catalogues of frontispieces point to these issues of agency; oftentimes, the illustrators or engravers are marked as unknown or anonymous. The most thorough catalogues were compiled by Arthur Hind, keeper of the prints at the British Museum in the mid-twentieth century, and finished by his apprentices after his death. See Hind, *A History.* See also Corbett and Lightbown, *The Comely Frontispiece.*

27. Rawley, "To the Reader."

28. Some might argue that Bacon's statement about not wanting to publish the *Sylva* was typical and meant to be an expression of humility. But the fact remains that the *Sylva* was an unfinished manuscript. Moreover, since Rawley was responsible for having it published, his preface—the text immediately following the frontispiece—is more appropriate for contextualizing the image than the independent semiotic system for images employed by Corbett and Lightbown.

29. Rawley, "To the Reader."

30. For example, the first experiment in Century I begins, "Dig a Pit upon the sea-shore, somewhat above the High-water mark, and sink it as deep as the Low-water mark"; the second experiment begins, "Take a glass and put water into it, and wet your finger, and draw it round about the lip of the Glass." The text continues on like this for "ten centuries." See Bacon, *Sylva Sylvarum.*

31. For a more detailed explanation of the process, see Ivins, *Prints,* 49. Because frontispieces were bound in separately, they could be engraved even when other images within the text were woodcuts.

32. Biographer Frans A. Stafleu wrote that Linnaeus himself had considerable artistic talent and therefore required that his "descriptive scientists" be able to draw well. Stafleu, *Linnaeus*, 22.

33. Stafleu, *Linnaeus*, 11.

34. For detailed explications of the frontispiece, see, for example, Broberg, "The Dragonslayer," and Dickinson, *Drawn from Life*, 170–74.

35. See, for example, Shteir and Lightman, *Figuring It Out.*

36. See, for example, Tibell, "Linnaeus Grows Bananas"; Broberg, "The Dragonslayer."

37. Linnaeus had been experimenting with the centigrade thermometer, which is depicted in the foreground. See Heller, "Introduction," 667.

38. This is Broberg's translation of Wandelaar's poem, which was written in Dutch. Broberg translated only the first few lines in his article. See Broberg, "The Dragonslayer," 37–38. The only other available English translation is by Klooster, "Explanation of the Frontispiece," 279, n. 141.

39. See Broberg, who explained in "The Dragonsayer" that the scene in the frontispiece is "possible to interpret (with the help of the explanation connected to it) as Flora being unveiled by Apollo, putting his foot on the dragon's head" (37). In his caption of the frontispiece, Broberg wrote, "In centre Natura, Flora, Cybele or Mother Earth, standing on the dragon or hydra of Hamburg is Apollo, Perseu or Linnaeus surrounded by representatives of the different continents" (38). For the same interpretation, see also Tibell, "Linnaeus Grows Bananas," and Dickenson, *Drawn from Life*. In these accounts, the authors indicate that readers would have recognized the figure as the god Apollo from Wandelaar's explanatory poem and their knowledge of classical symbols.

40. Linnaeus, *Hortus Cliffortianus*, 669. For the Latin, see Linné, *Hortus Cliffortianus:* "Creatum tam mirifice Hominem, sensibus & judicio instructum, quo ratiocinaretur de adstantibus, collocavit Creator in mirifico orbe, ubi nihil in sensus incurrebat praeter naturalia, praefertim planatarum mirae machinae, an ob aliam causam, quam ut ex opere pulcherrimo ductus Magistrum admiraretur? Veneraretur?"

41. Klooster, "Explanation of the Frontispiece," 279, n. 141. There are gaps where the Dutch is not translated, and the translation overall is not idiomatic. An alternative and equally rough translation might be: "So can Europe host to the circle of the year, with good honor when woven by the noblest of all crops, fruits, flowers have Asia, Africa and America to boast." For the Dutch, see Wandelaar, "Verklaaring van de Tytelprent": "Dus kan Europe hier den Ommekring van 't jaar/ Braveeren met Feestoen gevelochten by malkaer / Uit de alleredelste Gewassen, Vrugten, Bloemen/ Daar Azie, Afryke en Amerika op roemen."

42. Linnaeus, *Hortus Cliffortianus*, 673.

43. Ibid., 669. This is Heller's translation. For the original Latin, see Linné, *Hortus Cliffortianus:* "Homines hodie variae tenent deliciae; alii poculis generosis & cibis opiparis; alii palatorum splendore & vestimentorum fulgentibus crustis; alii picturis & dedalaeis operibus, armis antiquis & obsoletis alii, chinensibus testis & cochlearum mille modis variegates cucullis vero alii mentem fallaunt, falsaque occupant pulchritudinis imagine, dum brevis avolat hora; trahit sua quemque voluptas. Nullam tamen Ego

innocentiorem judicarem ea qua potius est creatus primus homo ea quae amicissimam mortalibus vitam sustentat. Sit hinc in plantis mea voluptas!"

44. Linnaeus, *Hortus Cliffortianus,* 670. For the Latin, see Linné, *Hortus Cliffortianus:* "Nulla pars medicinae, obstupesco dum dico verissimum, minus est exculta quam medicamentorum cognitio; nullibi plures errores, pluresque defectus quam in hac sola! caussa alia nulla quam neglectus simplicium, neglectus botanices."

45. In German, these titles are *Ideen zu einer Physiognomik der Gewächse* and *Ideen zu einer Geographie der Pflanzen.* There are a few variations to the title of this work. "Ideas for a Geography . . ." and "Essay on the Geography . . ." are more popular than "Ideas Towards a Geography . . ." but all of these translations correspond to the same work. See Humboldt, "From *Essay on the Geography of Plants.*"

46. See Humboldt, *Ideen zu einer Physiognomik der Gewächse.*

47. For a detailed account of his travels, see De Terra, *Humboldt,* 190–210.

48. Humboldt, "From *Essay on the Geography of Plants,*" 49–50.

49. According to De Terra, *Ideas for a Physiognomy of Plants* became a part of Humboldt's more comprehensive *Views of Nature* (*Ansichten der Natur*) in 1807—his most popular work, published in three different editions and translated into several different languages (208).

50. For more information about the goddess with a veil, see Hadot, "Isis Has No Veils," 349–53.

51. The design was then engraved by Raphael Urbain Massard. See Steigerwald, "Figuring Nature," 54, 79 n. 1.

52. Ibid., 79 n. 1. He visited his brother in the summer of 1805, after the French version of the *Geography* was published but before he delivered his lecture on the *Physiognomy* and published the German *Geography,* which explains why only the German version has the frontispiece.

53. Bukdahl, "Winckelmann," 227.

54. For the image and a more detailed account of the statue's history, see Galinsky, "The Apollo Belvedere."

55. The ancient Greek statue *Apollo Belvedere,* which now stands in the Cortile del Belvedere in the Vatican, was admired by Thorvaldsen's contemporaries as a representation of ideal beauty, and Thorvaldsen studied the statue closely. Bukdahl, "Winckelmann," 229.

56. De Terra, *Humboldt,* 58.

57. Steigerwald, "Figuring Nature," 66.

58. Steigerwald furthered this claim by making the connection between the figuring of nature in the frontispiece and the figuring of nature in Humboldt's maps and diagrams. This is a compelling point that is unfortunately not pursued in her essay. Instead, she wrote about the cultural significance of the imagery depicted in the frontispiece, asserting that "It should be read through the context of a fascination with ancient Egypt and cosmotheism, through the understanding of deities such as Diana as specific figurations of an indefinite cosmic divine power" ("Figuring Nature," 65). Ultimately, Steigerwald inserted Thorvaldsen's frontispiece into a catalogue of other similarly themed frontispieces

to construct an argument about Humboldt's personal convictions as they coincided with the cultural milieu of his time. Moreover, Steigerwald used the gendered portrayal of the unveiling of nature as a springboard for discussing fictional works such as Goethe's *Wilhelm Meister's Apprenticeship* (1795) and Schlegel's *Lucinde* (1799) and brought Humboldt's sexuality into her argument about how the frontispiece should be read (74–77).

59. Steigerwald removed the frontispiece from its context—that is, the book in which it appears, as well as other texts in Humboldt's oeuvre with which it is associated.

60. Hadot, *The Veil of Isis*, viii.

61. Ibid. In *The Veil of Isis*, Hadot explained that "The allegory was perfectly clear to educated people of this time" (viii).

62. Humboldt, "Ideas for a Physiognomy," 219. For the German, see Humboldt, *Ideen zu einer Physiognomik der Gewashse:* "Der Einfluss der physischen Welt auf die moralische, dies geheimnissvolle Ineinander-Wirken des Sinnlichen und Aussersinnlichen, giebt dem Naturstudium, wenn man es zu höheren Gesichtspunkten erhebt, einen eigenen, noch zu wenig gekannten Reiz" (14).

63. De Terra, *Humboldt*, 208.

64. The preface to their translation states: "Great pains have been taken with the present translation, as well in regard to fidelity and style, as in what may be termed the accessories." Humboldt, "Ideas for a Physiognomy of Plants," v. Bohn also described "the highly wrought and, it may be said, poetical descriptions, written in the Author's earlier years" (viii).

65. Humboldt, "Ideas for a Physiognomy," 215. For the German see Humboldt, *Ideen zu einer Physiognomik*, 9: "Diese Zunahme kann leicht von denen bezweifelt werden, welche nie unsern Welttheil verlassen, oder das Studium der allgemeinen Erdkunde vernachlässigt haben."

66. Humboldt, "Ideas for a Physiognomy," 212.

67. Humboldt, "Ideas for a Physiognomy," 213. For the German see Humboldt, *Ideen zu einer Physiognomik*, 5: "Unauslöschlich wird mir der Eindruck jener stillen Tropen-Nachte der Südsee bleiben, wo aus der duftigen Himmelsbläue das hohe Sternbild des Schiffes und das gesenkt untergehende Kreuz ihr mildes planetarisches Licht ausgossen, und wo zugleich in der schäumenden Meeresfluth die Delphine ihre leuchtenden Furchen zogen."

2. PORTRAITS OF SCIENTISTS AT WORK

1. "Biography of Linnaeus."

2. *Science Daily* bills itself as "Your source for the latest research news" and is set up like a news website, with headlines hyperlinked to articles on a wide range of scientific subjects. Tabs across the top of the main page link to articles on the following subjects: Health & Medicine; Mind & Brain; Plants & Animals; Earth & Climate; Space & Time; Matter & Energy; Computers & Math; Fossils & Ruins.

3. "New Role."

4. Kress and van Leeuwen, *Reading Images*, 108–9; Jordanova, *Defining Features*, 80.

5. Jordanova actually posits four functional possibilities for what she has called

"accoutrements": "They either provide visual interest, or follow established conventions, or convey information thought valuable to viewers, or act as symbols." Jordanova, *Defining Features*, 80.

6. This concept of a relationship between "represented participants" and viewers is explained in depth by Kress and van Leeuwen, *Reading Images*, 119–58.

7. Jordanova, *Defining Features*, 18, 20. The power of portraiture in shaping public identities for the viewing audience is also considered in a study of several portraits of the botanist/explorer Joseph Banks (1743–1820). See Fara, "Images of a Man of Science." Fara concludes that not only was Banks able to "restyle his own image," but, *through his portraits*, he also contributed to "transforming the stereotype of the English male traveler from the foppish aristocrat . . . into the masculine hero risking his life for the sake of England and of science" (42). In other words, Banks attempted to shape public conceptions of scientists through his own carefully styled, personal presentation. For example, in his 1772 portrait, commissioned from Joshua Reynolds, Banks appears at work in his study, posed with papers, a pen, and a globe next to him, which, Fara argues, follows in the style of medical practitioners' and architects' portraits to identify Banks as an intellectual man of science (46).

8. Perelman and Olbrechts-Tyteca, *The New Rhetoric*. Because the authors specifically say that they will consider the use of *language* only in persuasion (8), it is necessary to look to an expanded definition of presence, such as the one posited by Gross and Dearin, which encompasses visual persuasion. Gross and Dearin, *Chaim Perelman*. Perelman and Olbrechts-Tyteca acknowledge alternative forms of persuasion, particularly in propaganda, but set them outside the bounds of their treatise: "Our analysis will also neglect [these techniques]: we shall treat the conditioning of the audience by the discourse alone" (8–9).

9. This is opposed to a concept of presence that concerns isolated rhetorical techniques within an argument.

10. Atkinson, Kaufer, and Ishizaki, "Presence and Global Presence," 363, explain that Gross and Dearin's concept of presence is "explicitly multimodal."

11. Perelman and Olbrechts-Tyteca, *The New Rhetoric*, 178 (emphasis added).

12. Portable cameras with faster shutter speeds that replaced heavy equipment came into existence in the late 1920s with the German invention of the 35 mm Leica. The Graflex camera was another commonly used portable camera in the 1920s and 1930s. See Cookman, *American Photojournalism*, 94–97.

13. Although the camera replaced the paintbrush in the realm of portraiture, it took several decades before photography could eclipse painting and engraving in terms of its flexibility and cultural prestige in representing subjects. Because of the limitations of early photography—namely the requirement that subjects stand still for a substantial amount of time—it can be surmised that the *formal* portrait of the scientist was privileged in the late nineteenth century over images of scientists portrayed holding up flasks. The latter type of image, which persists as a stereotypical image of the scientist to this day, actually stems from the medieval image of the alchemist holding up a flask of urine to the light. See, for example, Ball, "The Origin," 17; Schummer and Spector, "Popular Images."

These drawings of scientists in situ could not be realized in photographs until technological advancements in photography took place in the early twentieth century.

14. Kozol, Life's *America*, 5–6.

15. Jacobi and Schiele, "Scientific Imagery," 749. It is worth noting that Jacobi and Schiele's study is limited to the types of photographs that appeared in popular scientific discourse, as opposed to publications with a more diverse readership, like *Life* magazine, which is the focus of my case study. Of the two magazines that Jacobi and Schiele used for their case study, one was described as "semi-professional" and the other, "popular" (734–35).

16. Ibid., 748–49.

17. Ibid., 750.

18. Ibid., 739.

19. Ibid., 737.

20. Kress and van Leeuwen, *Reading Images*, 119–58.

21. Ibid., 120.

22. de Chadarevian, "Portrait of a Discovery," 97.

23. Ibid.

24. Finnegan, "'Liars May.'" By attending to image vernaculars, Finnegan argued, rhetoricians could more aptly reconstruct the ways in which viewers understood and interpreted images (98). See also Finnegan, "Recognizing Lincoln."

25. *Life* was building on the tradition of documentary photography that began in the nineteenth century with notable figures such as Jacob Riis and continued into the twentieth century with the "iconic" photographs of Dorothea Lange and others. See also Barthes, "The Photographic Message," in *Image, Music, Text;* Mitchell, *Iconology;* Olson, Finnegan, and Hope, *Visual Rhetoric.* Roland Barthes, "The Photographic Message". Translated by Stephen North. New York: Hill and Wang, 1977. pp. 15–31. Lester C. Olsen, Cara A. Finnegan, and Diane S. Hope, Eds. *Visual Rhetoric: A Reader in Communication and American Culture.* Los Angeles: Sage, 2008.

26. Hariman and Lucaites, *No Caption Needed*, 9.

27. Kozol, Life's *America*, 7–11, 23–25; Cookman, *American Photojournalism*, 5–7.

28. Finnegan, "The Naturalistic Enthymeme," 135.

29. See, for example, Huppauf and Weingart, *Science Images*, 9. Robert Koch is one of the most frequently cited example of scientists who used the "objectivity" of photography to substantiate his projects in the mid-nineteenth century.

30. Daston and Galison, *Objectivity*, 18–19. These authors take visualizations appearing in scientific encyclopedias as exemplary of changing visualization practices and attitudes toward epistemological concerns. For more on the role of visualizations in scientific arguments, see, for example, Fahnestock, *Rhetorical Figures in Science;* Gross, Harmon, and Reidy, *Communicating Science;* Gross and Harmon, *Science from Sight.*

31. Daston and Galison, *Objectivity*, 18–19. For more on the subjectivity and manipulation of scientific visualizations, see, for example, Rossner and Yamada, "What's in a Picture?" For a completely different perspective, see Frankel, *Envisioning Science*, a monograph on the construction of aesthetically pleasing scientific images.

32. Barton, "Just before Nature," 5. See also Gross, Harmon, and Reidy, *Communicating Science*, 118.

33. Barton, "Just before Nature," 3. On the subject of popular science journals, see also Sheets-Pyenson, "Popular Science Periodicals," 555. Both describe popular science periodicals as undergoing a shift in purpose around the 1860s from encouraging amateur participation in scientific activities to deemphasizing participation in favor of simply garnering support for professional science. Also accounting for this change are Whalen and Tobin, "Periodicals," 198–99. Whalen and Tobin claim that the shift was the result of changes in editorship from small, self-appointed parties to larger corporate entities.

34. The "gap" between scientific communities and nonexpert publics is a concept credited to C. P. Snow, "The Two Cultures." For other current characterizations of the "gap" between the scientific community and the public, see, for example, Christensen, *The Hands-on Guide;* Nisbet and Scheufele, "What's Next"; and Russell, *Communicating Science.*

35. Lightman, "The Visual Theology," 652. Popular periodicals were not the only form of science popularization in the nineteenth century; much has been written on the subject of scientific spectacles, cabinets of curiosity, and public lectures that incorporated drawings. Besides Lightman, who has written prolifically on this subject, see, for example, Kuritz, "The Popularization of Science," and O'Connor, *The Earth on Show.*

36. Kronick, *"Devant le Deluge,"* 65; Gross, Harmon, and Reidy, *Communicating Science*, 120–21.

37. LaFollette, *Making Science Our Own.* Her study pertains not to photojournalism magazines but rather to mass circulation magazines in general, and so her characterizations of "images" of science and scientists are derived largely from articles. LaFollette's findings regarding public perceptions of science and scientists that are derived from textual analyses can also be applied to photographs from the same era.

38. Nelkin, *Selling Science,* 15.

39. Broks, *Understanding Popular Science,* 63, 67.

40. Ibid., 52–53. Science and scientists earned a respected place in society seemingly at the expense of nonexpert publics. See also Bensaude-Vincent, "A Genealogy," 100, 109. Bensaude-Vincent points to "science mediators" as being responsible for spreading the idea that there was a rupture between science and the public. Those responsible for communicating science to broad public audiences, she argues, ought to be held accountable for disenfranchising the public regarding science policy decision making by equating all science with nuclear physics during the cold war.

41. Broks, *Understanding Popular Science,* 75–77.

42. Ibid., 58–59, 80; Giddens, *The Consequences of Modernity,* 89.

43. Miller, "The Presumptions of Expertise," 194.

44. Ibid., 201. For a different perspective on scientific ethos, see also Walsh, *Scientists as Prophets,* in which she traces the prophetic ethos of scientists back to the oracle at Delphi. Walsh demonstrates the nuances of scientific ethos by examining how nonexpert publics and governing bodies put pressure on scientists to make predictions.

45. Giddens, *The Consequences of Modernity,* 89.

46. Miller, "The Presumptions of Expertise," 201.

47. LaFollette, *Making Science Our Own*, 4.

48. Nelkin, *Selling Science;* LaFollette, *Making Science Our Own*.

49. See, for example, Kozol, *Life's America;* Cookman, *American Photojournalism;* Hariman and Lucaites, *No Caption Needed.*

50. Kozol, *Life's America*, 5–6.

51. Luce, "Introduction," 3. Luce made use of the most up-to-date technology to ensure the highest quality images, and to earn wide circulation he successfully wooed advertisers to his project. Kozol, *Life's America*, 29–30.

52. Luce, quoted in Wainwright, *The Great American Magazine*, 90.

53. Finnegan, "'Liars May,'" 97.

54. Finnegan, "Recognizing Lincoln," 63.

55. The assertion that a magazine like *Life*—or any mass media publication, print or otherwise—is responsible for "constructing" public perceptions, however, has to be tempered. First, viewers' perceptions are constructed via multiple channels. Given the notion of an image vernacular, it can be said that viewers are participants in creating meaning, not passive witnesses (Finnegan, "Recognizing Lincoln," 63). Second, there is evidence from historical studies that mass media publications did not construct public opinions about science but rather reflected them (LaFollette, *Making Science Our Own*, 5). Analyzing thousands of science stories in eleven mass circulation magazines from 1910 to 1955, LaFollette was able to conclude that, "Although the attention to science . . . varied slightly among magazine types, the images of science and scientists did not differ significantly among the magazines studied, indicating that the images must have had deep roots in American culture" (5). To explain what she meant by public "images" of science, LaFollette referred to a quote by Walter Lippmann regarding "the pictures in our heads," which she said "affect public opinions about science and science-related political and social issues over the long term" (1–2). These "pictures in our heads" align with Finnegan's concept of an "image vernacular" in the sense that such pictures represent viewers' "tacit social knowledge" in the process of meaning-making ("Recognizing Lincoln," 62–63).

56. Cookman, *American Photojournalism*. Cookman contends that *Life's* downfall in the 1970s was in part the result of Luce's staunch conservativism and his stubborn commitment to an ideology that was no longer supported on a national scale (175–76).

57. Baughman, *Henry R. Luce;* Doss, *Looking at Life;* Littman, *Life: The First Decade;* Cookman, *American Photojournalism;* Kozol, *Life's America*. According to former *Life* staff member Loudon Wainwright in his "insider's perspective," by the 1950s Luce had handed over some of his editorial control to the new managing editor, Edward K. Thompson, so much so that "the people who worked under Thompson at Life thought of it as his magazine" (180). *Life* magazine's photographers pioneered candid photography, but, according to Wainwright, the managing editors had complete control over which photographs were published. For example, Thompson, by Wainwright's estimation, exercised control over every part of the publication process from the choice of stories, to the selection of images, to the layout, to the tone of the writing (180). Significantly, Wainwright argues that Thompson's editorial control and his ideology permeated the

finished product: "Because he was the kind of compulsively engaged editor he was—and the kind of inexhaustible and controlling man—almost every issue reflected his convictions, his tastes, his quirks, the way he saw America and Americans in the world" (180).

58. LaFollette, *Making Science Our Own.*

59. Every issue of *Life* has been made available online by Google Books. "Science" stories are not featured in every publication but in several—enough to make "Science" a category in the table of contents in issues where it does appear.

60. Although this section is focused on science stories with only one image of a scientist, these stories often contain other images—not of scientists but of a laboratory setting, for instance, or of scientific equipment.

61. As *Life* was a weekly publication, I sampled its "Science" section at five-year intervals, looking at a whole year's issues for 1936, 1940, 1945, 1950, 1955, and 1960. My rationale for sampling issues from *Life*'s inception through 1960 is based on historical accounts of the relationship between public audiences and the scientific enterprise that indicate that there was a distinct shift in public trust in science in the 1960s (see, for example, Broks, *Understanding Popular Science;* LaFollette, *Making Science Our Own*). Moreover, *Life*'s novelty as a visual news source diminished significantly after the advent of television, and I am interested in the magazine's portrayal of scientists and science when it was at the height of its popularity.

62. The other thirty-six stories contained multiple images of scientists, and there were often different types of portraits of scientists contained in the same story. For instance, in the March 21, 1955, science story, there are three traditional portraits, two pictures of scientists at work, two pictures of scientists posed with objects of study, and one picture of a group discussion. And in many cases, there is more than one type of depiction of the same scientist, as in the April 16, 1945, story, which contains one picture of the scientist at work and one picture of him posing with his invention.

63. Bowler and Morus, *Making Modern Science,* 470.

64. Ibid., 471.

65. Miller, "Learning from History," 295.

66. Ibid., 304.

67. Bush, "Science, The Endless Frontier." See also Broks, *Understanding Popular Science,* 77–78.

68. Miller, "Learning from History," 304.

69. LaFollette, *Making Science Our Own,* 15.

70. Miller, "Learning from History," 304.

71. Ibid., 299.

72. LaFollette, *Making Science Our Own,* 67.

73. Perelman and Olbrechts-Tyteca, *The New Rhetoric,* 287.

74. See, for example, Kress and van Leeuwen, *Reading Images,* 56–63.

75. "World's hottest furnace," 136–37.

76. Ibid.

77. LaFollette, *Making Science Our Own,* 12.

78. Broks, *Understanding Popular Science;* Giddens, *The Consequences of Modernity;* Miller, "The Presumptions of Expertise."

79. Miller, "Learning," 302.

80. LaFollette, *Making Science Our Own,* 108–9.

81. "Bubble blowing," 62.

82. Perelman and Olbrechts-Tyteca, *The New Rhetoric,* 90–91.

83. Aristotle, *On Rhetoric,* 64.

84. Luce, "Introduction," 3.

85. Ibid.

86. Gross and Dearin, *Chaim Perelman,* 151.

87. Henry Luce and his editors could have selected more traditional portraits of scientists for publication, ones in which scientists make eye contact and pose. If we extrapolate from the sample analyzed, it appears that a greater number of scientist-at-work portraits were selected for publication. This type of portrait might be useful for promoting awe and fascination with the scientific enterprise, as it invokes an ethos of expertise, but it is inevitable that an ethos of expertise will shift the message away from accessibility and toward exclusivity.

88. Kress and van Leeuwen, *Reading Images,* 126.

89. See, for example, LaFollette's study in *Making Science Our Own.*

90. Ibid., 158–73.

91. Ibid., 98. Whereas Jacobi and Schiele had no term for the "scientist at work," LaFollette's category of the "expert" most closely matches this category of scientific portrait.

92. Ibid., 101.

93. Ibid., 77. It seems fair to say that readers' experiences of scientist-at-work portraits can be understood through the dominant interpretations of science in the 1940s and 1950s that LaFollette characterized in her study.

94. Brooks, "Why the Scientist Stereotype."

95. Ibid.

96. Ibid.

97. Northcut, "Images as Facilitators," 9–10.

98. Jacobi and Schiele, "Scientific Imagery," 748–50.

3. POPULAR MAGAZINE COVERS

1. Nelkin, *Selling Science,* 15.

2. Ibid., 69–72

3. Johnson and Prijatel, *The Magazine,* 281.

4. See my discussion of the exordium in the *Rhetorica ad Herennium* in chapter 2. See [Cicero], *Rhetorica Ad Herennium.*

5. In the field of communication, rhetorically analyzing how the media frame issues and set agendas is called "framing criticism." See, for example, D'Angelo and Kuypers, *Doing News Framing.*

6. See, for example, Borchelt and Hudson, "Engaging."

7. See, for example, Barry, *Visual Intelligence;* Grabe and Bucy, *Image Bite Politics;* and Stephens, *The Rise of the Image.*

8. See Moran, "The Demise of *Scientific American,*" and Bernstein, "What Happened."

9. Fahnestock, "Accommodating Science," 278–79.

10. See, for example, ibid.; see also Baigrie, *Picturing Knowledge.*

11. The most popular type of printing used by magazines is offset lithography. See Wells et al., *Advertising Principles & Practice,* 379. The authors explain: "Offset printing uses a smooth-surface and chemically treated plane to transfer the image. Based on the principle that oil and water don't mix, the oil-based ink adheres to parts of the image but not to other parts. The offset plates are produced photographically."

12. Johnson and Prijatel, *The Magazine,* 281–86.

13. For more information about the editorial decisions regarding the cover art on *JAMA,* see Southgate, *The Art of JAMA.*

14. Grow, "Magazine Covers."

15. See, for example, Johnson and Prijatel, *The Magazine;* Grow, "Magazine Covers."

16. The idea to analyze magazine covers in conjunction with internal content could probably make for a separate, fascinating book project. However, it is unfortunately beyond the scope of this discussion.

17. Johnson and Prijatel, *The Magazine,* 281–86.

18. Lightman, "The Visual Theology," 652.

19. Kuritz, "The Popularization of Science," 266–67.

20. Sheets-Pyenson, "Popular Science Periodicals," 553–55.

21. Ibid.; Kuritz, "The Popularization of Science." See also Barton, "Just before Nature"; Whalen and Tobin, "Periodicals."

22. Whalen and Tobin, "Periodicals," 197–98. The authors focus on one company in particular, which took over several of the periodicals: the Science Press of James McKeen Cattell.

23. Broks, *Media Science,* 131.

24. Bowler, *Science for All,* 95.

25. Broks, *Media Science,* 15–16.

26. Bowler, *Science for All,* 265–271. See also Johnson and Prijatel, *The Magazine;* Grow, "Magazine Covers."

27. Bensaude-Vincent, "A Genealogy of the Increasing Gap," 109.

28. Ibid.

29. Nelkin, *Selling Science,* 79.

30. Ibid., 30.

31. Bernstein, "What Happened," 55.

32. Moran, "The Demise of *Scientific American*"; Bernstein, "What Happened."

33. Lewenstein, "Was There Really," 37.

34. This is according to the "Company History" page on *Scientific American*'s website, *Scientific American,* "Press Room."

35. Moran, "The Demise"; Bernstein, "What Happened."

36. An archive of *Scientific American*'s covers from 1950 to the present can be found on the website "backissues.com," *Scientific American* Archive.

37. Johnson and Prijatel, *The Magazine*, 285–86.

38. Valencia, "*Scientific American*," B3.

39. In 2007, *Scientific American*'s circulation was 550,000 to *Discover*'s 711,000, *Popular Science*'s 1.3 million, and *Wired*'s 656,000. Valencia, "*Scientific American*," B3.

40. Baynes, "*Scientific American*."

41. Lewenstein,"Was There Really," 38.

42. *Scientific American*, "Press Room."

43. According to the Bonnier Corporation website, "*Illustreret Videnskab* (Danish for "Science Illustrated") was the highest-circulation magazine in Scandinavia and the flagship of Bonnier's European portfolio." Bonnier Corporation website, 2011. http://www.nextmedia.com.au/science-illustrated/science-illustrated-magazine.html. After completing this chapter, I found out that *Science Illustrated* stopped publication in the United States and moved instead to Australia.

44. Jannot, "Science Illustrated."

45. See Jannot, "Science Illustrated" and "Subscribe to *Science Illustrated*," Bonnier Corporation website, 2011.

46. See, for example, Dondis, *A Primer*; Johnson and Prijatel, *The Magazine*.

47. She wrote that these choices are "meant to reinforce and strengthen expressive intentions for maximum control of response." Dondis, *A Primer*, 104.

48. Barthes, *Image Music Text*, 39–40. Barthes would say "anchored" in place of "accompanied," but I agree with Kress and van Leeuwen's complication of Barthes's theory, that is, images and text can carry their own separate messages as well as working together. Kress and van Leeuwen, *Reading Images*, 16–17. See chapter 1 for a fuller discussion of Kress and Leeuwen, *Reading Images*.

49. Kress and van Leeuwen call this technique "visual rhyme." Kress and van Leeuwen, *Reading Images*, 214–17. See chapter 1.

50. McQuarrie and Mick, "The Contribution," 207.

51. Dondis, *A Primer*, 15

52. Ibid., 31.

53. Ibid., 46.

54. Ibid., 44.

55. Kress and van Leeuwen, *Reading Images*, 160.

56. To make this point, Greg Myers takes an example from E. O. Wilson's sociobiology—a sketch of several lemurs—to show that a sketch, though not necessarily photorealistic, is preferable to a photorealistic image of a lemur in its natural habitat because it allows scientists to see lemurs engaging in several behaviors simultaneously. It would be quite serendipitous if a photographer were able to capture several lemurs engaging in different behaviors in a single photograph. Myers, "Every Picture Tells a Story," 242–44.

57. Kress and van Leeuwen, *Reading Images*, 170.

58. Ibid.

59. Johnson and Prijatel, *The Magazine*, 285.

60. Ibid., 285–86.

61. LaFollette, *Making Science Our Own*, 22.

62. Bowler, *Science for All*, 266–68.

63. See "About New Scientist," *New Scientist*, 2015 (https://www.newscientist.com/in16-about-new-scientist-magazine/). *New Scientist* is published by Reed Business Information, and the magazine claims to have acquired an extensive international readership since it established itself online in 1996.

64. Ibid.

65. A scan of the magazine's archives online points to this trend: see "Archives," *New Scientist*, 2015. (https://www.newscientist.com/issues/)

66. I looked at all of *New Scientist*'s covers from 1980 to 2015 and counted all of the ones that depicted a human head without a body. There have been nearly 200 such covers since 1980, approximately half published on issues after 2000.

67. The covers reproduced here are just a small sample—see note 66.

68. Graves, *Rhetoric in(to) Science*.

69. Lakoff and Turner, *More Than Cool Reason*, 92–93.

70. Ibid.

71. For example, a popular cultural icon for evolution, seen on bumper stickers and tee shirts, is an image of a monkey transforming into a human being.

72. Thornton, *Brain Culture*, 157.

73. Jack, "What Are Neurorhetorics," 405.

74. Thornton, *Brain Culture*, 31.

75. Racine et al., "fMRI in the Public Eye,"160.

76. Ibid., 160–61.

77. Johnson and Prijatel, *The Magazine*, 281.

78. Nisbet and Scheufele, "What's Next."

4. PORTALS ON THE WEB

1. Wilson, "Art Meets Science."

2. Landau is quoted in Pinholster and Ham, "Science Communication," 1464.

3. Ibid.

4. Soriano, "Art Meets Science."

5. Berman, "Art Meets Science."

6. Else, "Art Meets Science."

7. Ibid.

8. Keats, "Art Meets Science."

9. In 2015, the NSF changed the name of the competition to "The Vizzies." Prior to that, the competition was called "The International Science and Engineering Visualization Challenge," and it was cosponsored by the American Association for the Advancement of Science. It does not seem that any significant changes were made to the competition itself or to its mission statement. The images analyzed here are from the earlier version of the competition.

10. The National Science Foundation, "About the Visualization Challenge," emphasis added.

11. Criteria for using popular science images to include nonexpert publics in discussions about science have unfortunately not made their way into the scientific community. The criteria presented in this book point to what might be considered ethical or responsible visual science communication, and they are needed in the fields of Science Communication and Science and Technology Studies (STS), which have only recently begun to engage with visual communication. Compounding the issue, scientific communities are typically a few steps behind employing the methods that Science Communication scholars advise. In fact, scholars have found that scientific communities still communicate using "deficit model" techniques—an outdated and unaccepted model of communication characterized by a one-way flow of information from experts to citizens that does not account for audience's beliefs and values (see Introduction in this book). For more about these issues in science communication, see, for example, Borchelt and Hudson, "Engaging the Scientific Community"; Davies, "Constituting Public Engagement"; Perrault, *Communicating Popular Science;* and Priest, "Critical Science Literacy."

12. See, for example, Ottino, "Is a Picture Worth." A couple of historical exceptions, however, are worth noting. Besides the culture of aesthetically pleasing frontispieces discussed in chapter 2, the notion of aestheticizing science extends back to Andreas Vesalius's sixteenth-century anatomical drawings. Vesalius's drawings position dissected bodies in pastoral landscape settings. Whatever the reasons for Vesalius's choices in backdrop for his cadaver illustrations, there was, ostensibly, at least some concern for aesthetics. On a slightly less morbid note, illustrated albums of flowers, plants, and birds were both used by natural philosophers and appreciated by lay audiences. These collections of aesthetically pleasing drawings, which were at the height of their popularity between the seventeenth and nineteenth centuries, can be considered early iterations of the type of popular science images discussed here because of their aesthetic appeal. In scholarly discussions surrounding the uses of art in science, there is much more concern about the role of visualization in making scientific claims than there is about its role in popularizing science. In other words, there is consideration of the ways in which art serves science—but the relationship is not necessarily reciprocal. See, for example, Ford, *Images of Science;* Ellenius, *The Natural Sciences and the Arts;* Baigrie, *Picturing Knowledge.* Providing a history of scientific illustration, Brian Ford's *Images of Science* is one of the few studies that traces image reproduction technologies and viewing practices over time. Ford takes illustration practices as indicative of scientific research practices, and his study privileges accuracy in visualization, which has drawn criticism for being positivist and overly simplistic. Art and cultural historians have considered how images contribute to scientific knowledge even if they are not accurate representations of natural phenomena. Two collections of essays embody this perspective: Ellenius's *The Natural Sciences and the Arts* and Baigrie's *Picturing Knowledge.* Importantly, many if not most of the essays in both collections address the relationship between images and text with the aim of proving that images play a more important role than serving as mere ornament or supplement to text. From the former collection, Ackerman's piece "Early Renaissance

'Naturalism'" clearly sets out the ways in which artists "furthered the aims of science," and mimicry of nature is only one of these ways; there were also conceptual drawings that were intended to convey an ideal (1–2). In the same vein, Baigrie's own contribution to the latter collection explains how Descartes's conceptual drawings resist "an assumed identity between drawing and seeing"; rather, nonrepresentational drawing is experimental and designed to contribute to "the creation of knowledge" (94–96). A more recent example is examined in Brown's essay in that collection, in which he explains that Feynman diagrams visualize probability functions, as opposed to picturing physical processes (267).

13. In *Rhetorical Figures in Science*, Fahnestock provided examples of visual instantiations of verbal figures. A verbal figure "epitomizes a line of reasoning," she noted (24), but it is also possible to have "visual rendering of arguments" (42), a concept that has implications for popularizations as well as primary scientific texts. For example, side-by-side images of male and female brain scans have been used to make arguments about gendered differences in cognitive ability—an example of a visual antithesis. The most comprehensive study of scientific visualization from a rhetorical perspective is Gross and Harmon's *Science from Sight*, which sets out a framework for evaluating visualizations on the basis of their inherent purpose as opposed to their presented format. The framework advanced in their book is ostensibly applicable to scientific visualizations that advance new knowledge, but their application of the framework to popular images aimed at nonexpert audiences is less convincing.

14. To restate a call issued by Fahnestock in the *Sage Handbook of Rhetorical Studies*, there is still much to be done with the "relatively untouched area of how visuals perform in popularizations." Fahnestock, "The Rhetoric of the Natural Sciences," 188.

15. Dyehouse, "A Textbook Case"; Huppauf and Weingart, "Introduction."

16. Kress and van Leeuwen refer to such required knowledge as "coding orientations." Science images belong to a "technical coding orientation." Kress and van Leeuwen, *Reading Images*, 170.

17. Ottino, "Is a Picture."

18. Huppauf and Weingart, "Introduction," 16.

19. Gross and Harmon, *Science from Sight*, 38.

20. Ibid., 33.

21. This argument is also made by Myers in his study of Wilson's *Sociobiology*: Myers, "Every Picture."

22. Schriver, *Dynamics*, 413.

23. Myers, "Every Picture," 249–50. See also Dyehouse, "A Textbook Case," 339–40. Techniques that can be used in captions, Dyehouse explains, include posing questions to viewers and pointing out questionable scientific claims.

24. Myers, "Every Picture," 249–50. This concept of textual "anchorage" comes from Barthes, *Image Music Text*, 39–40. See also Kress and van Leeuwen's modification in *Reading Images*, 17: "the visual component of a text is an independently organized and structured message—connected with the verbal text, but in no way dependent on it: and similarly the other way around."

25. Priest, "Reinterpreting the Audiences," 230.

26. *Science* is a peer-reviewed journal published by the American Association for the Advancement of Science (AAAS) and is one of the world's premier publications of original scientific research.

27. There is a tendency to see the nonexpert publics as a singular entity—"the general public"—rather than as a stratified, diverse series of subgroups with distinct values and belief systems. The same goes for the scientific enterprise, which is not a monolithic entity but rather a stratified, diverse series of subfields with distinct disciplinary conventions. See, for example, Whitley, "Knowledge Producers."

28. National Science Foundation, "About the Visualization Challenge."

29. See, for example, Christensen, *The Hands-on Guide;* Priest, "Critical Science Literacy"; Russell, *Communicating Science.*

30. National Science Foundation, "Judging Criteria."

31. Ibid.

32. Nesbit and Bradford, "2006 Visualization Challenge," 1729.

33. According to Barthes, "linguistic messages are employed to fix the meaning of an image, providing a foundation for the viewer's interpretation." By emphasizing some aspects of the image and avoiding others, the text is thus able to "remote-control [the reader] towards a meaning chosen in advance." Barthes, *Image Music Text,* 39–40.

34. Chatterjee, "Special Feature," 1731.

35. Frankel is quoted in Chatterjee, "Special Feature," 1731. See also Frankel, "Communicating Science," 1312–14, in which she explains her methodology of preparing and "redesigning" samples to produce photographs. This redesigning involves "thinking about what to include in that sample (and what is *not* necessary)," an unambiguously rhetorical process. Frankel is also the author of *Envisioning Science,* a guide for researchers who wish to present their work in a way that is appealing to "the general public," mentioned in the Introduction to this book.

36. See Thomas, "Still Life," and Robbins, "Math as Art," respectively.

37. Thomas, "Still Life."

38. It should be said that no viewer comments or "tweets" appear on either *Plus* or "Science Dude," indicating that these venues have not been measurably successful at reaching a broad audience.

39. Lester, "Special Feature," 1859.

40. Ibid.

41. Ibid.

42. Nesbit and Bradford, "2006 Visualization Challenge," 1729, emphasis added.

43. See McGee, "Kelp Takes"; Zielinski, "Picture of the Week"; "Best Science Images."

44. McGee, "Kelp Takes."

45. Zielinski, "Picture of the Week."

46. Boyle, "The Best Sights." The introduction to Boyle's article also propagates the stereotype of the wacky scientist by characterizing a CT scan as "looking up someone's nose" and "finding beauty."

47. Ibid.

48. The blogs mentioned either have discussions that have been closed or do not show viewer comments about the images.

49. The full illustration can be found on the NSF's competition website: http://www .nsf.gov/news/special_reports/scivis/winners_2008.jsp. The *Science* magazine cover can be found on AAAS's website: http://science.sciencemag.org/content/321/5897.

50. Zelkowitz, "Special Feature," 1768.

51. See Graham, "Science Visualized," and Boyle, "Picture Stories."

52. Graham, "Science Visualized."

53. Ibid.

54. See "Science as Art: A Visualization Challenge."

55. Quoted material is from the competition website. See "About Science as Art."

56. Ibid.

57. Ibid.

58. Moreover, the amount of time and money that must have been spent on the impeccable website design—not to mention the thoroughness of the explanations of the competition itself and its goals—suggests that the same care could have been taken with the explanations of the images themselves.

59. This information appears on the competition website. See "Categories."

60. This is clearly a nonequivalent set, but each category is judged separately, and a first-place award goes to a submission from each.

61. The title of the image is not explained on the website. Perhaps the title was selected because it shares its root with "thrombosis."

62. Sierad, "Thrombousthai," ellipsis in original.

63. Quoted information comes from the competition website. See "Art of Science Competition 2010."

64. Ibid.

65. "Aesthetic excellence" is not defined anywhere on their website. See "Art of Science Competition 2010."

66. The quoted material comes from the competition website. See "Gallery."

67. On PhysOrg.com, a science blog to which the image traveled, it is referred to as a photo, a detail that was probably clear to expert viewers but is not provided on the Princeton website. See "Art of Science 2010."

68. Ross, "Xenon Plasma Accelerator."

69. Ibid.

70. Ibid.

71. Alamino, "Scientific Art."

72. Banks, "The Art of Science."

73. Anders, "Black Holes." *Io9* is a science fiction blog.

74. Ibid.

75. Ibid. For example, this person's question was answered by another commenter: "Yup. They're mainly used for stationkeeping for geosynchronous satellites, and very slow (but cheap) interplanetary voyages."

76. Lydon, "Science Image Competition."

77. Ibid. Despite many efforts, I was unable to contact the artist to ask for permission to use her image.

78. Yau, *Data Points*, 74.

79. Ibid., 78.

80. Ibid., 77.

81. See also Brasseur, *Visualizing Technical Information*, for a discussion of the valorization of science through visual discourse.

82. Jenkins et al., *Spreadable Media*, 13.

EPILOGUE

1. Perrault, *Communicating Popular Science*, 81. She points to ways in which science writing can move beyond "the myth that science is a realm apart" such that it creates avenues for publics to participate in decision making, as opposed to addressing publics as if they are ignorant. See also Nelkin, *Selling Science*, 30: "By neglecting the substance of science . . . the press ultimately contributes to the obfuscation of science and helps to perpetuate the distance between science and the citizen."

2. Perrault, *Communicating Popular Science*, 166.

3. Myers, "Every Picture," 233.

4. Northcut, "Images as Facilitators," 3.

5. Dyehouse, "A Textbook Case," 343.

6. Ibid., 340.

7. Northcut, "Images as Facilitators," 2, 11–12.

8. Myers, "Every Picture," 262.

9. Northcut, "Images as Facilitators," 12.

10. Ibid., 11.

11. See, for example, Kelly, *What Technology Wants;* Rheingold, *Netsmart;* Jenkins et al., *Spreadable Media.*

12. Jenkins et al., *Spreadable Media*, 199.

13. Ibid., 11.

BIBLIOGRAPHY

"About Science as Art." Clemson University (2011). http://www.scienceasart.org/about (accessed June 7, 2011).

Adhémar, Jean. *Graphic Art of the 18th Century.* Translated by M. I. Martin. New York: McGraw-Hill, 1964.

Alamino, Roberto C. "Scientific Art." *Skepsisfera,* May 27, 2010. http://skepsisfera .blogspot.com/2010/05/scienctific-art.html (accessed June 7, 2011).

Anders, Charlie Jane. "Black Holes and Xenon Accelerators You'll Want to Hang on Your Walls." *Io9,* May 20, 2010. http://io9.com/5543296/black-holes-and-xenon-accelerators -youll-want-to-hang-on-your-walls (accessed June 7, 2011).

Aristotle. *On Rhetoric.* Translated by George A. Kennedy. Oxford: Oxford University Press, 1991.

"Art of Science 2010." *PhysOrg.com,* May 17, 2010. http://www.physorg.com/news193333 630.html (accessed June 7, 2011).

"Art of Science Competition 2010." Princeton University (2010). http://www.princeton .edu/~artofsci/gallery2010/about.php.html (accessed June 7, 2011).

Atkinson, Nathan S., David Kaufer, and Suguru Ishizaki. "Presence and Global Presence in Genres of Self-Presentation: A Framework for Comparative Analysis." *Rhetoric Society Quarterly* 38.4 (2008): 357–384.

Bacon, Francis. *Novum Organum, with Other Parts of The Great Instauration.* Edited and Translated by Peter Urbach and John Gibson. Chicago: Open Court Publishing Company, 1994.

Bacon, Francis. *Sylva Sylvarum or A Natural History in Ten Centuries, 11th Edition* (1685). Edited by William Rawley. Reel 1029:21, Microfilm, 1–2. London: B. Griffin, 1980.

Baigrie, Brian S., ed. *Picturing Knowledge: Historical and Philosophical Problems Concerning the Use of Art in Science.* Toronto: University of Toronto Press, 1996.

Ball, Phillip. "The Origin of the Archetypal Image of the Chemist." *Nature* 433 (January 6, 2005): 17.

Banks, Michael. "The Art of Science." *Physicsworld,* May 18, 2010. http://physicsworld .com/blog/2010/05/the_art_of_science.html (accessed, 7 June 2011).

Barry, Anne Marie. "Science and Visual Communication." Presentation at Boston College, 2005.

Barry, Anne Marie Seward. *Visual Intelligence: Perception, Image and Manipulation in Visual Communication.* Albany: State University of New York Press, 1997.

Barthes, Roland. *Image Music Text*. Translated by Stephen North. New York: Hill and Wang, 1977.

Barton Ben F., and Marthalee S. Barton. "Modes of Power in Technical and Professional Visuals." *Journal of Business and Technical Communication* 7.1 (1993): 138–162.

Barton, Ruth. "Just before Nature: The Purposes of Science and the Purposes of Popularization in Some English Popular Science Journals of the 1860s." *Annals of Science* 55 (1998): 1–33.

Baughman, James L. *Henry R. Luce and the Rise of the American News Media*. Baltimore, Md.: Johns Hopkins University Press, 2001.

Baynes, Grace. "*Scientific American* Forms Consumer Media Division of Nature Publishing Group." *Nature Publishing Group* (June 22, 2009).

Bensaude-Vincent, Bernadette. "A Genealogy of the Increasing Gap between Science and the Public." *Public Understanding of Science* 10 (2001): 99–113.

Berman, David S. "Art Meets Science: Physicist in a Cultural Landscape." *New Scientist* blog, May 12, 2010. http://www.newscientist.com/blogs/culturelab/2010/05/art-meets-science-physicist.html (accessed June 30, 2015).

Bernstein, Jeremy. "What Happened to *Scientific American*?" *Commentary* (May 1997): 53–55.

"Best Science Images of 2007 Honored." *National Geographic*, September 27, 2007. http://news.nationalgeographic.com/news/2007/09/photogalleries/science-pictures/ (accessed January 12, 2010).

"Biography of Linnaeus." UMCP Berkeley. http://www.ucmp.berkeley.edu/history/linnaeus.html (accessed April 30, 2012).

Bizony, Piers. "The Great Divide." *Engineering & Technology* (January 17, 2009): 41–43.

Blair, J. Anthony. "The Rhetoric of Visual Arguments." In *Defining Visual Rhetorics*. Edited by Charles A. Hill and Marguerite Helmers, 41–61. Mahwah, N.J.: Lawrence Erlbaum, 2004.

Borchelt, Rick, and Kathy Hudson. "Engaging the Scientific Community with the Public: Communication as a Dialogue, Not a Lecture." *Science Progress* (April 21, 2008). http://www.scienceprogress.org/2008/04/engaging-the-scientificcommunity-with-the-public/ (accessed June 10, 2010).

Bowler, Peter J. *Science for All: The Popularization of Science in Early Twentieth-Century Britain*. Chicago: University of Chicago Press, 2009.

Bowler, Peter J., and Ian Rhys Morus. *Making Modern Science. A Historical Survey*. Chicago: University of Chicago Press, 2005.

Boyle, Alan. "The Best Sights in Science." *Cosmic Log: MSNBC*, September 27, 2007. http://cosmiclog.msnbc.msn.com/archive/2007/09/27/383647.aspx (accessed January 12, 2010).

Boyle, Alan. "Picture Stories." *Cosmic Log: MSNBC*, September 25, 2008. http://www.msnbc.msn.com/id/26891829/displaymode/1107/s/2/framenumber/14/ (accessed January 12, 2010).

Brasseur, Lee E. *Visualizing Technical Information: A Cultural Critique*. Amityville, N.Y.: Baywood, 2003.

Brierly, Sean. *The Advertising Handbook,* 2nd edition. New York: Routledge, 2002.

Broberg, Gunnar. "The Dragonslayer." *TijdSchrift voor Skandinavistiek* 29 (2008): 29–43.

Broks, Peter. *Media Science before the Great War.* New York: St. Martin's Press, 1996.

Broks, Peter. *Understanding Popular Science.* New York: Open University Press, 2006.

Brooks, Michael. "Why the Scientist Stereotype Is Bad for Everyone, Especially Kids." *Wired* (June 15, 2012).

"Bubble Blowing for Business: An Illinois Professor Makes a Scientific Study of Gaseous Bubbles." *Life* 39.13 (1955): 62.

Bukdahl, Else Marie. "Winckelmann, Wiedewelt, Thorvaldsen and Danish Sculpture in the 1980s." *Thorvaldsen: L'Ambiente L'Influsso Il Mito.* Edited by Patrick Kragelund and Mogens Nykjaer, 219–236. Rome: L'Erma di Bretschneider, 1991.

Burke, Kenneth. *A Rhetoric of Motives.* Berkeley: University of California Press, 1969.

Bush, Vannevar. "Science, the Endless Frontier." 1945 Report to the President on a Program for Postwar Scientific Research. *National Science Foundation,* 1960.

Cantor, Geoffrey, and Sally Shuttleworth. *Science Serialized: Representation of the Sciences in Nineteenth-Century Periodicals.* Cambridge, Mass.: M.I.T. Press, 2004.

"Categories." Guidelines for Science as Art: A Visualization Challenge. Clemson University (2011). http://www.scienceasart.org/guidelines/categories-eligible-entries (accessed June 7, 2011).

Ceccarelli, Leah. "The Rhetoric of Science and Technology." In *Encyclopedia of Science, Technology, and Ethics, Vol. 3: L-R,* 1625–29. Edited by Carl Mitchem. Detroit: Macmillan Reference, 2004.

Chatterjee, Rhitu. "Special Feature: 2006 Visualization Challenge Winners." *Science* 313 (September 22, 2006): 1731.

Christensen, Lars Lindberg. *The Hands-On Guide for Science Communicators: A Step-by-Step Approach to Public Outreach.* New York: Springer, 2007.

[Cicero, Marcus Tullius.] *Rhetorica ad Herennium.* Translated by Harry Caplan. Cambridge, Mass.: Harvard University Press, 1954.

Coleman, Renita. "Framing the Pictures in Our Heads: Exploring the Framing and Agenda-setting Effects of Visual Images." In *Doing News Framing Analysis: Empirical and Theoretical Perspectives.* Edited by Paul D'Angelo and Jim A. Kuypers, 233–262. New York: Routledge, 2009.

Cookman, Claude. *American Photojournalism: Motivations and Meanings.* Evanston, Ill.: Northwestern University Press, 2009.

Corbett, Margery, and Ronald Lightbown. *The Comely Frontispiece: The Emblematic Title-Page in England 1550–1660.* London: Routledge & Kegan Paul, 1979.

Damasio, Antonio. *Descartes' Error: Emotion, Reason, and the Human Brain.* New York: Penguin Group, 1994.

D'Angelo, Paul, and Jim Kuypers. *Doing News Framing Analysis.* New York: Routledge, 2010.

Daston, Lorraine, and Peter J. Galison. *Objectivity.* New York: Zone Books, 2010.

Davies, Sarah R. "Constituting Public Engagement: Meanings and Genealogies of PEST in Two U.K. Studies." *Science Communication* 35.6 (2013): 687–707.

de Chadarevian, Soraya. "Portrait of a Discovery: Watson, Crick, and the Double Helix." *Isis* 94 (2003): 90–105.

De Terra, Helmut. *Humboldt: Life and Times (1769–1859)*. New York: Octagon Books, 1979.

Dickenson, Victoria. *Drawn from Life: Science and Art in the Portrayal of the New World*. Toronto: University of Toronto Press, 1998.

Dondis, Donis A. *A Primer of Visual Literacy*. Cambridge, Mass.: M.I.T. Press, 1973.

Doss, Ericka. *Looking at Life Magazine*. Washington: Smithsonian Institution Press, 2001.

Doty, William G. *Mythography: The Study of Myths and Rituals*, 2nd Edition. Tuscaloosa, AL: University of Alabama Press, 2000.

Dragga, Sam, and Dan Voss. "Cruel Pies: The Inhumanity of Technical Illustrations." *Technical Communication* 48.3 (2001): 265–274.

Dyehouse, Jeremiah. "'A Textbook Case Revisited': Visual Rhetoric and Series Patterning in the American Museum of Natural History's Horse Evolution Displays." Technical Communication Quarterly 20.3 (2011): 327–346.

Ellenius, Allen, ed. *The Natural Sciences and the Arts: Aspects of Interaction from the Renaissance to the 20th Century*. Uppsala: Almqvist & Wiksell, 1985.

Else, Liz. "Art Meets Science: Reuniting the Severed Cultures." *New Scientist* blog, May 11, 2010. http://www.newscientist.com/blogs/culturelab/2010/05/art-meets-science -reuniting-the-severed-cultures.html (accessed June 30, 2015).

Fahnestock, Jeanne. "Accommodating Science: The Rhetorical Life of Scientific Facts." *Written Communication* 3.3 (1986): 275–296.

Fahnestock, Jeanne. "The Rhetoric of the Natural Sciences." In *The Sage Handbook of Rhetorical Studies*. Edited by Andrea Lunsford, Kurt H. Wilson, and Rosa A. Eberly, 175–195. Thousand Oaks, Calif.: Sage.

Fahnestock, Jeanne. *Rhetorical Figures in Science*. New York: Oxford University Press, 1999.

Fara, Patricia. "Images of a Man of Science." *History Today* (October 1998): 42–49.

Finnegan, Cara A. "'Liars May Photograph': Image Vernaculars and Progressive Era Child Labor Rhetoric." *POROI* 5.2 (2008): 94–139.

Finnegan, Cara A. "The Naturalistic Enthymeme and Visual Argument: Photographic Representation in the 'Skull Controversy.'" *Argumentation and Advocacy* 37 (Winter 2001): 133–149.

Finnegan, Cara A. "Recognizing Lincoln: Image Vernaculars in Nineteenth-Century Visual Culture." In *Visual Rhetoric: A Reader in Communication and American Culture*. Edited by Lester C. Olson, Cara A. Finnegan, and Diane S. Hope, 61–78. Los Angeles: Sage, 2008.

Ford, Brian. *Images of Science: A History of Scientific Illustration*. New York: Oxford University Press, 1993.

Frankel, Felice. "Communicating Science through Photography." *Journal of Chemical Education* 78.10 (2001): 1312–1314.

Frankel, Felice. *Envisioning Science: The Design and Craft of the Science Image*. Cambridge, Mass.: M.I.T. Press, 2002.

Galinsky, Karl. "The Apollo Belvedere." *Introduction to the Ancient World: Greece.* University of Texas Classical Civilization (February 27, 2005). (accessed June 30, 2012).

"Gallery." Art of Science. Princeton University (2010). http://www.princeton.edu/artof science/gallery2010/ (accessed June 7, 2011).

Genette, Gerard. *Paratexts: Thresholds of Interpretation.* Translated by Jane E. Lewin. New York: Cambridge University Press, 1997.

Giddens, Anthony. *The Consequences of Modernity.* Stanford, Calif.: Stanford University Press, 1990.

Gigante, Maria E. "Accommodating Scientific Illiteracy: Award-Winning Visualizations on the Covers of *Science.*" *Journal of Technical Writing & Communication* 42.1 (2012): 21–38.

Grabe, Maria Elizabeth, and Erik Page Bucy. *Image Bite Politics: News and the Visual Framing of Elections.* Oxford: Oxford University Press, 2009.

Graham, Nicholas. "Science Visualized as Art: 2008 Winning Images." *Huffington Post,* September 27, 2008. http://www.huffingtonpost.com/2008/09/27/science-visualized-as-art _n_129940.html (accessed January 12, 2010).

Graves, Heather. *Rhetoric in(to) Science: Style as Invention in Inquiry.* New York: Hampton Press, 2004.

Gross, Alan G. "Toward a Theory of Verbal-Visual Interaction: The Example of Lavoisier." *Rhetoric Society Quarterly* 39.2 (2009): 147–169.

Gross, Alan G., and Ray D. Dearin. *Chaim Perelman.* Albany: SUNY Press, 2003.

Gross, Alan G, and Joseph E. Harmon. *Science from Sight to Insight: How Scientists Illustrate Meaning.* Chicago: University of Chicago Press, 2013.

Gross, Alan G., Joseph E. Harmon, and Michael Reidy. *Communicating Science: The Scientific Article from the 17th Century to the Present.* Oxford: Oxford University Press, 2002.

Grow, Gerald. "Magazine Covers and Cover Lines: An Illustrated History." *Journal of Magazine and New Media Research* (2002): n.p.

Hadot, Pierre. "Isis Has No Veils." Translated by Michael Chase. *Common Knowledge* 12.3 (2006): 349–353.

Hariman, Robert, and John Louis Lucaites. *No Caption Needed: Iconic Photographs, Public Culture, and Liberal Democracy.* Chicago: University of Chicago Press, 2007.

Heller, John L. "Introduction to Linnaeus's *Hortus Cliffortianus.*" In *Taxon: Journal of the International Association for Plant Taxonomy* 17 (1968): 667.

Hill, Charles A., and Marguerite Helmers, eds. *Defining Visual Rhetorics.* Mahwah, N.J.: Lawrence Erlbaum, 2004.

Hill, Charles A., and Marguerite Helmers. "Introduction." In *Defining Visual Rhetorics.* Edited by Charles A. Hill and Marguerite Helmers, 1–23. Mahwah, N.J.: Lawrence Erlbaum, 2004.

Hind, Arthur. *A History of Engraving and Etching from the 15th Century to the Year 1914.* New York: Dover Publications, 1963.

Humboldt, Alexander von. "From *Essay on the Geography of Plants.*" In *Foundations of Biogeography: Classic Papers with Commentaries.* Edited by Mark V. Lomolino, Dov F.

Sax, and James H. Brown. Translated by Francesca Kern and Philippe Janvier. Chicago: University of Chicago Press, 2004.

Humboldt, Alexander von. "Ideas for a Physiognomy of Plants." In *Views of Nature: or, Contemplations on the Sublime Phenomena of Creation; with Scientific Illustrations* (1850). Translated by E. C. Otte and Henry G. Bohn, Microfiche, v. London: H. G. Bohn, 1967.

Humboldt, Alexander von. *Ideen zu einer Physiognomik der Gewächse*. Project Gutenberg (2007). http://www.gutenberg.org/files/22761/22761-h/22761-h.html (accessed March 30, 2011).

Huppauf, Bernd, and Peter Weingart. "Introduction." In *Science Images and Popular Images of the Sciences*. Edited by Bernd Huppauf and Peter Weingart, 3–32. New York: Routledge, 2008.

Ivins, William M. *Prints and Visual Communication*. New York: Da Capo Press, 1969.

Jack, Jordynn. "What Are Neurorhetorics?" *Rhetoric Society Quarterly* 40.5 (2010): 405–410.

Jacobi, Daniel, and Bernard Schiele. "Scientific Imagery and Popularized Imagery: Differences and Similarities in the Photographic Portraits of Scientists." *Social Studies of Science* 19 (1989): 731–753.

Jannot, Mark. "Science Illustrated Mission Statement." *Bonnier Corporation, 2011.*

Jasinski, James. *Sourcebook on Rhetoric: Key Concepts in Contemporary Rhetorical Studies*. Thousand Oaks, Calif.: Sage, 2001.

Jenkins, Henry, Sam Ford, and Joshua Green. *Spreadable Media: Creating Value and Meaning in a Networked Culture*. New York: New York University Press, 2013.

Johnson, Alfred Forbes. *Catalogue of Engraved and Etched English Title-Pages to 1691*. Oxford: Oxford University Press, 1934.

Johnson, Sammye, and Patricia Prijatel. *The Magazine from Cover to Cover*, 2nd edition. New York: Oxford University Press, 2007.

Jordanova, Ludmilla. *Defining Features: Scientific and Medical Portraits 1660–2000*. London: Reaktion Books, 2000.

Kahlor, LeeAnn, and Patricia A. Stout, eds. *Communicating Science: New Agendas in Communication*. New York: Routledge, 2010.

Kaoukji, Natalie, and Nicholas Jardine. "'A Frontispiece in Any Sense They Please?' On the Significance of the Engraved Title-page of John Wilkins's *A Discourse Concerning a New World & Another Planet*, 1640." *Word & Image* 26.4 (2010): 429–447.

Keats, Jonathon. "Art Meets Science: Aesthetics, Politics and Metaphysics." *New Scientist* blog, May 12, 2010. http://www.newscientist.com/blogs/culturelab/2010/05/art-meets-science-aesthetics-politics-and-metaphysics.html (accessed June 30, 2015).

Kelly, Kevin. *What Technology Wants*. New York: Viking, 2010.

Klooster, Willem. "Explanation of the Frontispiece." In *Puritan Conquistadors: Iberianizing the Atlantic, 1550–1700* by Jorge Cañizares-Esguerra, 279 n.141. Stanford: Stanford University Press, 2006.

Kohut, Andrew, Scott Keeter, Carroll Doherty, and Michael Dimock. *Scientific Achievements Less Prominent Than a Decade Ago: Public Praises Science; Scientists Fault Public,*

Media. Washington, D.C.: Pew Research Center for the People & the Press, 2009. http://www.people-press.org (accessed June 10, 2010).

Kozol, Wendy. *Life's America: Family and Nation in Postwar Photojournalism.* Philadelphia: Temple University Press, 1994.

Kress, Gunther, and Theo van Leeuwen. *Reading Images: The Grammar of Visual Design.* New York: Routledge, 1996.

Kronick, David A. *"Devant le Deluge" and Other Essays on Early Modern Scientific Communication.* Lanham, Md.: Scarecrow Press, 2004.

Kuritz, Hyman. "The Popularization of Science in Nineteenth-Century America." *History of Education Quarterly* 21.3 (1981): 259–274.

LaFollette, Marcel C. *Making Science Our Own: Public Images of Science 1910–1955.* Chicago: University of Chicago Press, 1990.

Lakoff, George, and Mark Turner. *More Than Cool Reason: A Field Guide to Poetic Metaphor.* Chicago: University of Chicago Press, 1989.

Lester, Benjamin. "Special Feature: 2007 Visualization Challenge Winners." *Science* 317 (September 28, 2007): 1859.

Lester, Paul Martin. *Visual Communication: Images with Messages.* Boston: Wadsworth, Cengage Learning, 2011.

Lewenstein, Bruce V. "Was There Really a Popular Science 'Boom'?" *Science, Technology, & Human Values* 12.2 (1987): 29–41.

Lightman, Bernard. "The Visual Theology of Victorian Popularizers of Science: From Reverent Eye to Chemical Retina." *Isis* 91 (2000): 651–680.

Littman, Robert R. *Life: The First Decade.* Boston: New York Graphic Society, 1979.

Linnaeus, Carl. *Hortus Cliffortianus.* Edited and Translated by John L. Heller. In *Taxon: Journal of the International Association for Plant Taxonomy* 17 (1968): 667–669.

Linné, Carl von. *Hortus Cliffortianus* (1737). Arranged by Kurt Stueber (2007). http://caliban.mpiz-koeln.mpg.de/linne/hortus/index.html (accessed March 30, 2011).

Luce, Henry. "Introduction to the First Issue of Life." *Life* 1.1 (November 23, 1936): 3.

Lydon, Susie. "Science Image Competition." SIGNET and CPIB at Nottingham University (May 2011). http://www.cpib.ac.uk/events/science-image-competition/ (accessed June 7, 2011).

Lynch, Michael, and Steve Woolgar. *Representation in Scientific Practice.* Cambridge, Mass.: M.I.T. Press, 1990.

Manning, Alan, and Nicole Amare. "Visual-rhetoric Ethics: Beyond Accuracy and Injury." *Technical Communication* 53.2 (2006): 195–211.

McGee, Tim. "Kelp Takes Our Breath Away." *TreeHugger,* September 30, 2007. http://www.treehugger.com/natural-sciences/kelp-takes-our-breath-away.html/ (accessed January 12, 2010).

McQuarrie, Edward F., and David Glen Mick. "The Contribution of Semiotic and Rhetorical Perspectives to the Explanation of Visual Persuasion in Advertising." In *Persuasive Imagery: A Consumer Response Perspective.* Edited by Linda M. Scott and Rajeev Batra, 191–222. Mahwah, N.J.: Lawrence Erlbaum, 2003.

Messaris, Paul, and Linus Abraham. "The Role of Images in Framing News Stories." In

Framing Public Life: Perspectives on Media and our Understanding of the Social World. Edited by Stephen D. Reese, Oscar H. Gandy, and August E. Grant, 215–226. Mahwah, N.J.: Lawrence Erlbaum, 2001.

Miller, Carolyn R. "Learning from History: World War II and the Culture of High Technology." *Journal of Business and Technical Communication* 12.3 (1998): 288–315.

Miller, Carolyn R. "The Presumptions of Expertise: The Role of Ethos in Risk Analysis." *Configurations* 11.2 (2003): 163–202.

Mitchell, W.J.T. *Iconology: Image, Text, and Ideology.* Chicago: University of Chicago Press, 1986.

Moran, Laurence A. "The Demise of *Scientific American.*" *Sandwalk: Strolling with a Skeptical Biochemist,* April 14, 2007. http://sandwalk.blogspot.com/2007/04/demise-of-scientific-american.html (accessed June 6, 2011).

Myers, Greg. "Every Picture Tells a Story: Illustrations in E. O. Wilson's Sociobiology." *Human Studies* 11.2 (1988): 231–265.

National Science Foundation. "About the Visualization Challenge." *Visualization Challenge.* https://www.nsf.gov/news/special_reports/scivis/challenge.jsp (accessed June 30, 2015).

National Science Foundation. "Judging Criteria." *Visualization Challenge,* 2015. http://www.nsf.gov/news/special_reports/scivis/judging.jsp (accessed November 30, 2015).

Nelkin, Dorothy. *Selling Science: How the Press Covers Science and Technology.* New York: W. H. Freeman, 1995.

Nesbit, Jeff, and Monica Bradford. "2006 Visualization Challenge." *Science* 313 (September 22, 2006): 1729.

"New Role for Immune System Pathway in Post-Heart Attack Inflammation." *Science Daily,* March 9, 2009. http://www.sciencedaily.com/releases/2009/03/090309191509.htm (accessed November 11, 2011).

Nisbet, Matthew C., and Dietram A. Scheufele. "What's Next for Science Communication? Promising Directions and Lingering Distractions." *American Journal of Botany* 96.10 (2009): 1767–1778.

Northcut, Kathryn M. "Images as Facilitators of Public Participation in Science," *Journal of Visual Literacy* 26.1 (2006): 1–14.

O'Connor, Ralph. *The Earth on Show: Fossils and the Poetics of Popular Science, 1802–1856.* Chicago: University of Chicago Press, 2007.

Olson, Lester C., Cara A. Finnegan, and Diane S. Hope, eds. *Visual Rhetoric: A Reader in Communication and American Culture.* Los Angeles: Sage, 2008.

Ottino, Julio. "Is a Picture Worth 1,000 Words?" *Nature* 421 (January 30, 2003): 474–476.

Pauwels, Luc, ed. *Visual Cultures of Science: Rethinking Representational Practices in Knowledge Building and Science Communication.* Lebanon, N.H.: Dartmouth University Press, 2006.

Perelman, Chaim, and Lucie Olbrechts-Tyteca. *The New Rhetoric: A Treatise on Argumentation.* Notre Dame: University of Notre Dame Press, 1969.

Perrault, Sarah T. *Communicating Popular Science: From Deficit to Democracy.* New York: Palgrave-Macmillan, 2013.

Pinholster, Ginger, and Becky Ham. "Science Communication Requires Time, Trust, and Twitter." *Science* 342 (December 20, 2013): 1464.

Priest, Susanna. "Critical Science Literacy: What Citizens and Journalists Need to Know to Make Sense of Science." *Bulletin of Science, Technology & Society* 33 (2013): 138–145.

Priest, Susanna. "Reinterpreting the Audiences for Media Messages about Science." In *Investigating Science Communication in the Information age: Implications for Public Engagement and Popular Media*. Edited by Richard Holliman, Elizabeth Whitelegg, Eileen Scanlon, Sam Smidt, and Jeff Thomas, 223–236. Oxford: Oxford University Press, 2009.

Racine, Eric, Ofek Bar-Ilan, and Judy Illes. "fMRI in the Public Eye." *Nature Reviews Neuroscience* 6 (February 2005): 159–164.

Rawley, William. "To the Reader." In *Sylva Sylvarum or A Natural History in Ten Centuries, 11th Edition* (1685) by Sir Francis Bacon. Edited by William Rawley. Reel 1029:21, Microfilm, 1–2. London: B. Griffin, 1980.

Rawlins, Jacob D. "Mythologizing Change: Examining Rhetorical Myth as a Strategic Change Management Discourse." *Business and Professional Communication Quarterly* 77.4 (2014): 453–472.

Rawlins, Jacob D., and Gregory D. Wilson. "Agency and Interactive Data Displays: Internet Graphics as Co-created Rhetorical Spaces." *Technical Communication Quarterly* 23.4 (2014): 303–322.

Rees, Graham. "Introduction." In *The Oxford Francis Bacon XIII*. Edited by Graham Rees, lxxiii–lxxxiii. Oxford: Oxford University Press, 2000.

Remmert, Volker R. "'Docet parva pictura, quod multae scripturae non dicunt.' Frontispieces, Their Functions, and Their Audiences in Seventeenth-Century Mathematical Sciences." In *Transmitting Knowledge: Words, Images, and Instruments in Early Modern Europe*. Edited by Sachiko Kusukawa and Ian Maclean, 239–270. Oxford: Oxford University Press, 2006.

Rheingold, Howard. *Netsmart: How to Thrive Online*. Cambridge, Mass.: M.I.T. Press, 2012.

Robbins, Gary. "Math as Art." *Science Dude*, September 28, 2006. http://sciencedude.freedom blogging.com/2006/09/ (accessed January 12, 2010).

Rosenthal, Earl. "Plus Ultra, Non Plus Ultra, and the Columnar Device of Emperor Charles V." *Journal of the Warburg and Courtauld Institutes* 34 (1971): 204–228.

Ross, Jerry. "Xenon Plasma Accelerator." Art of Science. Princeton University (2010). http://www.princeton.edu/artofscience/gallery2010/one.php%3Fid=1326.html (accessed June 7, 2011).

Rossner, Mike, and Kenneth Yamada. "What's in a Picture? The Temptation of Image Manipulation." *Journal of Cell Biology* 166.1 (2004): 11–15.

Rudwick, Martin. "The Emergence of a Visual Language for Geological Science 1760–1840." *History of Science* 14 (1976): 149–195.

Russell, Nicholas. *Communicating Science: Professional, Popular, Literary*. Cambridge: Cambridge University Press, 2010.

Schiebinger, Londa. "Feminine Icons: The Face of Early Modern Science." *Critical Inquiry* 14.4 (1988): 661–691.

Schriver, Karen. *Dynamics in Document Design*. New York: John Wiley, 1997.

Schummer, Joachim, and Tami Spector. "Popular Images versus Self-Images of Science: Visual Representations of Science in Clipart Cartoons and Internet Photographs." In *Science Images and Popular Images of the Sciences.* Edited by Bernd Huppauf and Peter Weingart, 69–96. New York: Routledge, 2008.

"Science as Art: A Visualization Challenge." Clemson University (2011). http://www .scienceasart.org/ (accessed June 7, 2011).

Sheets-Pyenson, Susan. "Popular Science Periodicals in Paris and London: the Emergence of a Low Scientific Culture, 1820–1875." *Annals of Science* 42 (1985): 549–572.

Sheriff, Mary. "Decorating Knowledge: The Ornamental Book, The Philosophic Image and the Naked Truth." *Art History* 28.2 (2005): 151–173.

Shteir, Ann B. "Iconographies of Flora: The Goddess of Flowers in the Cultural History of Botany." In *Figuring It Out: Science, Gender, and Visual Culture.* Edited by Ann B. Shteir and Bernard Lightman, 3–27. Hanover, N.H.: Dartmouth College Press, 2006.

Shteir, Ann B., and Lightman, Bernard, eds. *Figuring It Out: Science, Gender, and Visual Culture.* Hanover, N.H.: Dartmouth College Press, 2006.

Sierad, Lee. "Thrombousthai." Science as Art: A Visualization Challenge 2010. Clemson University. http://www.scienceasart.org/past/2010/all/place/1/2 (accessed June 7, 2011).

Simpson, David. "Francis Bacon," *Stanford Internet Encyclopedia of Philosophy.* Last modified December 29, 2003. http://plato.stanford.edu/entries/francis-bacon/ (accessed February 26, 2009).

Snow, C. P. "The Two Cultures and the Scientific Revolution." *The Rede Lecture,* 1959. Cambridge: Cambridge University Press, 1961.

Soriano, Kathleen. "Art Meets Science: A Curator Who Wants to Open Windows." *New Scientist* blog, May 11, 2010. http://www.newscientist.com/blogs/culturelab/2010/05/art -meets-science-curator.html.

Southgate, Therese. *The Art of JAMA: One Hundred Covers and Essays from the* Journal of the American Medical Association. Chicago: Mosby, 1997.

Sprat, Thomas. *The History of the Royal Society* (1667). Edited by Jack Lynch. http:// andromeda.rutgers.edu/~jlynch/Texts/sprat.html (accessed April 30, 2015).

Stafleu, Frans A. *Linnaeus and The Linnaeans: The Spreading of Their Ideas in Systematic Botany, 1735–1789.* Utrecht: Oosthoek, 1971.

Steigerwald, Joan. "Figuring Nature/Figuring the (Fe)male: The Frontispiece to Humboldt's *Ideas Towards a Geography of Plants.*" In *Figuring It Out: Science, Gender, and Visual Culture.* Edited by Ann B. Shteir and Bernard Lightman, 54–82. Hanover, N.H.: Dartmouth College Press, 2006.

Stephens, Mitchell. *The Rise of the Image the Fall of the Word.* New York: Oxford University Press, 1998.

Strain, Daniel. "Caption." National Science Foundation's Visualization Challenge, February 21, 2012. http://www.nsf.gov/news/special_reports/scivis/winners_2011.jsp# illustration (accessed February 28, 2012).

Tanner, Marie. *The Last Descendent of Aeneas: The Hapsburgs and the Mythic Image of the Emperor.* New Haven CT: Yale University Press, 1993.

Thomas, Rachel. "Still Life." *Plus,* April 10, 2006. http://plus.maths.org/latestnews/sep
-dec06/visualisation/index.html (accessed January 12, 2010).

Thornton, Davi Johnson. *Brain Culture: Neuroscience and Popular Media.* New Brunswick,
N.J.: Rutgers University Press, 2011.

Tibell, Gunnar. "Linnaeus Grows Bananas and Comes Up with a 'Modern' Thermometer."
Linné online. Uppsala University, 2008. http://www.linnaeus.uu.se/online/life/6_3.html
(accessed June 15, 2010).

Tufte, Edward R. *Beautiful Evidence.* Cheshire, Conn.: Graphics Press, 2006.

Tufte, Edward R. *Envisioning information.* Cheshire, Conn.: Graphics Press, 1990.

Valencia, Jorge. "*Scientific American* Goes under a Microscope; Redesign Aims to Bring
Print, Web Site Closer; Advertisers Stay Aboard." *Wall Street Journal* (June 25, 2007):
B3.

Wainwright, Loudon. *The Great American Magazine: An Inside History of* LIFE. New York:
Knopf, 1986.

Walsh, Lynda. *Scientists as Prophets: A Rhetorical Genealogy.* Oxford: Oxford University
Press, 2013.

Wandelaar, Jan. "Verklaaring van de Tytelprent." In *Hortus Cliffortianus* (1737), by Carl
von Linné. Arranged by Kurt Stueber, 2007. http://caliban.mpiz-koeln.mpg.de/linne/
hortus/index.html (accessed March 30, 2011).

Wells, William, John Burnett, and Sandra Moriarty. *Advertising Principles & Practice,* 6th
edition. Upper Saddle River, N.J.: Prentice Hall, 2003.

Whalen, Matthew D., and Mary F. Tobin. "Periodicals and the Popularization of Science
in America, 1860–1910." *Journal of American Culture* 3.1 (1980): 195–203.

Whitley, Richard. "Knowledge Producers and Knowledge Acquirers: Popularization as
a Relation between Scientific Fields and their Publics." In "Expository Science: Forms
and Functions of Popularization." *Sociology of the Sciences A Yearbook* 9 (1985): 3–28.

Wilson, Stephen. "Art Meets Science: Speaking a Lingua Digica." *New Scientist* blog,
May 13, 2010. http://www.newscientist.com/blogs/culturelab/2010/05/art-meets-science
-lingua-digica.html (accessed June 30, 2015).

"World's Hottest Furnace: Concave Mirror Focuses Sun's Rays to Produce Highest Con-
trolled Temperatures Reached by Man." *Life* 29.19 (1950): 136–137.

Wysocki, Anne Frances, and Dennis Lynch. *Compose, Design, Advocate.* New York: Pear-
son Longman, 2007.

Yau, Nathan. *Data Points: Visualization that Means Something.* Indianapolis, Ind.: John
Wiley, 2013.

Zelkowitz, Rachel. "Special Feature: 2008 Visualization Challenge Winners." *Science* 321
(September 26, 2008): 1768.

Zielinski, Sarah. "Picture of the Week." *Smithsonian,* May 1, 2009. http://blogs.smithsonian
mag.com/science/tag/seaweed/ (accessed January 12, 2010).

Zigrosser, Carl. *The Book of Fine Prints: An Anthology of Printed Pictures and Introduction
to the Study of Graphic Art in the West and the East.* New York: Crown, 1948.

INDEX

ABOUT THE AUTHOR

MARIA E. GIGANTE is an associate professor of rhetoric and writing stud-
ies in the English Department at Western Michigan University, where she has
spearheaded the development of a science-writing curriculum. Her work on the
visual rhetoric of science has appeared in *Rhetoric Review* and the *Journal of
Technical Writing and Communication.*